Sports Illustrated Sports Illustrated
Sports Illustrated Sports Illustrated Sports
Sports Illustrated Sports Illustrated
Sports Illustrated Sports Illustrated Sports
Sports Illustrated Sports Illustrated Sports
Sports Illustrated Sports Illustrated
Sports Illustrated Sports Illustrated Sports
Sports Illustrated Sports Illustrated
Sports Illustrated Sports Illustrated Sports
Sports Illustrated Sports Illustrated
Sports Illustrated Sports Illustrated Sports
Sports Illustrated Sports Illustrated Sports
Sports Illustrated Sports Illustrated
Sports Illustrated Sports Illustrated Sports
Sports Illustrated Sports Illustrated
Sports Illustrated Sports Illustrated Sports
Sports Illustrated Sports Illustrated Sports
Sports Illustrated Sports Illustrated
Sports Illustrated Sports Illustrated Sports
Sports Illustrated Sports Illustrated

DREW BREES

CELEBRATING A NEW ORLEANS LEGEND

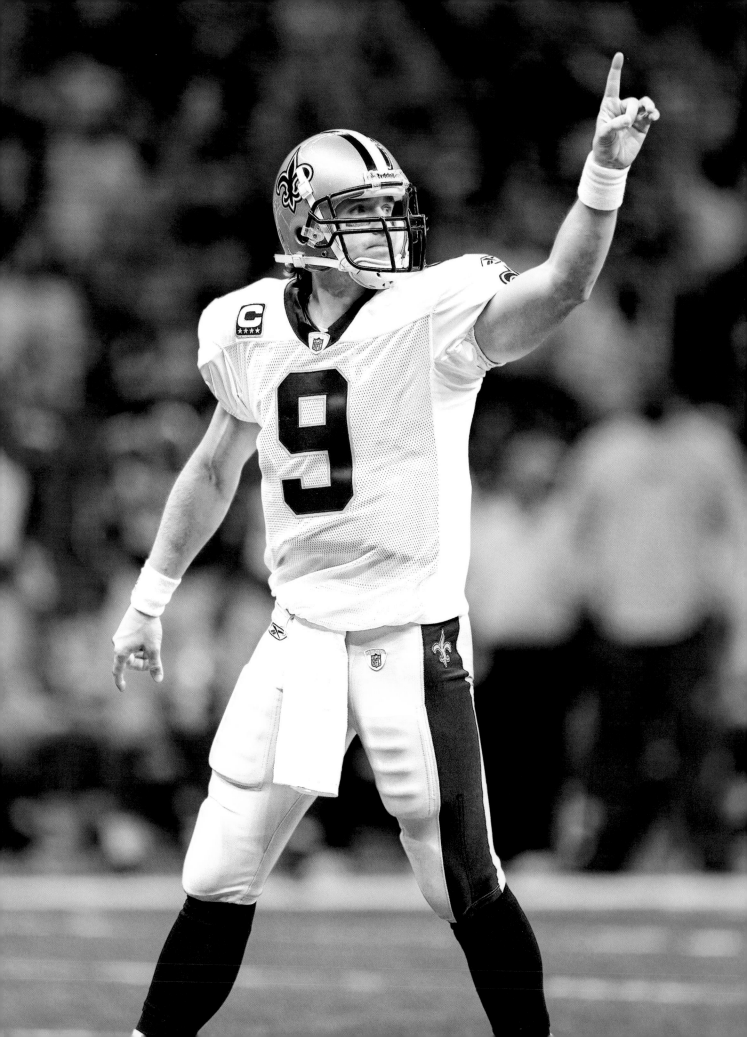

CONTENTS

Drew Brees retired as New Orleans's all-time leader in almost every passing category, including yards, completions, and touchdowns.

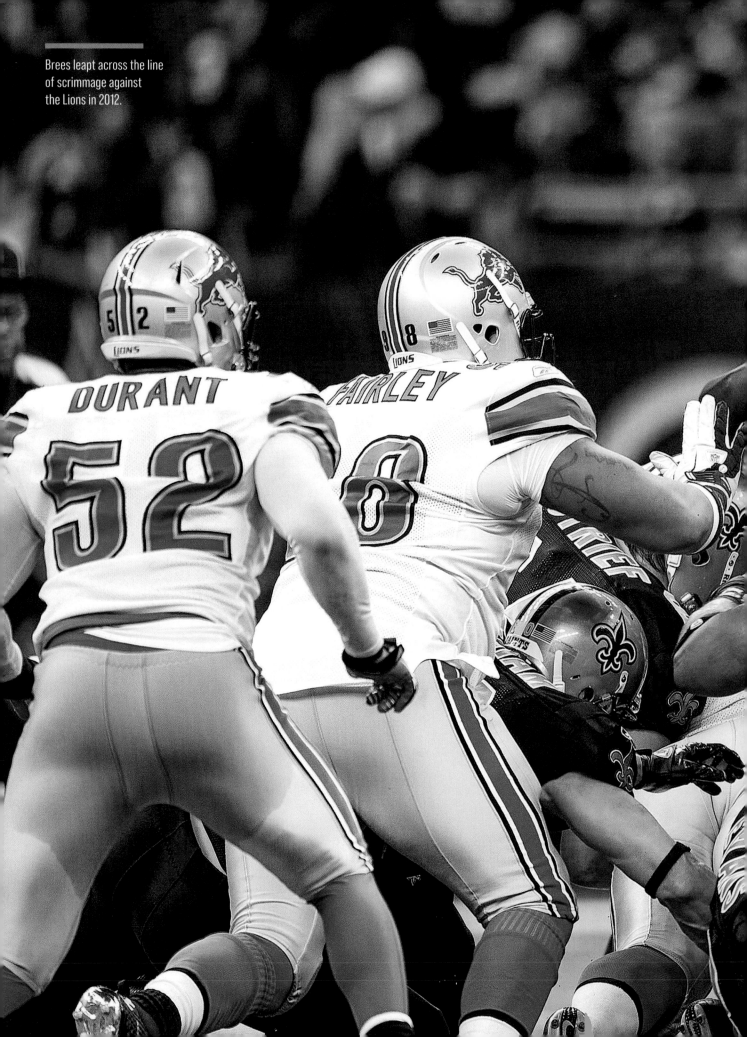

Brees leapt across the line of scrimmage against the Lions in 2012.

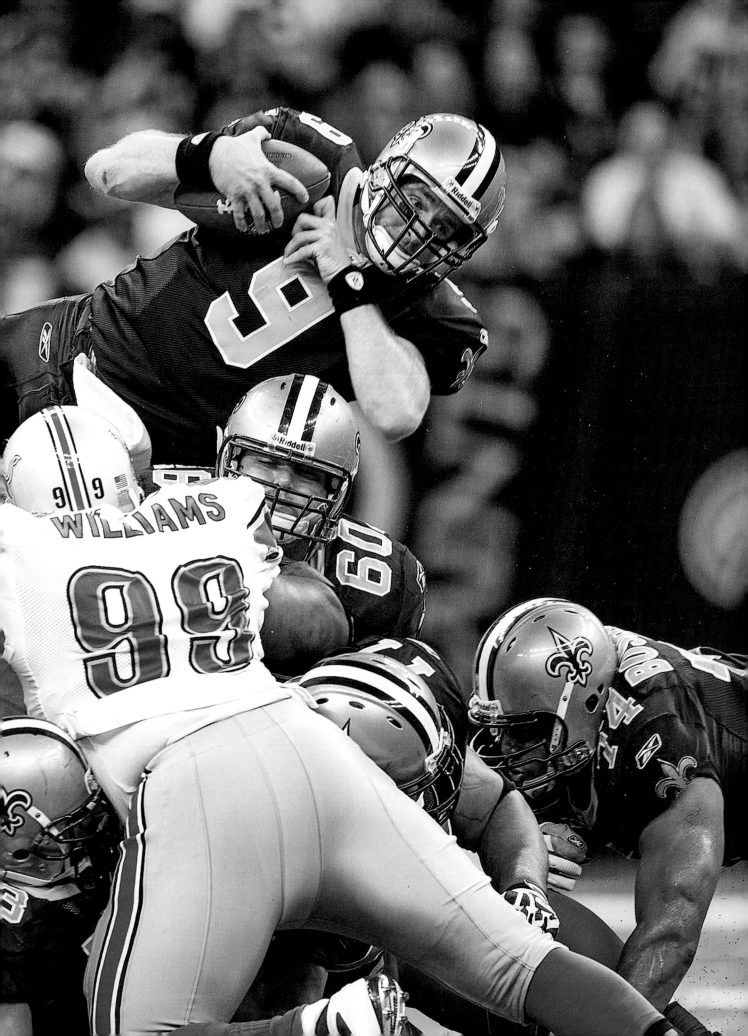

A Regular Legend

Drew Brees accomplished the extraordinary while remaining refreshingly ordinary

BY GREG BISHOP

Drew Brees's transcendent pro football career will be defined by numbers, so many numbers, because the digits he collected are way too staggering to ignore: 80,358 passing yards, 571 touchdown throws, 67.7% completion rate, 20 seasons spent dissecting NFL defenses as the premier surgical QB, not just of an era but of all time.

He'll be tagged, too, for winning only *one* Super Bowl, as if historically great quarterbacks can just snap their fingers and collect rings.

I'll remember Brees, though, not just for the records he collected with an assassin's ruthlessness, but also for how damn grounded he was in the most abnormal of ecosystems, the alternate universe of NFL stardom. When I interviewed him for a 2018 SPORTS ILLUSTRATED cover story, he invited me to his son's bounce-house birthday party afterward and even packed a plate of food to go for me. Funny enough, the pizza, pasta and salad were neatly separated in the container he provided. Brees remained precise and meticulous, always, from the most meaningful interactions to a totally meaningless one.

Those who know Brees best understand this side of him. "He's probably the most normal of all the superstars I've come across," says Tom House, the respected throwing coach who has trained Brees, Tom Brady and Nolan Ryan, among many others in various sports. So many elite athletes, House says, put their careers first. He's not judging; they have to in order to maximize their earnings and potential. Brees, though, struck House as closer to 50-50 in how he split his priorities between his team and his family. Each pursuit made Brees better for the other.

House, a former major league pitcher, knew the other way from experience, as baseball had cost him his first marriage. Now remarried, the throwing guru who helped stabilize the motion of the most accurate passer in NFL history learned an important lesson about balancing his life in return. That marks yet another measure of Brees's outsize impact, which extended to the

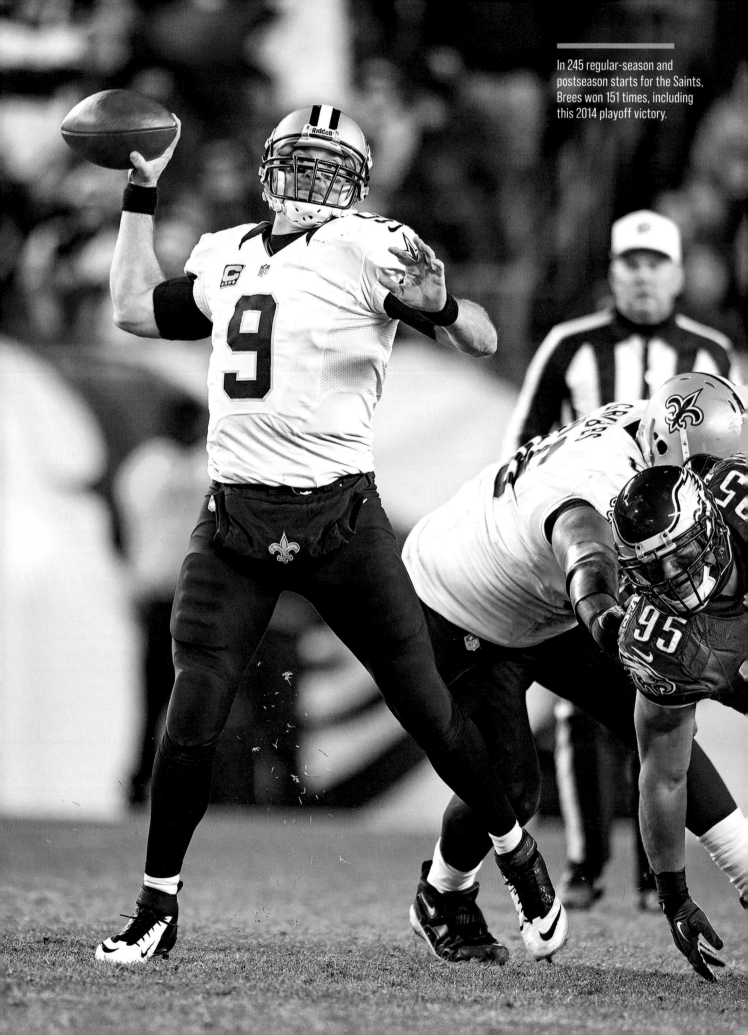

In 245 regular-season and postseason starts for the Saints, Brees won 151 times, including this 2014 playoff victory.

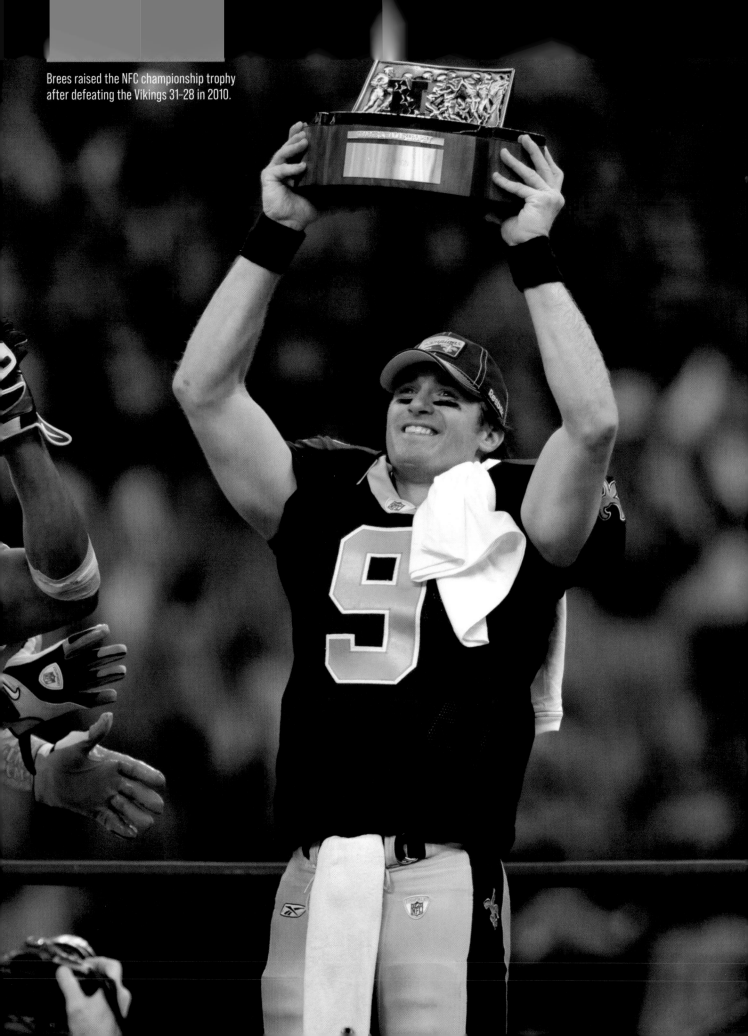

Brees raised the NFC championship trophy after defeating the Vikings 31–28 in 2010.

injured athletes inspired by his 2006 comeback from shoulder surgery to fellow NFL players who appreciated his work as a member of their union's executive committee.

Like every fan who ever tugged on a Saints jersey, House wishes that Brees had won another championship. He came so close in the last four seasons, leading teams with legitimate hopes only to be knocked out on a fluky catch now known as the Minneapolis Miracle (2017), a terrible pass interference call ('18), an odd overtime upset ('19) and, most recently, a GOAT named Brady ('21). But House asks, fairly: Why define Brees by the games he didn't win when we have so many examples of his brilliance?

Sure, there were missteps. Brees endorsed AdvoCare, a health and wellness company that in 2019 paid $150 million to settle charges of operating a pyramid scheme. Then there was the Yahoo! Finance interview in which he advocated that players stand for the national anthem rather than kneel in protest. But there Brees should be commended for listening to teammates outraged over what he said, for trying to understand the issues that led to the protests and committing to work toward improvements.

Brees was named to the Pro Bowl 13 times, was the Comeback Player of the Year in 2004 and won 172 games as a starting quarterback. He led the NFL in passing yards seven times and fashioned more than 50 game-winning drives. He won Super Bowl XLIV after the '09 season and nabbed that game's MVP honors, too.

His impact, though, stretched far beyond wins and those statistics, eye-straining as they were. Brees will be lauded for what he did in, to and for New Orleans, starting with his arrival in 2006, fresh off the surgery to repair the torn right labrum that threatened to end what to that point was an uneven career. He took a city still reeling from Hurricane Katrina and gave back an important and unquantifiable commodity in short supply: hope.

"There's something almost miraculous about that relationship," says James Carville, the famous political consultant and lifelong Saints fan. "Drew defines the psyche of a place more than any athlete I can recall. It's more than wins and losses. It's borderline supernatural, the way it fits."

As the seasons flew by, Brees became a vital part of Carville's life, almost like a friend. The two men never actually met, but Carville began defending Brees in public and private conversations, arguing, fairly, that Brees belonged with Brady and Joe Montana in the best-ever NFL quarterback conversation. "If you don't count touchdowns, yards and completions, then he's not," Carville quips. When the Rams knocked the Saints from the playoffs three seasons ago, after that phantom P-INT, Carville says he felt most "for Brees," knowing that his odds to secure another title dwindled with each passing year.

Carville also notes, correctly, that how Brees is considered, his ultimate standing in NFL history, will "age well over time." We'll view Brees more favorably in 10 years, Carville posits. The missteps will fade, the numbers will remain and the chance that anybody ends up approaching them—beyond, maybe, Patrick Mahomes under fairly ideal circumstances—is as likely as Brees's growing another six inches in retirement.

House agrees. He says that when football analysts look back at the quarterback era that's now close to ending, Brees and Brady will stand alone. "All the pundits are saying [Aaron] Rodgers is this and [Peyton] Manning is that," House says. "But Drew is right there with the GOAT. Time will bear that out."

Brees will now move into broadcasting, at NBC Sports, where he's likely to excel, as a "normal" legend who can break down football with uncanny precision. In other words, he'll continue to be Drew Brees, the superstar quarterback who never carried himself that way. ●

The unassuming Brees quietly
rewrote the NFL record books.

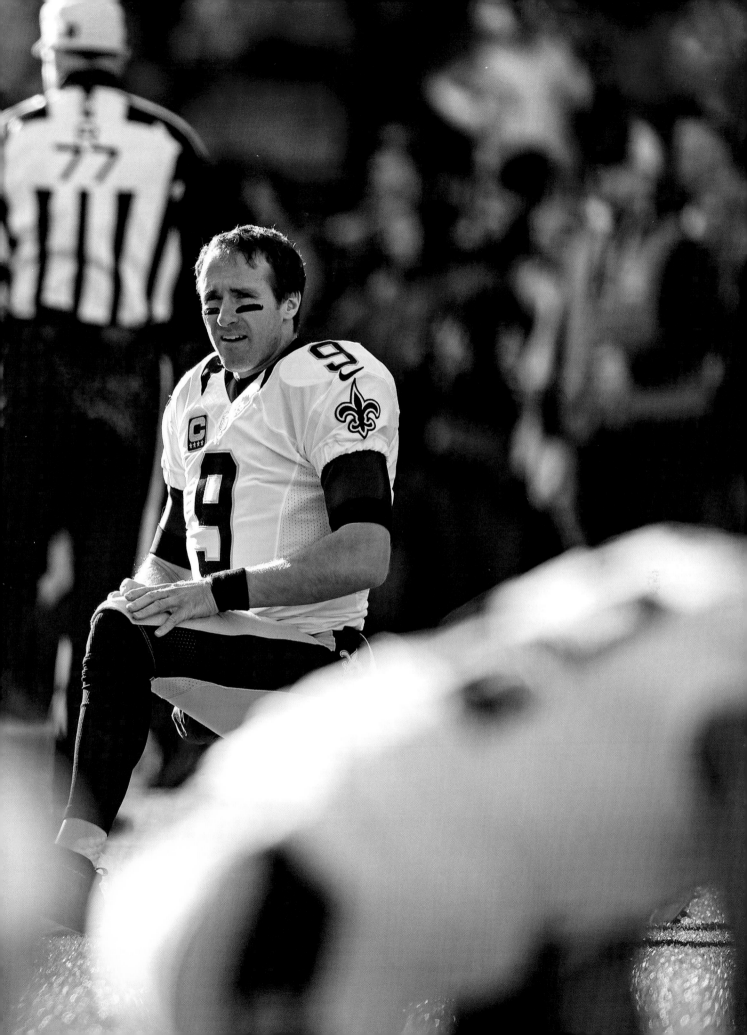

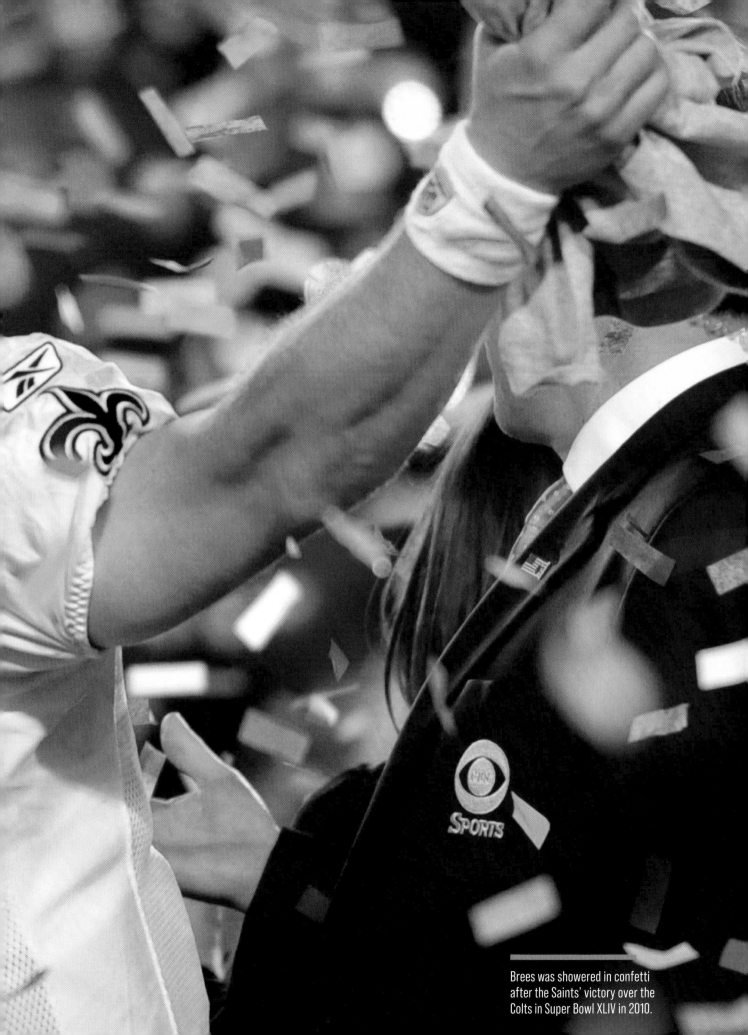

Brees was showered in confetti after the Saints' victory over the Colts in Super Bowl XLIV in 2010.

EARLY YEARS

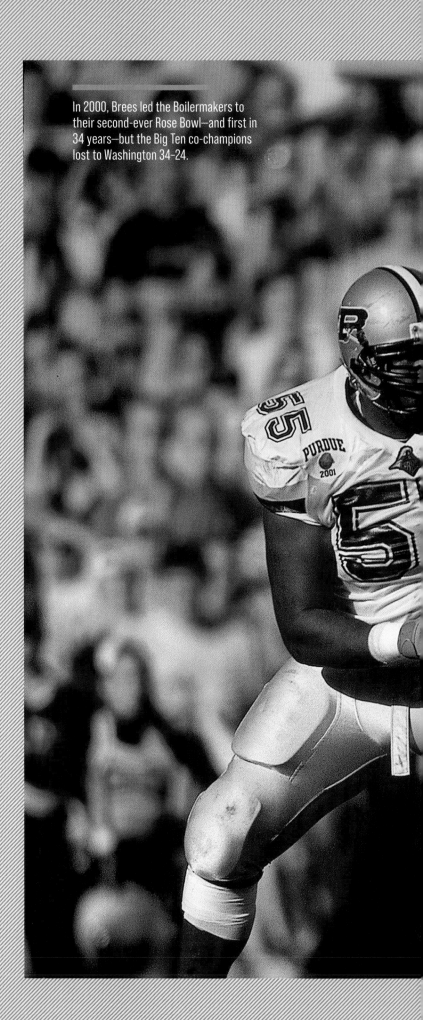

In 2000, Brees led the Boilermakers to their second-ever Rose Bowl—and first in 34 years—but the Big Ten co-champions lost to Washington 34–24.

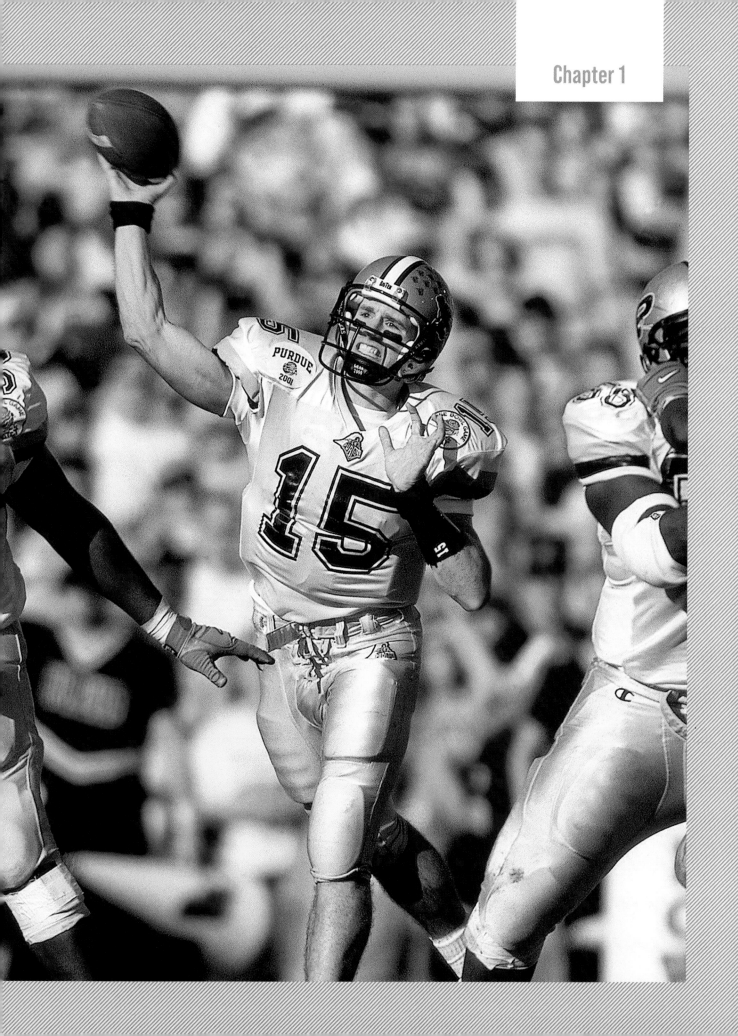

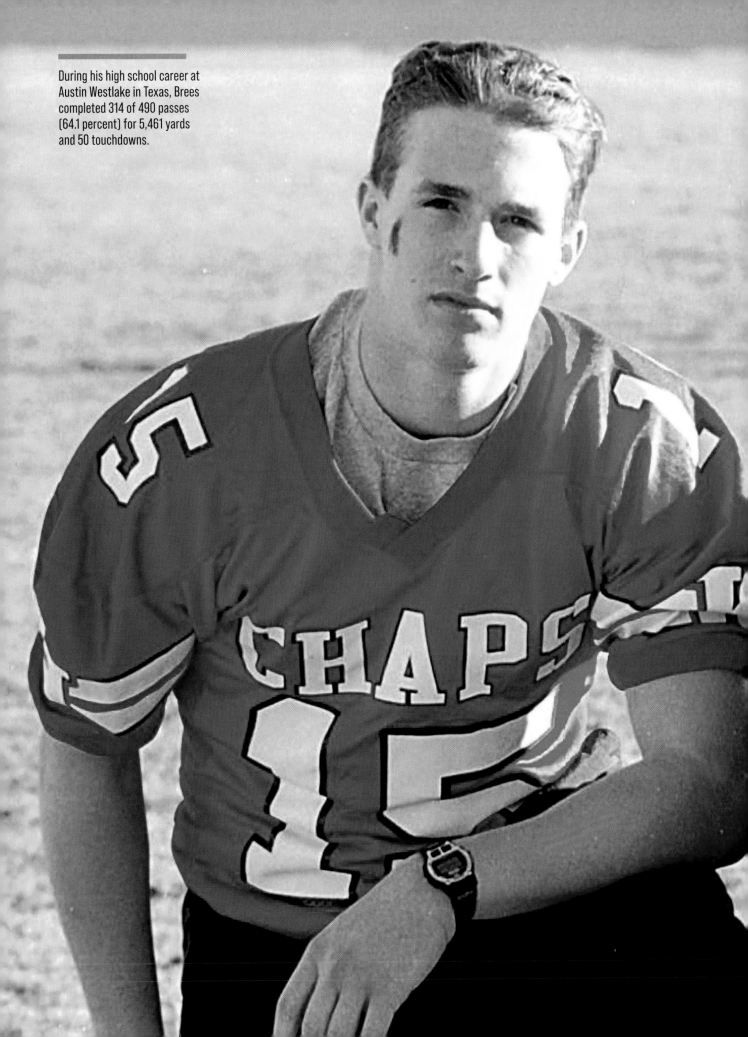

During his high school career at Austin Westlake in Texas, Brees completed 314 of 490 passes (64.1 percent) for 5,461 yards and 50 touchdowns.

After rehabbing from an ACL tear, Brees started at quarterback for two seasons at Austin Westlake, leading the Chapparrals to a record of 28–0–1.

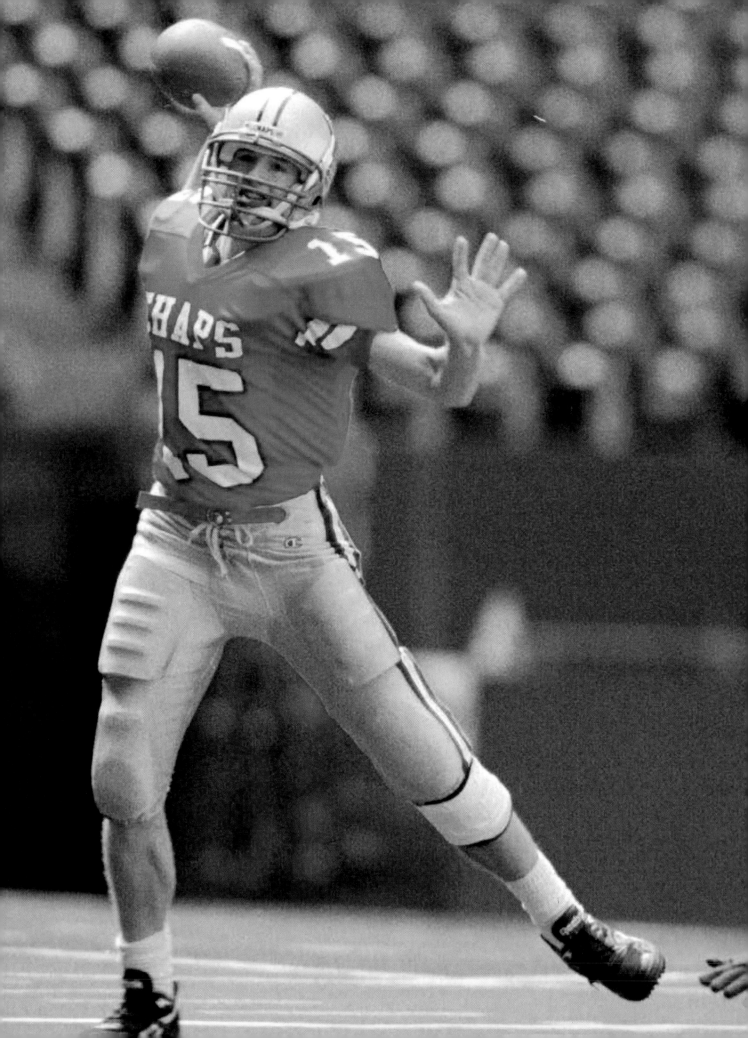

In 1996, Brees led
Austin Westlake
to a 16–0 record and a
Texas state championship.

Excerpted from SPORTS ILLUSTRATED, August 16, 1999

Mark of Distinction

By virtue of his play, Drew Brees turned a birthmark from an object of curiosity to a point of pride and celebration across the Purdue campus

BY TIM LAYDEN

The fuzzy brown birthmark on quarterback Drew Brees's right cheek approximates the size, shape and texture of a small woolly-bear caterpillar. For the first 19 years of Brees's life, the birthmark invited occasional wide-eyed shock, a lot of harmless derision and more than a little humor, but nothing beyond that.

It was there on Jan. 15, 1979, when Chip and Mina Brees named their newborn son after Cowboys wide receiver Drew Pearson. On first viewing his son, Chip recoiled at the sight of the brown patch, and Mina wondered if she had caused it when she fell on her right side while running on an icy footpath not long before delivering Drew. "That's where an angel kissed you," Mina would tell him as he and the birthmark grew up together, a touching image offset by Drew's rugrat buddies who called the spot leech, roach and turd. Surgery was considered when Drew was three, but doctors assured the family that the mark was harmless.

When Brees arrived at Purdue in the summer of 1997, fellow freshman recruit Ben Smith was stunned that a football player was wearing on his face what appeared to be a goofy Purdue pep decal, like the ones cheerleaders apply to their cheeks in hopes of a close-up on television. "It looked like a Purdue Pete," recalls Smith, who would become Brees's close friend. "I was thinking, Man, that guy's a sad dude." One night at a dance club a woman who was dancing with Brees wet her thumb and wiped at the birthmark, prompting fall-down laughter from Brees's friends and the following response from Brees: "It ain't comin' off." During Brees's freshman year, in which he played backup quarterback to Billy Dicken, his teammates named the birthmark Pernick, after Matt Pernick, a walk-on wideout at Purdue in 1997 who had perpetually wild hair, much like the horizontal burrs on Brees's face.

Then in the fall of '98 everything changed. Brees went big-time, and Pernick—the birthmark, not the player—went with him. On

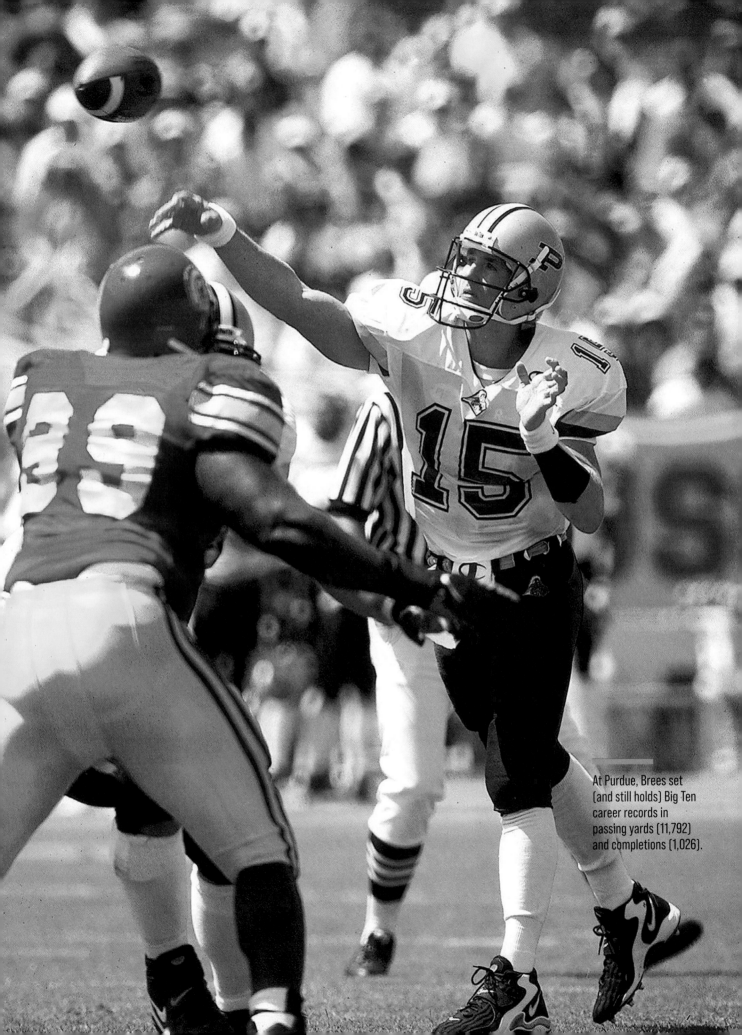

At Purdue, Brees set (and still holds) Big Ten career records in passing yards (11,792) and completions (1,026).

Halloween night, after Brees had passed for 362 yards and four touchdowns that afternoon in a 36–14 win over Iowa, Brees's roommate, linebacker Jason Loerzel, went to a costume party dressed as . . . Brees, complete with a No. 15 practice jersey and one fuzzy eyebrow from a pair of Groucho glasses glued to his right cheek. "I walked in the door, and everybody knew who I was supposed to be," says Loerzel. Brees and his friends had once amused themselves at parties by guessing the number of people (women, usually) who would approach Brees and ask what was on his mug. Suddenly people stopped asking. In nine short weeks the birthmark had become Cindy Crawford's mole or Ricky Williams's dreadlocks, at least in West Lafayette, Ind.

During an autumn rich in exceptional college quarterbacks, of whom Tim Couch, Donovan McNabb and Akili Smith would go one-two-three in the NFL draft, Brees, a sophomore, was among the most spectacular. He threw for more yards (3,983) and touchdowns (39) and for a better completion percentage (63.4) than McNabb of Syracuse, Smith of Oregon, Cade McNown of UCLA, Joe Germaine of Ohio State and Michael Bishop of Kansas State. He bettered Central Florida's Daunte Culpepper and Tulane's Shaun King in yards and touchdowns and led Purdue to a 9–4 season, capped by an Alamo Bowl victory over Bishop and the Wildcats.

Last season Brees shifted coach Joe Tiller's spread one-back offense into fifth gear at Wisconsin's Camp Randall Stadium, throwing an NCAA-record 83 passes—"This year we're going for 100," Brees said jokingly during the offseason—and completing an NCAA-record-tying 55 of his attempts for 494 yards in a 31–24 loss. He also threw four interceptions in that game and 20 for the season, the one blot on his résumé and the reason his pass efficiency rating (137.8) was lower than that of any other marquee passer in the class of 1998. Brees was voted second-team All–Big Ten, behind Germaine, by both the media and the conference's coaches. "Brees is more accurate than Germaine, and he's got a stronger arm," says Minnesota defensive coordinator David Gibbs.

The cynics' response to Brees's breakout season is that Gwyneth Paltrow could throw for 300 yards a game in the Boilermakers' madcap offense. That's an easy out. "Sure, their offense is great," says Wisconsin defensive coordinator Kevin Cosgrove, "but you need an operator, and they've got one. He's as good as I've seen in the 19 years I've been in this league."

With the top 10 finishers in last year's Heisman Trophy voting having left for the NFL, it's no stretch to imagine Brees's mug, birthmark and all, soon filling wall space at the Downtown Athletic Club. Turd no more. Over the winter Loerzel and Ben Smith began exploring ways to produce temporary tattoos in the shape of Brees's birthmark to sell outside Ross-Ade Stadium at Purdue home games the next fall. Stroking the fuzz with the index finger of his left hand while sitting in a steak house near campus in the offseason, Brees laughed and said, "I'll tell you what. At this point it's staying right where it is."

This is a Texas story being played out in Indiana. Drew's maternal grandfather is Ray Akins, one of the most successful coaches in the history of high school football in the state of Texas. Drew's mother excelled in four high school sports and was a baseball cheerleader at Texas A&M, where she met Drew's father. After Mina divorced Chip in 1987, when Drew was eight and his younger brother, Reid, was nearly six, she was married for 10 years to Harley Clark, a state district court judge and former Texas yell-leader who is credited with inventing the famous Hook 'em Horns salute. Chip married Amy Hightower, whose father, Jack, was a legislator from north Texas and later a state supreme court judge. There's more: One of Drew's uncles

is Marty Akins, an All–Southwest Conference quarterback at Texas in '75 who started for two years in the same backfield as Earl Campbell. Cut Drew open, and you'd find a Lone Star beating where his heart should be.

One afternoon last spring, at Mina's house on the west side of Austin, Ray Akins, a 74-year-old former Marine, bent down to make an imaginary snap like the center he once was. He has thick, gnarled hands and a twisted nose that was never protected by a face mask. After slogging with bazookas and flamethrowers through the jungles of the South Pacific during World War II, Akins returned home to Texas in 1946 and played four years of football at Southwest Texas State. Shortly thereafter he embarked on a 38-year coaching career during which he won 302 games, the third most in state history, before retiring in '88. Most of those victories came in 24 years at Gregory-Portland High, near Corpus Christi on the Gulf Coast.

Brees has often been his grandfather's shadow. Between the ages of five and 10 he spent the last five summers of Akins's coaching career attending two-a-day preseason practices at Gregory-Portland, where assistant coach Ronnie Roemisch often shaved Brees's head over a trash can and then watched him roam the practice fields under a scorching sun. "I worshipped the guys who played for my grand-father," says Brees. "I worshipped him, too." When Akins retired to a ranch 50 miles north of College Station, Drew and Reid would visit every summer. They helped with chores—"I had to bust their heinies a few times," says Akins—and listened to their grandfather's tales. "He would tell us stories about the war and about football and about the value of hard work," says Drew. "He's an amazing man."

Bob McQueen, the longtime coach at Temple High, near Waco, Texas, had known Akins for four decades but until recently was unaware that Akins and Brees were related. "You tell me that Drew Brees is Ray Akins's grandson,

that tells me a lot about why he's such a solid young man," says McQueen.

Akins wasn't the only one who influenced Brees's athletic development. Chip played hours of weekend catch with Drew. Mina introduced Drew to tennis, and he became one of the best junior players in Texas, attaining a No. 3 ranking in the USTA's age-12 group before drifting away from the game at 13. Mina, who was a singles player for Austin city championship teams in 1995 and '96, used to compete ferociously with her son, with Drew winning only occasionally.

Once Chip and Mina, both lawyers, were divorced, they became "joint managing conser-vators" for Drew and Reid. The boys slept half their nights at Mina's house and half at Chip's. The arrangement was—and sometimes still is—delicate, but Drew has seen worse. "I've had teammates with horrible divorces," he says. "My parents get along."

Brees wasn't a football prodigy. He didn't wear pads until he was in ninth grade at Westlake High and then played only on the freshman B team. One year later he ascended to backup quarterback on the junior varsity and then jumped to first string just before the season when the starter got Wally Pipped by a knee injury. He started two years for the varsity and went 28-0-1; as a senior he led Westlake to the Class 5A big school championship and won the 5A offensive MVP award. He threw for 5,416 yards and 50 touchdowns during those last two seasons.

It seemed a lock that Brees would be sought by the most storied college programs in the state, those of Texas and Texas A&M. He wasn't. Perhaps it was because he tore the ACL in his left knee in the penultimate game of his junior season and thus wasn't at full strength for summer camps. Perhaps it was because he was only 6 feet or because his release was too slow.

"Believe me, we told them he was the most accurate passer we'd ever seen, that he was a great leader and a tough kid," says Neal Lahue, Brees's

Some questioned whether Brees's gaudy college numbers were a product of Purdue's spread offense.

offensive coordinator at Westlake High and now the coach at Tivy High in Kerrville, Texas. "Nobody listened."

Texas didn't recruit him at all. "One form letter in my junior year," says Brees. Texas A&M, which he loved, pursued Brees just enough to leave scars. Chip and Mina had taken him to their alma mater—together and separately—when he was young. He knew the distinctive yells and chants that make College Station one of the most alluring game-day towns in the country. "If A&M had offered me a scholarship, I would have gone there in a minute," says Brees.

What the Aggies did, to Brees's recollection, was unforgivable. According to Brees, A&M assistant Shawn Slocum, son of coach R.C. Slocum, contacted Brees in November of his senior season and took him to lunch with Westlake teammate Seth McKinney, who had already been recruited by A&M and is now the Aggies' starting center. Brees says Shawn arranged for him to make an official visit on the fourth weekend in January. Shawn, who's now an assistant at Southern Cal, says no visit was arranged.

Two weeks before he thought he was to visit A&M, Brees called Shawn to firm up the date. "As soon as I mentioned the visit, Slocum said,

'Hey, Drew, I've got an important call on the other line. Can I call you right back?' That's the last I heard from A&M. They just blew me off."

Shawn says, "I don't remember all the details of that phone call." The Aggies were chasing quarterback Major Applewhite of Baton Rouge but lost him to Texas. They did sign Matt Schobel, a 6'4", 230-pound quarterback from Columbus, Texas, with speed and classic form, but he never played a down for A&M and transferred to TCU after his freshman season. "I hope there are no hard feelings," Shawn says. "Looking back on it, of the three kids we were after, it's safe to say the guy who went to Purdue turned out to be the best of the bunch. He's a winner."

Purdue opened last season at USC, with Brees making his first start. The Trojans won 27–17, but Brees completed 30 of 52 passes for 248 yards and two touchdowns. Shawn approached Brees after the game. "Hey, Drew, remember me?" he asked, and Brees snapped at him. "I don't remember my exact words," says Brees. "I know what I wanted to say was, 'Remember you? You're the reason I wanted to win this game.' That's the way I feel about all the coaches who didn't recruit me."

Two who did were Hal Mumme at Kentucky and Joe Tiller at Purdue, both first-year coaches who were itching to throw. In the end Purdue's highly regarded academic program in management and the chance to play in the Big Ten swayed Brees.

Standing on the Mollenkopf Athletic Center indoor practice field before an offseason workout, Purdue sophomore tight end Tim Stratton had a Brees story to tell. "One day last fall we were practicing indoors," Stratton says, "and a few of the quarterbacks and some other guys were having a contest to see who could make the most accurate throws. They're going at it, when Drew just walks in and grabs a ball. There were two soccer goals against the wall, about 40 yards away and about three feet apart. Drew puts it on a line right between them. End of contest."

Others have their stories, too. Junior wideout Vinny Sutherland remembers drifting across the back of the end zone early in the second quarter of last year's game against Minnesota, hopelessly lost in red-zone traffic. "I couldn't even see Drew," says Sutherland. "All of sudden, there's the ball, about 10 feet away from me. I just put my hands up, almost in self-defense, and grabbed it."

Senior Randall Lane recalls running a deep corner route in the same game and coming out of his last cut in time to see Brees make a seemingly desperate heave just as he was hit. "He took a serious wallop," says Lane, "but when I looked up, here came the ball, right over my shoulder." Another touchdown, this one from 46 yards. Lane laughs. "Around here," he says, "we call him Cool Brees."

When Tiller, who came to Purdue from Wyoming in November 1996, signed Brees as part of his first recruiting class, he wasn't sure what he was getting. As they watched Brees practice behind Dicken in the fall of 1997, Tiller and his staff grew enamored with Brees's uncanny accuracy—"Every ball was on the receiver's body," says Tiller—but they had doubts about his readiness to take over. "Hell, yes, I had doubts," says Tiller. "I was so sure he was going to be a great player for us that I recruited a junior college quarterback, [David Edgerton], in case Brees fell on his face."

Not even close. Brees won the starting quarterback job in the preseason last year and matured with each week. His once suspect mechanics are now textbook. Late last spring quarterbacks coach Greg Olson popped a tape into his office VCR for a visitor. The play on the tape was a third-down pass on the comeback drive that resulted in a 25–24 victory at Michigan State. Brees drops straight back but finds himself under siege from at least three blitzing defenders. He begins backpedaling to his left, one step, two, three . . . eight steps backward, staying balanced and keeping the

pursuers at bay until he fires a pass to Lane, who's crossing the field from left to right, for a 10-yard gain and a first down. The footwork is extraordinary, surely a by-product of all those tennis matches. The pass is freakish. "About as impressive a throw as you'll ever see," says Olson.

Michigan State coach Nick Saban says, "Brees reminds me of Joe Montana. He makes you feel that, play after play, you're about to do something big against him, and then he does something big against you. It's incredibly frustrating for a coach or a team."

Brees's quick feet and sweet accuracy have given rise to his one major flaw. "He tries to make every throw," says Tiller. "Sometimes you just can't." Hence those 20 interceptions.

In mastering Tiller's complex offense, Brees has taken a Peyton Manning–esque approach to preparation. Often assistants leaving the Mollenkopf Center at 11 on weeknights during the season run into Brees just arriving to study tape. He has to go in late because most of his evenings are occupied with maintaining a 3.20 grade point average in industrial management, which requires him to take courses like economics, physics and multivariate calculus. "Most of the courses he takes, I wouldn't consider," says Stratton.

This year the Boilermakers will play Michigan and Ohio State back-to-back, on the road, followed by Michigan State and Penn State at home, all in October. This torturous stretch will give Brees an uncommon opportunity to shine or to fail.

One afternoon last spring Brees strolled the walkway that separates Mackey Arena from Ross-Ade Stadium in one corner of the Purdue campus. "I won't forget the people who thought I couldn't succeed," he says, meaning the people who made him settle for Purdue, the people who chased him north, "but this is the right place for me."

Angel kiss? Just maybe. ●

Brees threw for 350 yards in a game against Wisconsin in 1999.

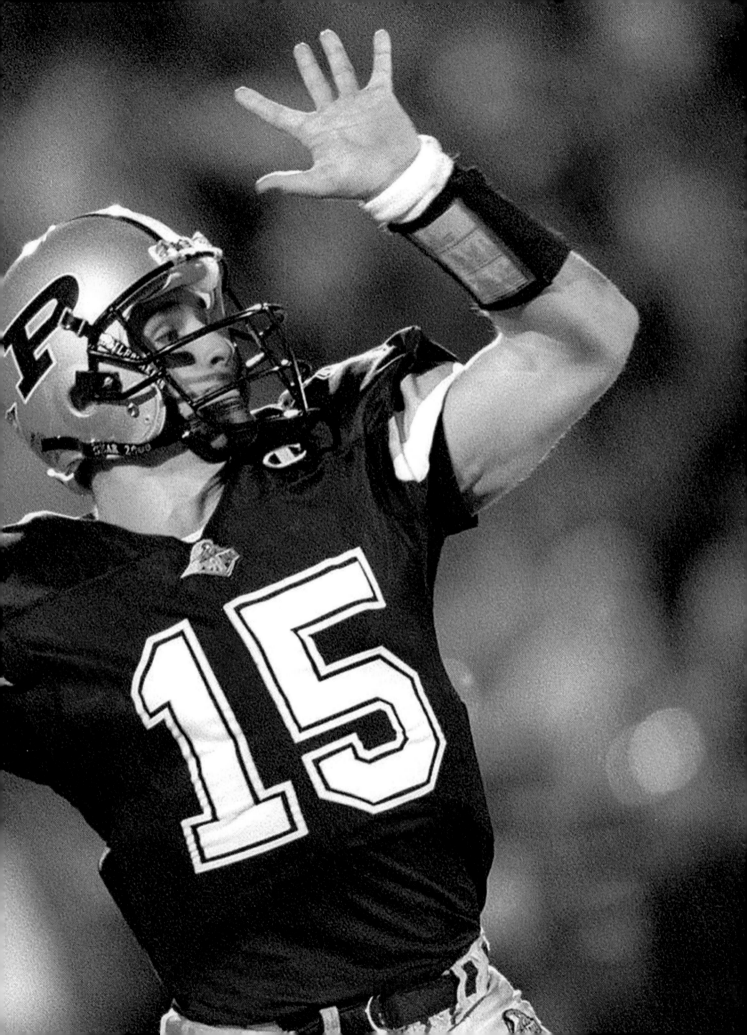

Brees was forced to scramble in the fourth quarter of a game against Notre Dame in 2000.

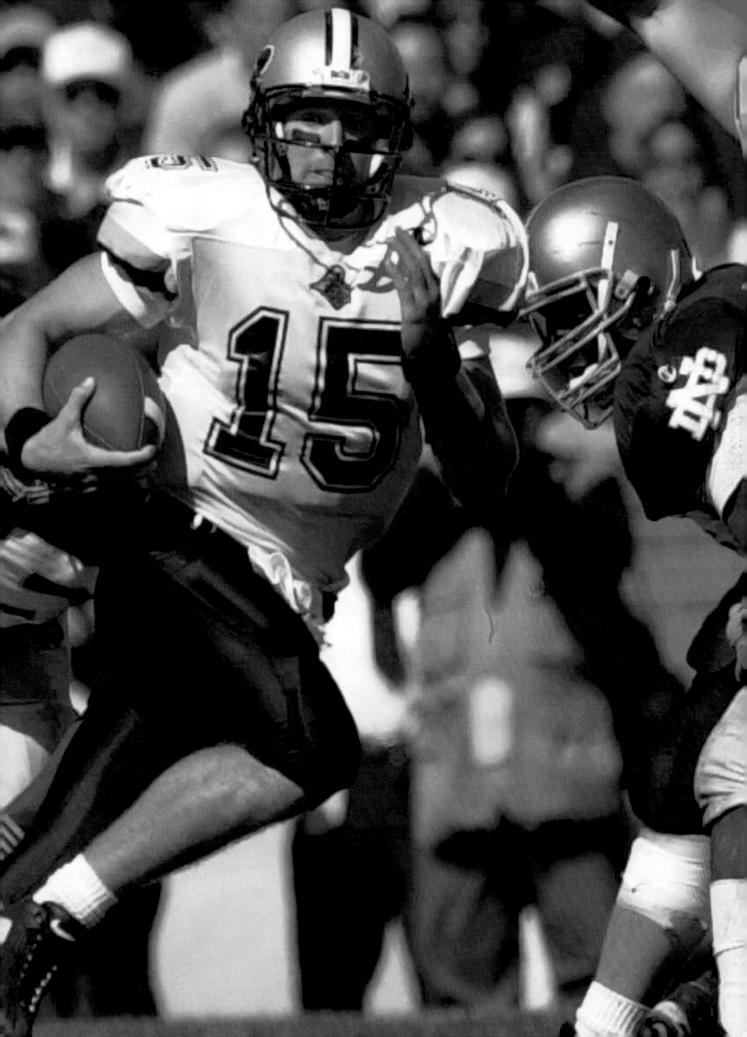

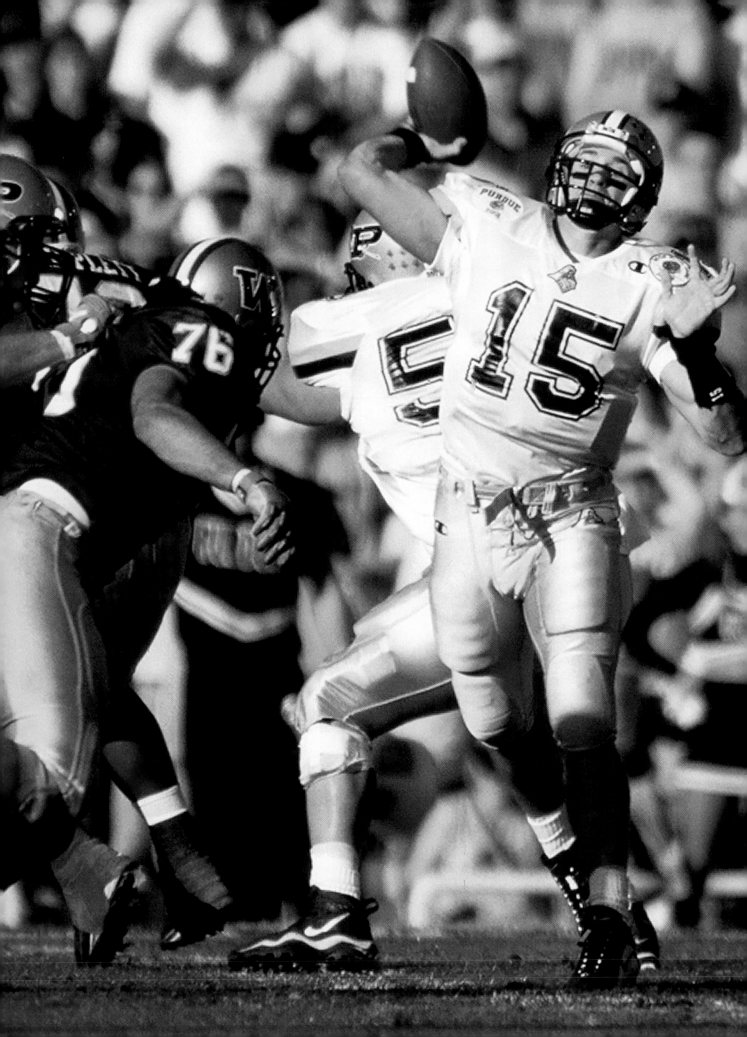

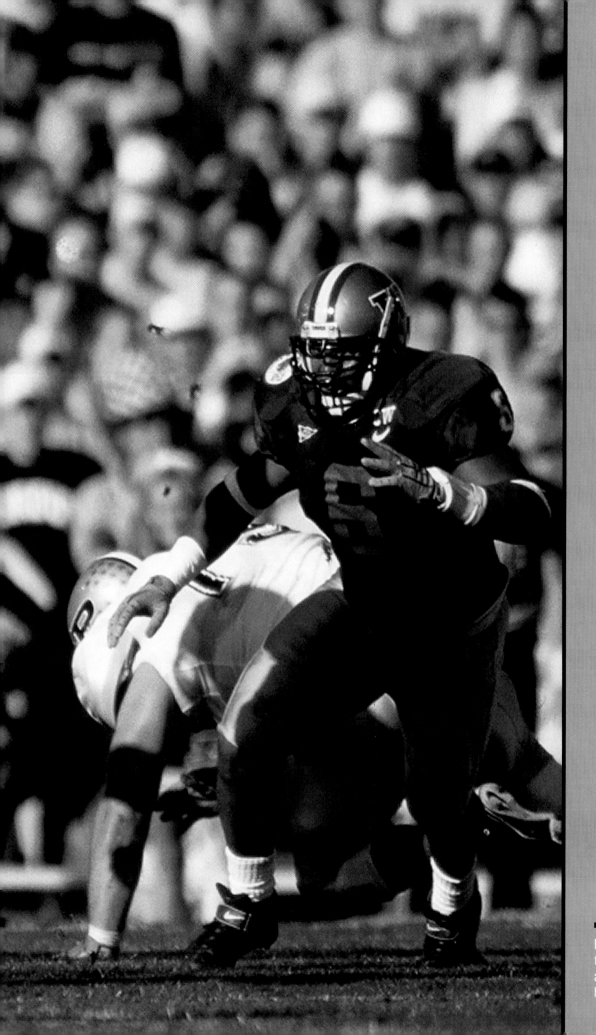

Brees led the Boilermakers to a Rose Bowl berth against Washington in his senior season.

Brees signed autographs
before playing in the
Hulu Bowl in 2001.

Brees participated in the
skills and drills competition
during Super Bowl
weekend in 2001.

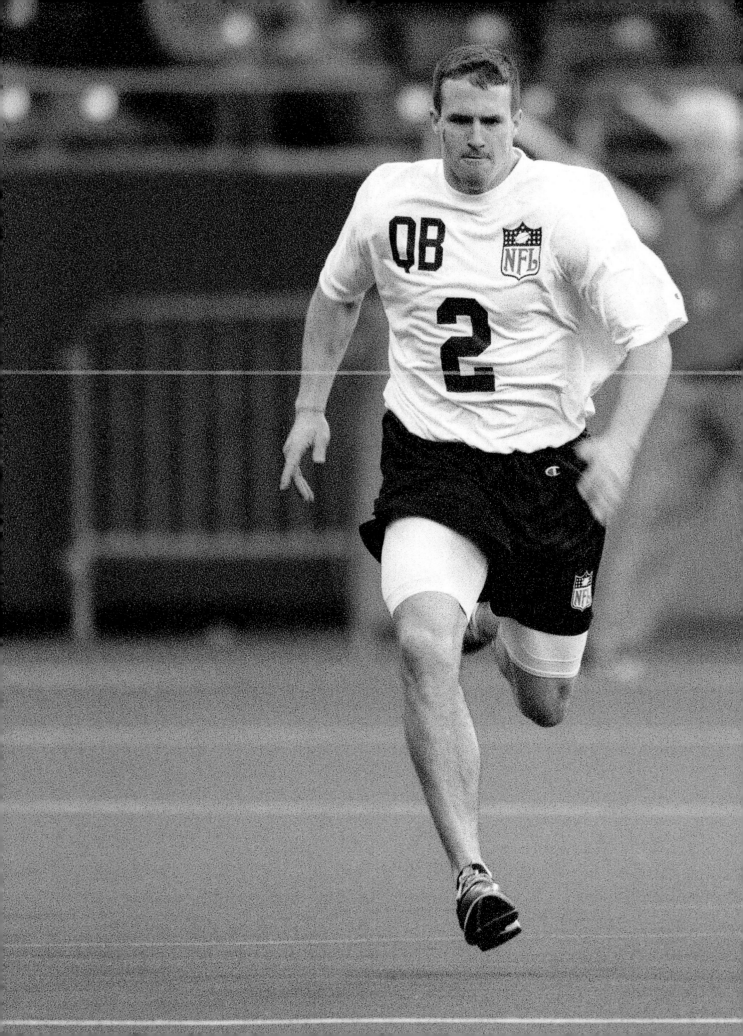

Brees ran the 40-yard dash at the NFL combine in 2001. His performance led some to question his ability to excel at the next level.

While his dog watched him eat chicken wings, an equally intent Drew Brees awaited his selection in the 2001 NFL draft; the Chargers took him with the 32nd pick (the Saints, on the clock at this moment, selected RB Deuce McAllister).

Excerpted from SPORTS ILLUSTRATED, April 30, 2001

Who Will Take Drew?

Drew Brees's path to the NFL draft included a disastrous combine workout that dimmed his prospects—and a brilliant private session that put him back on track

BY TIM LAYDEN

There is no sound quite like the trilling of a telephone on draft day, a beautiful noise with the power to transform anxiety into fulfillment. When the call came for Drew Brees at 3:30 that Saturday afternoon, the former Purdue quarterback was washing dishes in his kitchen, trying to distract himself from the torture of waiting.

The cordless handset chirped twice before Brees's girlfriend, Brittany Dudchenko, snatched it off the living-room floor and shouted, "Drew, the phone's ringing!" On the television screen disembodied voices informed viewers that the Chargers were next on the draft clock, with the first pick of the second round, the 32nd overall. The room became a still life.

This is how the waiting ends. Nearly 16 weeks after playing his final college game, Brees would at last find out where football would take him next. It had been a strange and tumultuous time, spent in a no-man's land between collegian and professional, where a player's stock rises and falls, buoying him one week, mocking him the next. For Brees the ride had been measured in

increments as short as an eighth of an inch in height and as long as the 70 yards a ball sails when thrown by a passer with an NFL-approved arm. He had juggled the demands of a college curriculum and those of 31 NFL teams, and never had he felt in control.

JANUARY 1 PASADENA

Brees's college career ends on the pristine grass of the Rose Bowl, where Purdue loses 34–24 to Washington. Brees completes 23 of 39 passes for 275 yards and two touchdowns, but his counterpart, Huskies senior Marques Tuiasosopo, completes 16 of 22 for 138 yards and a touchdown, runs for 75 yards and another touchdown and is named the game's MVP.

Many teams gave Brees a hard look, but just before the draft he had a feeling he would be chosen by the Chargers.

Brees could be deflated, but he's not. When he decided a year earlier to return for his senior season, he set his mind on winning the Big Ten and playing in the Rose Bowl. Purdue had done neither in 32 years. "How many players can set goals like that and achieve them?" Brees asks. In the locker room, and outside the stadium, he implores teammates to take pride in the season. "Don't let this ruin what we did this year," he tells them.

JANUARY 3–5 AUSTIN

Brees's transition from amateur to professional is almost instantaneous. He is home in Austin to deliberate with his parents on the choice of an agent. Mina and Chip Brees, who are divorced, are both attorneys.

It comes down to a final three, and in the end Brees chooses Tom Condon of IMG. This decision is based largely on instinct. "I got a good feel from the IMG guys," he says. It will be widely speculated that Brees chose Condon because Condon reps Indianapolis quarterback Peyton Manning, who is a friend of Brees's. Not true. "I haven't talked to Peyton in months," says Brees. "He got a new cellphone, and I don't have the number."

JANUARY 12 WEST LAFAYETTE, IND.

It is common for potential early-round draft picks to leave college after the fall semester and relocate to a training center to cram for the NFL scouting combine and for personal workouts, but Brees has chosen to stay at Purdue. He is enrolled for the spring semester to graduate on time, in four years. It wasn't an easy decision for him to make. He is projected as a mid- to low-first-round choice, but draftniks and NFL scouts have questions about him: Were his big college numbers a product of Purdue's spread offense? Is Brees, barely 6 feet tall, gifted enough to overcome his size? Does he have quick feet and passable sprinting speed? The combine will be important, and Brees would benefit from boot camp. Instead, he will train alone at Purdue. Still, he will have a busy winter. He will soon leave for a week in Maui to play in the Hula Bowl, the first of many diversions from his academic quest.

JANUARY 14–20 MAUI

If it weren't for the presence of scouts, the Hula Bowl would be the all-time postseason boondoggle: enticing locale, great weather, free afternoons and nightly luaus. All a college player has to do in return is show up for practice every morning and, on Saturday, play in a glorified scrimmage at a high school stadium. However, the 60 NFL scouts and personnel executives turn this week from Club Med into *Survivor*.

Most players in Maui are marginal draft fodder. Brees is the only college star at the

"

With less than two weeks to go before the combine, a leaguewide consensus on Brees has formed: good head, decent feet, average arm.

game. He is here as a favor to his Purdue coach, Joe Tiller, who is one of the Hula Bowl coaches, and game organizers used Brees's name to sell tickets.

After one practice each player is weighed and measured. This is a big moment for Brees. He was listed at 6'1" throughout his college career. The height question hangs over him because the NFL treats short quarterbacks like the Ebola virus. Inside a dank youth recreation center near the practice fields, a parade of players walks across a stage. Scouts sit at tables, like patrons at a Las Vegas revue. Heights are shouted in succession. The scouts scribble. These numbers will be logged into the NFL's master computer system and regarded as official, at least until the combine.

When Brees is measured, the attendant pauses before barking, "Five-eleven-seven [5' 11⅞"]." The audience groans. Brees steps back and stares at the scale and its operator. He asks to be measured again. "Six even!" bellows the attendant. Scouts applaud. "He's a good kid; we all want him to be a 6-footer," says Cowboys director of college and pro scouting Larry Lacewell.

FEBRUARY 14 DAVIE, FLA.

In his office at the Dolphins' complex, Rick Spielman, Miami's vice president of player personnel, pops in a videocassette of the 2000 Purdue-Minnesota game. He draws a nine-square grid on a white board and begins charting Brees's throws. Short, medium, long. Right, center, left. "That's a catch, nice release," Spielman says. "That's a drop. That's underthrown a little." After only three series, Spielman's grid is full of notations.

January and February are video months for NFL personnel staffs. They sit in front of TV monitors charting the top college players in almost lunatic detail. Brees started 37 games and threw 1,678 passes at Purdue. "At least three people on our staff have seen every snap in his

career," says Spielman. The Dolphins do medical and security checks and personality tests on the top 100 players available for the draft. "We will have a substantial file on Brees before we interview him at the combine in Indianapolis," says Spielman.

With less than two weeks to go before the combine, a leaguewide consensus on Brees has formed: good head, decent feet, average arm. He will need to run reasonably fast and throw well in Indianapolis to improve his file.

FEBRUARY 25 HIGHWAY 65 NORTH, IND.

The 1997 Chevy Tahoe, a gift from Chip Brees to his son when he won a scholarship to Purdue, blasts through the darkness on the way from Indianapolis back to West Lafayette. Drew is talking on his cellphone to his mother: "It wasn't great, Mom. . . . It wasn't like I expected. . . . I'm tired, really tired. . . . I'm glad it's over." Brees tells his mother he loves her, flips the phone shut, swings into the left lane and pushes the speedometer past 80 mph. It's been a lousy day, and the sooner it ends, the better.

Brees went to the NFL scouting combine with high expectations and specific targets.

Forty-yard dash: 4.79 seconds, .07 faster than Marshall quarterback Chad Pennington ran in the 2000 combine. (Brees's actual time: somewhere between 4.73 and 4.83. Not bad.)

Five-10-five-yard shuttle: 4.15 seconds. (Actual time: 4.19. Acceptable.)

"L" shuttle: 7.05 seconds. (Actual time: 7.09. Also acceptable.)

Vertical jump: low 30s. (Actual height: 32 inches. Right on.)

Bottom line: Brees proved himself a good enough athlete to satisfy most doubters, and he delivered under pressure. He even measured a hair taller, 6'¼". That's the good news. The bad news: Brees had one other goal for Indianapolis—"I don't want any incompletes in the passing drills"—but he didn't come close.

SPORTS ILLUSTRATED was allowed to watch a day of drills at the five-day combine, which is usually off-limits to journalists. The heart of the quarterbacks' workout was a series of 20 throws: two pass attempts on each of 10 patterns. Brees was prepared to work at full speed, taking a hard drop and throwing on rhythm, before the receiver broke. However, Seahawks quarterbacks coach Jim Zorn, who ran the session, told the passers, "Just ease up and complete balls. Don't worry about anything else."

Brees was confused. Some quarterbacks took Zorn's advice and threw three-quarter-speed spirals to wideouts long after the receivers came out of their breaks. Balls like those would get picked off in a game, but they were safe passes in this arena. Brees stuck with his game plan and threw on rhythm. Some wideouts made sharp breaks, others didn't. Of Brees's 20 balls, 11 were solid throws and nine were poor. He one-hopped a simple out-cut and overthrew another. His long throws—the post-corner and the streak—were wobbly, setting off alarms throughout the league.

Hours later, Brees sits in the Tahoe, idling in the parking lot of a West Lafayette hotel. During his three days in Indianapolis, almost all teams in the league interviewed him. The Bengals, Dolphins, Bills, Raiders and Washington, most of whom are unsettled at quarterback, had long sessions with him. Seahawks coach Mike Holmgren interviewed Brees for more than an hour. The two men seemed to connect. "I'd love to play for Coach Holmgren," Brees says. He is silent for a long time. This is familiar territory for him. He was lightly recruited in high school and had to establish himself at Purdue. "Now," he says, "I have to prove myself all over again."

FEBRUARY 27 KANSAS CITY, MO.

At IMG football headquarters, reaction to Brees's combine performance is swift. "He took a step back, no question," says Condon. "I don't think he hurt his status as the number 2 quarterback in the draft, but he didn't have a good day."

If Brees held his draft position, it's because there is little else to choose from at quarterback after the presumed No. 1, Michael Vick. Mel Kiper Jr., who ranked Brees No. 16 before the combine, drops him out of his top 25 prospects.

Brees wants to audition again soon. Purdue seniors will work out for NFL scouts on March 8, and Brees wants to throw on that day, as well as in a private workout, scheduled for March 21. Condon puts his foot down and tells Brees to channel all his energy into preparing for the March 21 workout. They also make plans to get Brees to Bradenton, Fla., during his spring break to work with Larry Kennan, a former NFL assistant who runs training sessions for quarterbacks at IMG Academies. "I wish it were tomorrow," says Brees.

MARCH 9 WEST LAFAYETTE

NFL free-agent signings are giving Brees a headache. On March 2 the Seahawks acquired Matt Hasselbeck from the Packers in a trade. Does that mean Seattle won't pick Brees? He is disappointed. "Does Holmgren think Hasselbeck is the guy?" Brees asks. "I could see him and me fighting for the job. Then again, Jim Zorn was running my drills in Indy, and I stunk, so maybe they're not interested in me. I don't know. Nobody calls to tell you. There's no feedback."

Then, three days later, the Buccaneers sign Brad Johnson. The Bengals follow by picking up Jon Kitna, who had been with Seattle. It's also looking as if the Chargers will bring in Doug Flutie, whom the Bills let go in favor of Rob Johnson. Should Brees scratch all these teams? "It's crazy," he says. "I'm trying to keep an open mind, but every signing seems to affect my future."

MARCH 11-18 BRADENTON

Over 15 years Kennan was an offensive coach for six NFL teams. The last was the Patriots, in 1997. He is now executive director of the NFL coaches' association, but for three years he has

also been a hired gun for IMG, tutoring college quarterbacks before their individual work-outs with NFL teams. Brees spends a week in Bradenton rehearsing with Kennan.

They work on a high school practice field across a highway from IMG Academies. Brees and Florida State's Chris Weinke throw routes to Charlie Jones, a four-year NFL veteran who is looking to sign as a free agent. To rest Jones, Kennan has three high school players run patterns for Brees and Weinke. One of them slips and slides along the short grass in shiny spit-and-polish ROTC shoes, yet he moves with grace and speed. "Florida athletes," says Brees. "Incredible."

MARCH 21 WEST LAFAYETTE

By 10:45 a.m. representatives of seven NFL teams are at one end of the Mollenkopf Center's 100-yard indoor practice field. Almost the entire Kansas City brain trust is here. This stands to reason, because the Chiefs have lost Elvis Grbac to free agency and haven't succeeded in trading for Trent Green. San Diego, which has the first pick in the draft, is represented by coach Mike Riley and offensive coordinator Norv Turner. Cincinnati has offensive coaches John Garrett and Ken Anderson in attendance. The Bills, Cowboys, Falcons and Panthers are also here. Chiefs president Carl Peterson walks over to IMG's Ken Kremer and says, "Well, we all wish he were a couple inches taller, but what can you do?"

At 11:06, Kennan says, "We'll start now. Drew is going to make 75 or 80 throws, and I think you'll all see everything you need to see." The tension is palpable: A player's future is on the line.

For the next 20 minutes, Brees is in an ungodly zone. He throws a total of 74 balls, and only two hit the ground by his doing. (Dawson drops several others.) He finishes by launch-ing two 70-yard bombs, hitting the receivers in stride. "He threw the s--- out of it, in case you

Brees faced scrutiny at the combine, where he ran well enough but was off with his throwing.

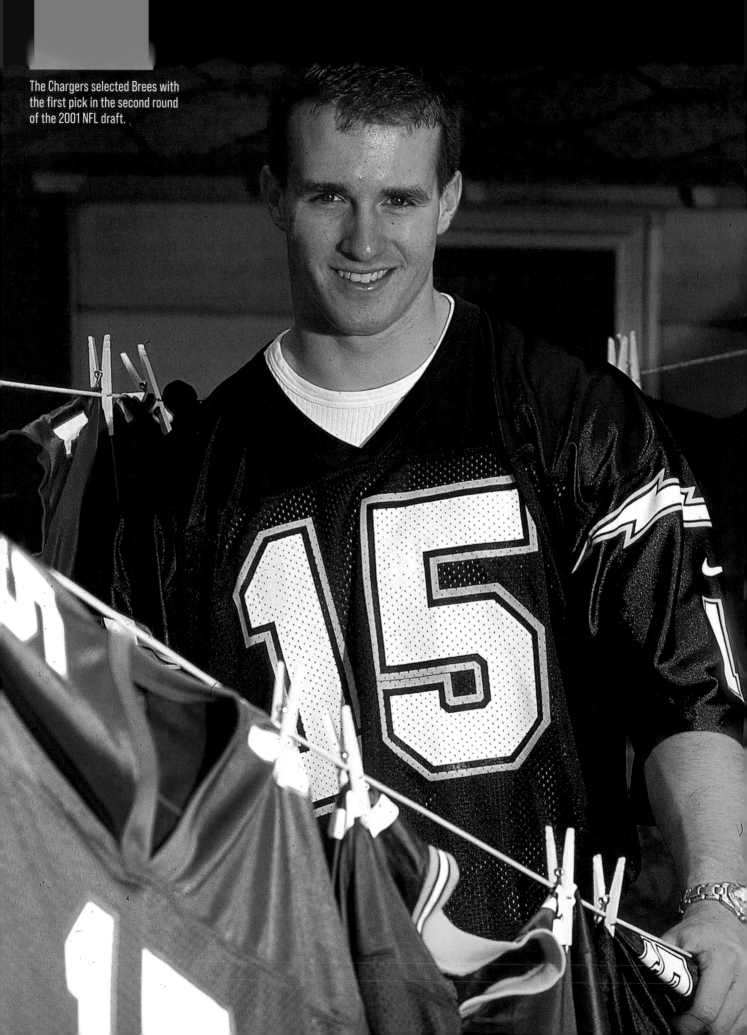

couldn't tell," Kennan says. "It was about the best individual workout I've ever seen."

NFL reps would sooner cut off their thumbs than tip their hands, but they don't disguise their response today.

Long after the brass leave, Brees flops onto a weight bench and gives a zillion-watt smile. "That was me out there," he says. "Throwing on rhythm, moving back and forth. I feel like 1,000 pounds got lifted off my shoulders." Whatever damage was done at the combine has been undone here. Brees is back in the mix.

MARCH 29 **WEST LAFAYETTE**

The Chargers want another look. They will conduct private workouts for only two players: Brees and Vick.

Turner runs Brees through the entire San Diego offense. He demands many of the same throws that Brees made a week earlier but confuses Brees by asking him for more touch on some difficult throws. Brees struggles, bouncing several throws. The next afternoon Vick will dazzle the Chargers' crew with his athletic skills and cannon arm, and survive in the classroom. What's more, nobody is offering enough for San Diego to trade the top pick. Brees is convinced that the Chargers will draft Vick.

APRIL 20 **WEST LAFAYETTE**

One day left. Brees bounds down the concrete steps into Mackey Arena for a photo shoot. "Three weeks ago I thought the draft would never get here," he says. "Now I'm pretty calm." That won't last. Minutes later Purdue sports information director Jim Vruggink finds Brees and tells him, "San Diego traded the first pick to Atlanta for Atlanta's number five, Tim Dwight and some other picks. The Chargers say they want Tomlinson."

Brees's eyes are like saucers. "Woooooo," he says. This changes everything. He tries to figure out how San Diego can take him. "Come on, somebody, take L.T. before the Chargers!" Brees howls. Somebody suggests the Chargers will take Brees in the second round. "I want to be a first-round pick," he says.

Later he reflects, "Three months ago I had no idea who would pick me, and I still don't. But I've got a funny feeling about San Diego."

APRIL 21 **WEST LAFAYETTE**

For the first hour of the draft he is on the sideline at the Purdue spring football game. Brees is back home in time to see the Chargers take Tomlinson with the No. 5 pick. He shows no emotion. NFL officials invited him to New York City for the draft, but he refused. "Don't want to be the last guy in the green room," he says.

Just before Miami picks at No. 26, Dudchenko walks into the kitchen. "It's getting stressful," she says. Brees moves the phone in front of the television. "Ring, baby, ring!" he shouts. The Dolphins take Wisconsin cornerback Jamar Fletcher.

Twenty-nine minutes later Brees is on the phone with San Diego general manager John Butler. "Yessir, it's me," Brees says. Then: "I'm comin' to play, baby." When ESPN announces his name, Brees shoots his right fist into the air. Dudchenko cries.

The calm in the apartment explodes into delirium. Brees does a teleconference with the San Diego media and agrees to jump on an 8:55 p.m. flight to California. "Man, I'm excited," he says. "I'm already visualizing the plays that Norv and I went over when he was here."

Exactly 63 minutes after Butler's call, Brees climbs into the Tahoe in the parking lot outside his apartment. He points it toward the Purdue campus for one last press conference in Mollenkopf Center before the long, sweet flight west. ●

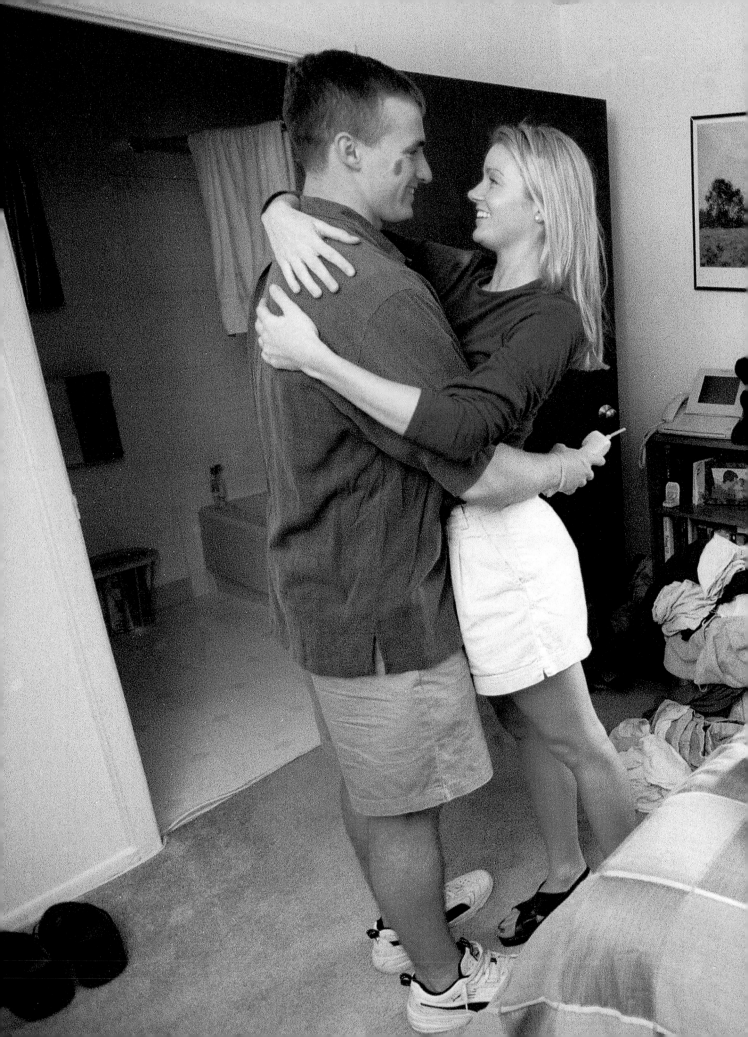

Soon after he was drafted, Brees rejoiced with future wife Brittany as he prepared to begin his NFL journey in San Diego.

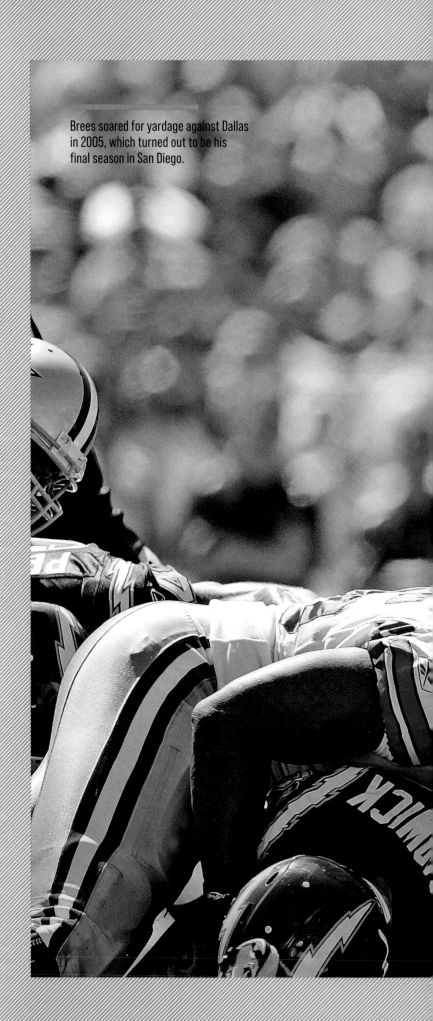

LEAP TO THE NFL

Brees soared for yardage against Dallas in 2005, which turned out to be his final season in San Diego.

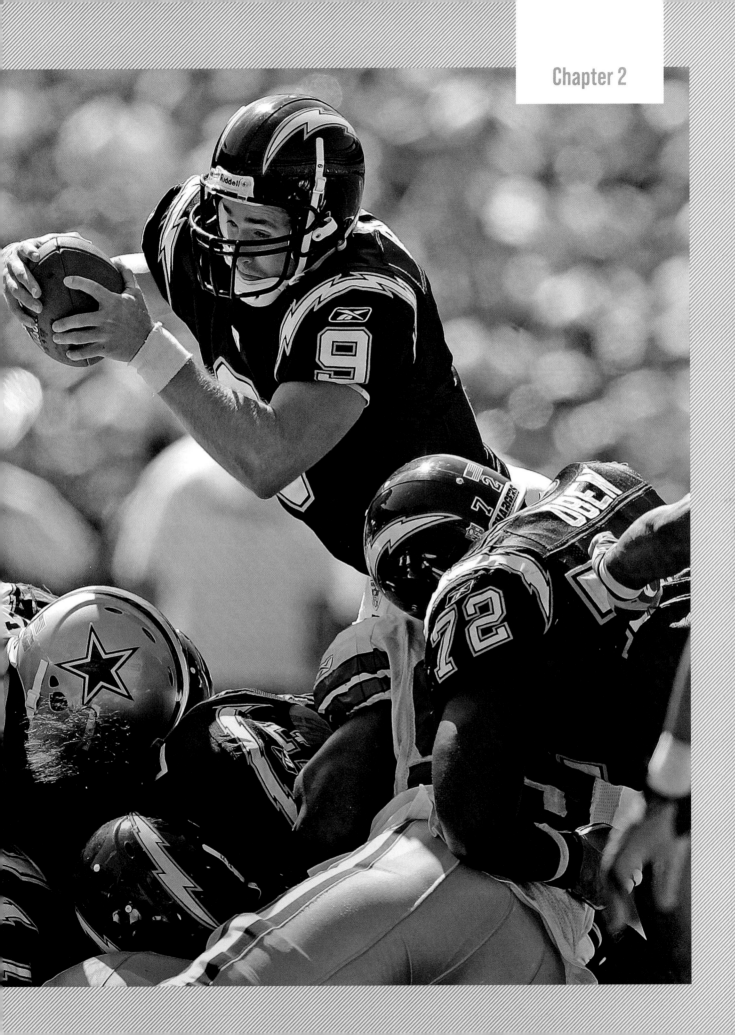

After backing up Doug Flutie for the entirety of his rookie year, Brees started all 16 games for the Chargers in 2002–03.

Excerpted from SPORTS ILLUSTRATED, October 21, 2002

Charged Up

In his second pro season, Drew Brees impressed his teammates with his leadership and confidence as he set out to right a listing franchise in San Diego

BY MICHAEL SILVER

He's the guy who goes on flipping through his magazine when the airplane hits heavy turbulence, the dude who casually takes cover in a doorway when the earthquake strikes. For nearly a year we've been hearing that Drew Brees, the Chargers' 23-year-old quarterback, is preternaturally calm in times of crisis, and the theory was put to its sternest test in his Week 6 game against the Chiefs. With 2:24 left in the game, San Diego trailed Kansas City by six points.

Brees entered the huddle with no timeouts remaining and 71 yards standing between him and NFL adulthood.

"Let's get it done," he told his teammates, flashing a sly grin. "You know we're going to win this game."

Never mind that Brees had already thrown two ugly interceptions, part of a give-away-fest that nearly gave first-year coach Marty Schottenheimer a migraine. The kid was hell-bent for a happy ending, and when he spoke in the huddle, the other 10 men there got almost as excited as the 58,995 fans at Qualcomm Stadium. *Yeah, Drew, we're with you! Come on, baby, do your thing!*

"We just felt it," said second-year running back LaDainian Tomlinson, who finished with 78 yards rushing and another 78 receiving. "He was cool. Cool Brees."

Seven plays later when Brees connected with rookie wideout Reche Caldwell on a two-yard touchdown pass with 14 seconds to go, the winds of change had officially swept through this battered football town. Blown away by San Diego's 35–34 victory were the haunting memories of Ryan Leaf (whom the Chargers,

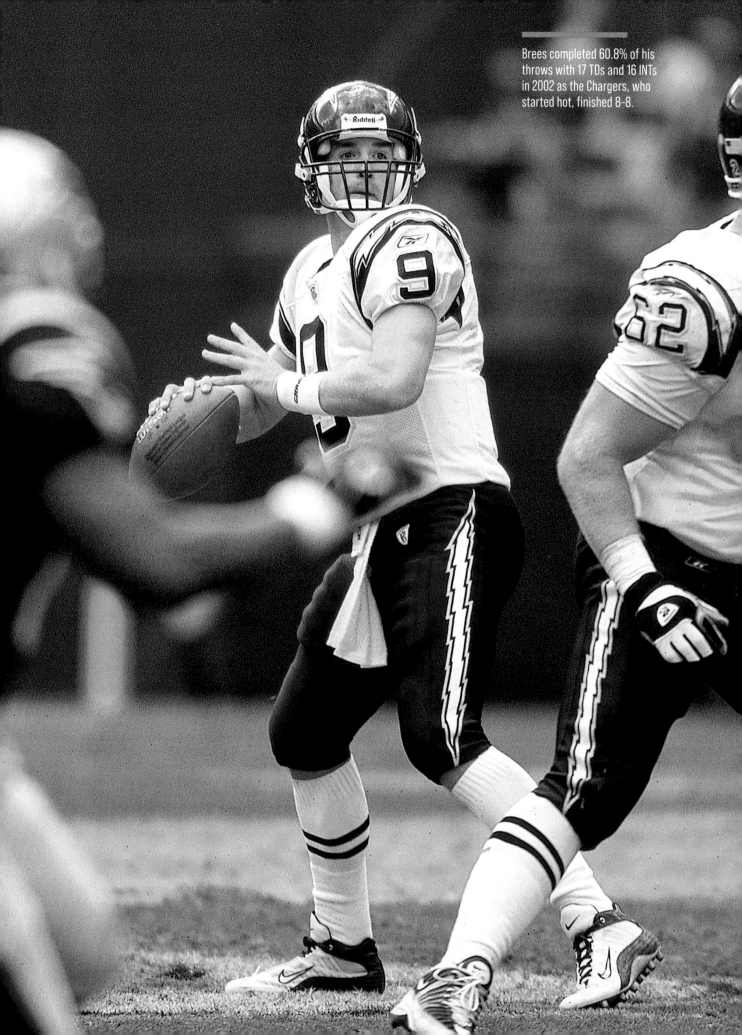

Brees completed 60.8% of his throws with 17 TDs and 16 INTs in 2002 as the Chargers, who started hot, finished 8-8.

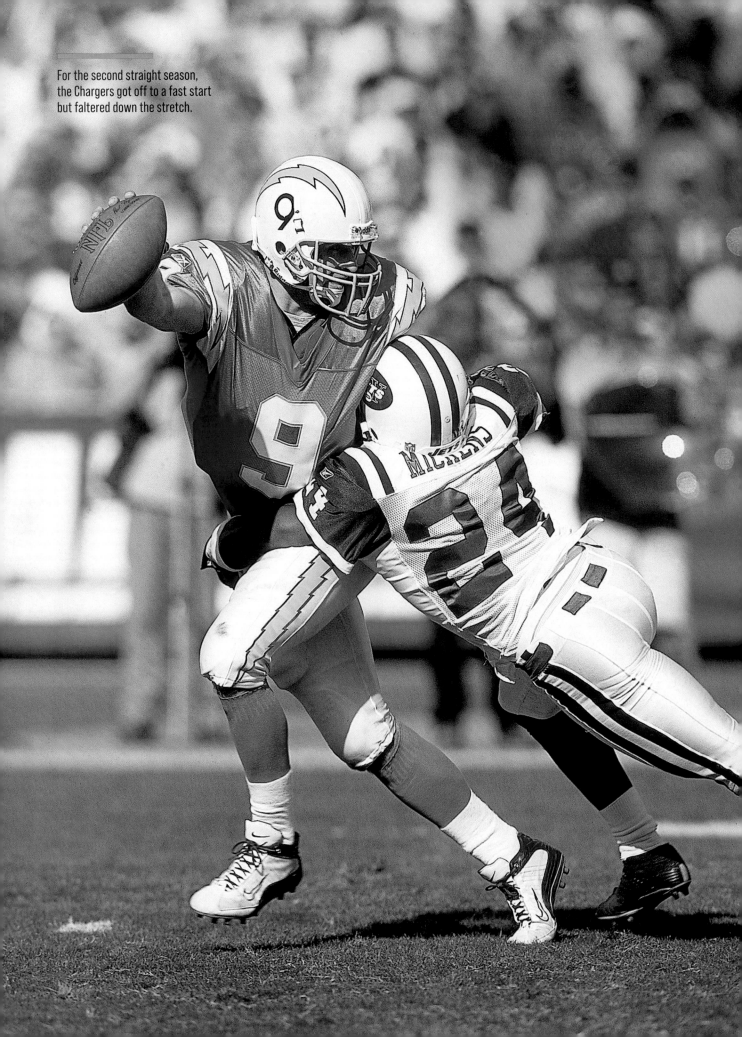

For the second straight season, the Chargers got off to a fast start but faltered down the stretch.

to their regret, drafted second in 1998) and the lingering hangover from their '93 Super Bowl loss. When the dust had settled, the Chargers were 5–1.

In San Diego the time has come to start anew with Drew. Call it Revolution No. 9. "I love our belief in one another," Brees said after beating the Chiefs. "When the offense falters, the defense is there to pick us up, and vice versa. We're doing this together, and we're so confident that we can find a way to win."

It must be noted that San Diego raced to a 5–2 start last season before losing its final nine games, which ensured the departure of coach Mike Riley. "Last year a lot of guys were like, 'Oh, my God, we won'—they didn't know what to do," says 39-year-old quarterback Doug Flutie, the 2001 starter who was beaten out by Brees in training camp. "This year it's a more businesslike approach. We *expect* to win."

When All-Pro tight end Tony Gonzalez caught a three-yard touchdown pass with 8:06 left, putting the Chiefs up 31–21, it looked like a good time to make one last trip to the fish-taco stand and bolt for the freeway. But Brees wasn't having any of that. *No. 9? No. 9?* "He's a football player, man," says veteran Chargers safety Keith Lyle. "That's why we like the guy so much."

Though the Chiefs tried to rattle him both verbally and physically, Brees (28 of 41 for 319 yards and two touchdowns), whose resting pulse rate is a reported 38 beats per minute, stayed cool all day. Just before the start of the second half, he looked on the stadium's video screen and recognized the pretty blond sitting in a luxury box. "Hey," he said, nudging Tomlinson, "that's Trista [Rehn], the girl from *The Bachelor*. Dude, check it out, she's wearing your jersey."

With 4:07 to go, Brees threw an 11-yard TD pass to Tim Dwight to complete a nine-play, 65-yard drive and cut K.C.'s lead to

31–28. The Chiefs then made it 34–28 on Morten Andersen's 43-yard field goal with 2:30 remaining.

It was time for the kid to rock, and Brees never flinched, completing five consecutive passes to set up second-and-one at the Kansas City two. From the shotgun he threw a perfect pass to Caldwell's outside shoulder, and the rookie juked defensive back Eric Warfield and skated into the end zone. Steve Christie's extra point provided the final margin, and the only remaining question was which of the NFL's most frequent weepers—Schottenheimer or Chiefs coach Dick Vermeil—would be the first to shed a tear. Schottenheimer nearly did, getting choked up as he told his team, "There's a lot of character in this room. I'd rather have good people than good players."

It was all a bit heavy for Brees, who had one more connection to make. An hour after the game he returned to the field to greet Trista, now cast as *The Bachelorette*, with a film crew in tow. After she and Brees chatted for a few minutes, the quarterback, perhaps mindful that he soon won't be a bachelor, jogged over to his fiancé, Brittany Dudchenko, and said, "Come on over and meet her."

"Absolutely not," Dudchenko replied, frowning.

Brees, however, was just getting warmed up. He set up a long-throwing contest for the Bachelorette's five male suitors, jumping up and down excitedly when the dude wearing a Brees jersey won with a 50-yard heave. All the while, Flutie was standing across the field with a mischievous smile, flinging footballs in his direction.

"Hey, you know what we should do?" Brees said to no one in particular. "Let's get a big flag-football game going out here."

The calmest 23-year-old in San Diego playfully cocked his arm, looking for the open man. •

DREW BREES

In December 2002, the Chargers beat the Broncos 30–27 in what turned out to be their last win of the season.

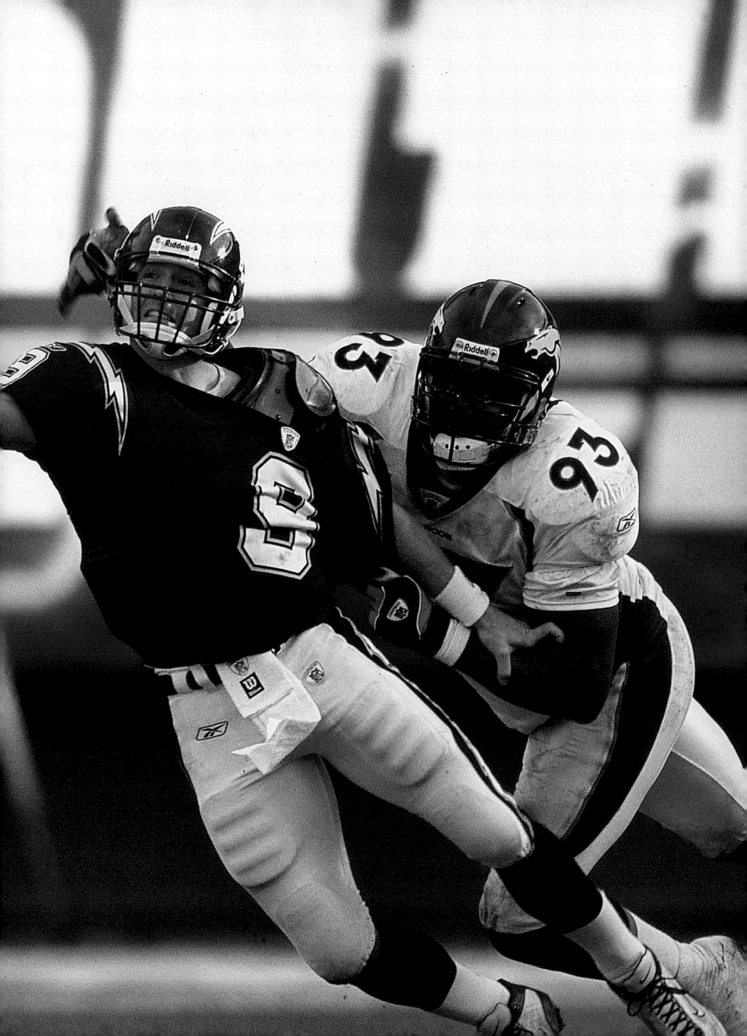

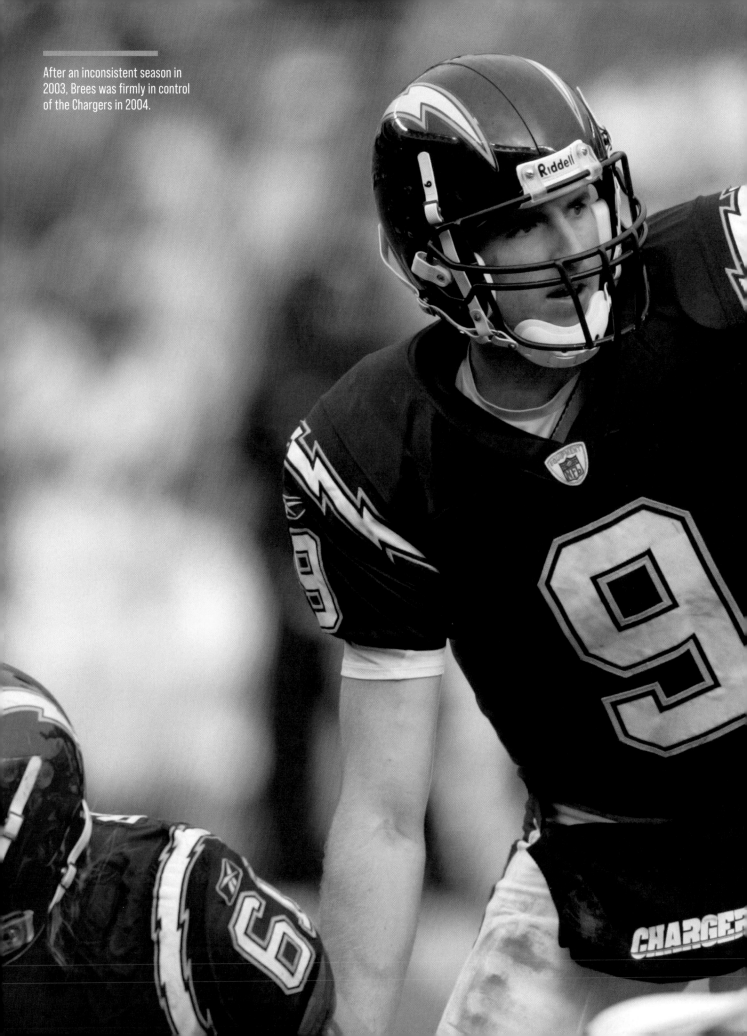

After an inconsistent season in 2003, Brees was firmly in control of the Chargers in 2004.

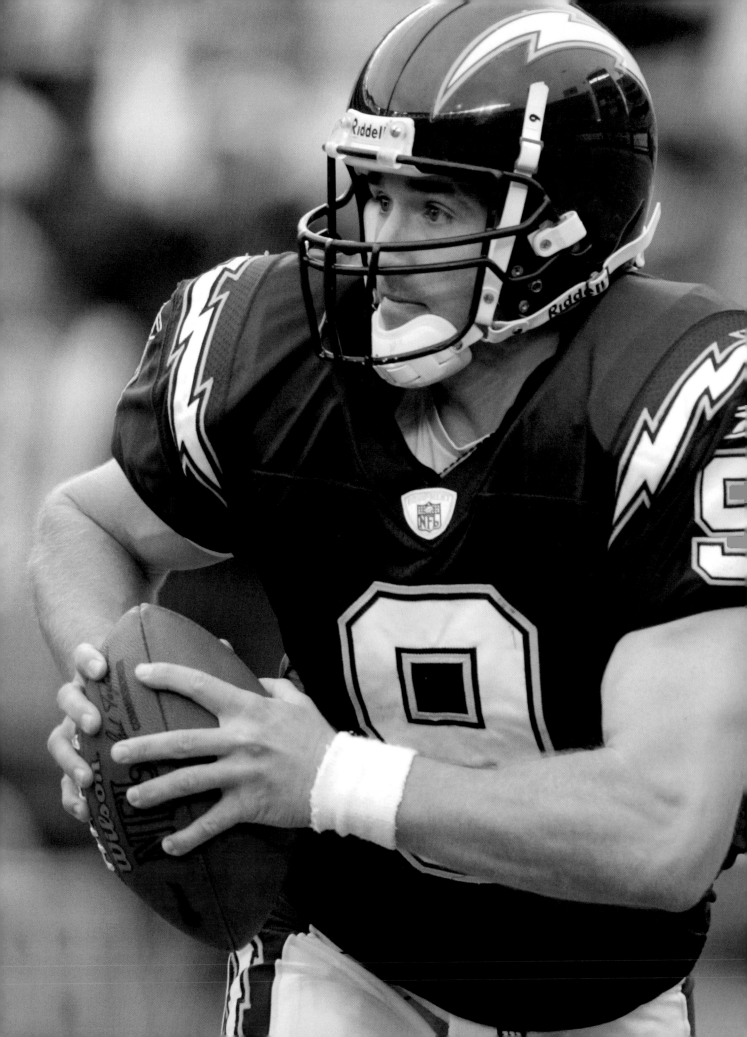

San Diego acquired
quarterback Philip Rivers
during the 2004 draft, but
Brees stayed focused on
the task at hand.

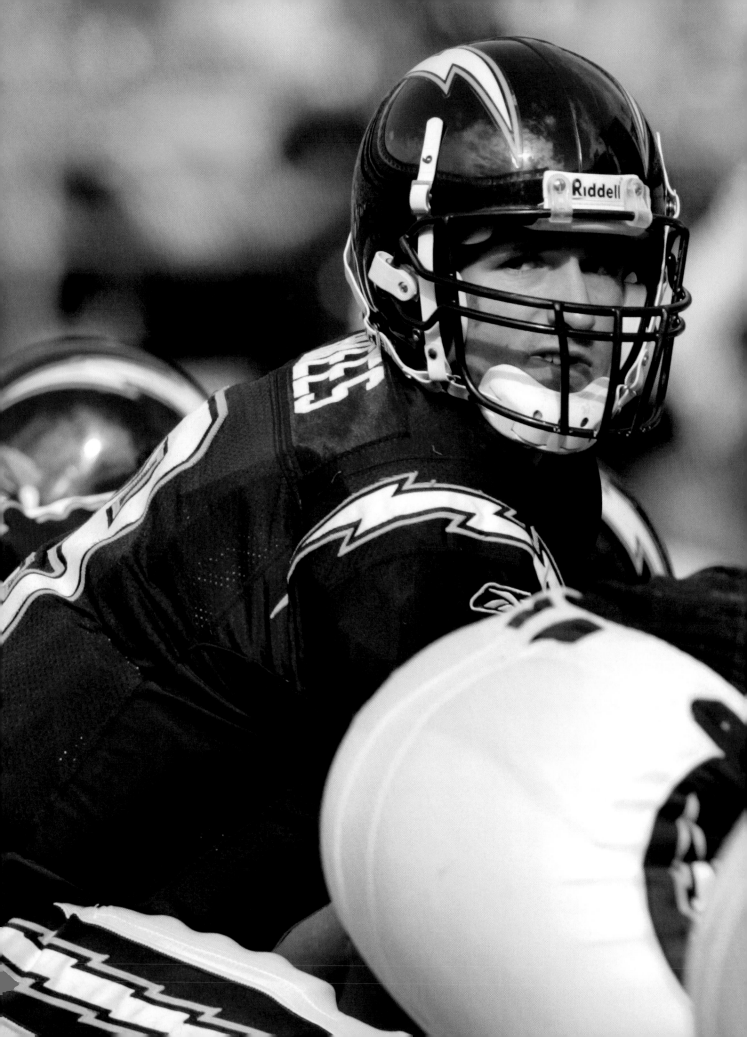

Long hours at the practice facility and an improved roster helped the Chargers go 12-4 and make their only postseason with Brees under center.

Excerpted from SPORTS ILLUSTRATED, November 15, 2004

Unwanted, and On Fire

After the Chargers acquired Philip Rivers on draft day 2004,
Drew Brees elevated his game and proved that he could
win in the NFL—if not for this team, then for another

BY JOSH ELLIOTT

Hours after a 42–14 rout of visiting Oakland on Halloween, Chargers quarterback Drew Brees sat in a private dining room of a restaurant, surrounded by family and friends chattering over platters of chicken wings and crab cakes, burgers and fries. As they talked, Brees watched a nearby television screen, on which Chicago rookie QB Craig Krenzel was leading the Bears to victory over San Francisco.

Brees turned to his father, Chip, and asked, "Did you ever think the Bears believed that Craig Krenzel would be their quarterback right now?" Chip just smiled, leaving his son's question, so loaded with irony, unanswered.

Did you ever think . . . Is there a better motto for this unpredictable NFL season? No team exemplifies that more than San Diego. Because really, did you ever think that arguably the worst team of a year ago, the hapless 4–12 Chargers, would be celebrating such an eye-popping reversal of fortune, with a player who has traded goat horns for gold stars (and possible MVP consideration)?

That once absurd scenario grows more plausible by the week, especially after Brees's performance in a 43–17 blowout of visiting New Orleans in Week 9. Running the offense as though it were a passing drill, Brees toyed with the Saints' overmatched secondary, completing 22 of 36 throws for 257 yards and four scores and becoming the first Chargers quarterback since Dan Fouts in 1985 to lead San Diego to consecutive games of 40-plus points. In his last six starts Brees has thrown 15 touchdown passes (nine in the last two) and just one interception, keeping the Chargers tied with Denver atop the AFC West.

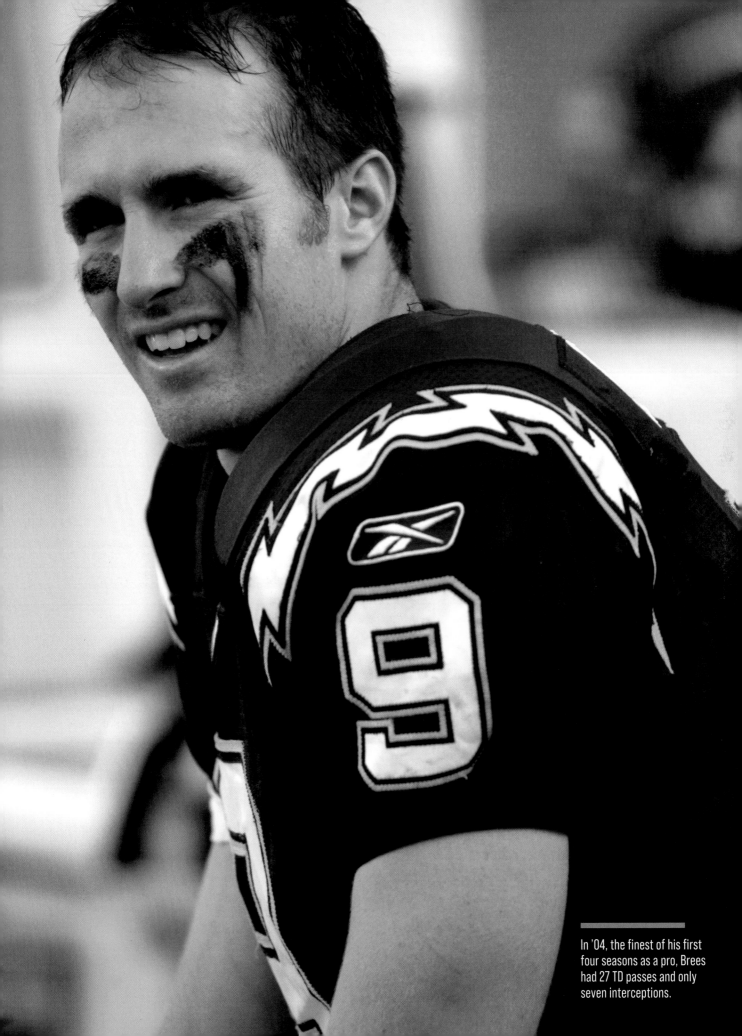

In '04, the finest of his first four seasons as a pro, Brees had 27 TD passes and only seven interceptions.

That stands in stark contrast to the 2003 season, a disaster laid squarely at the feet of the ineffective Brees, who completed just 57.6% of his passes, threw for only 191.6 yards per game, had more interceptions (15) than touchdown passes (11) and was benched for five games following the team's 1–7 start. "I just felt helpless," he says. "I mean, it was hard on everyone, but I was very, very disappointed. Nothing ever felt right. We lost our first two games; then all of a sudden we were 0–5. Then people started pointing fingers, and the wheels just fell off the bus. I started pressing, trying to win each game on every play."

It was during his benching that Brees first heard the rumors that San Diego would replace him come the April draft. Those rumors were confirmed at the NFL scouting combine last February, when Chargers general manager A.J. Smith said, "We're not flying under the radar with this. We're looking for a quarterback. [Brees is] a big boy. He can handle [it]."

"It was devastating," Brees says. "I was angry. No one wants to hear that he's not wanted. But once I got past it, I knew I could only worry about things in my control."

Brees had already composed a detailed wish list in late January, enumerating the changes he thought necessary in his weight training, his film study, his mental preparation. At the Chargers' practice facility he became more efficient with his time, even as he invested more of it than his teammates did. "I accepted I had to do much more than ever before," Brees says. "I'd check things off that list and look up at the clock, and suddenly the sun was down. But every day it got easier."

"We're expected to be around 2 to 2½ hours a day during the offseason," linebacker Donnie Edwards says. "Drew was here six, seven hours every day. Overcoming adversity is one thing. But to work that hard, not knowing if it'd be enough, that was awesome."

"He had that inner fire," says Chargers backup quarterback Doug Flutie. "He'd watch film, but it wasn't just to learn the offense. He'd study each lineman's assignments on run plays. He'd study receivers' splits. He'd study defenses—not just schemes, but philosophies. He was all business. Someone asked me if I ever saw him smile during all of it, and, aside from the QB meetings, I'd have to say no."

Through it all, Brees's golf clubs gathered dust; his lazy days with his wife, Brittany, grew infrequent. When Brees felt tired or frustrated, he'd contemplate this ugly truth—my own team is done with me—and go back to work. But he never let his bitterness get the best of him. "Brittany and I talked a lot about the need for patience and calm," Brees says. "She's a brilliant, witty person, and she gave me balance. She felt the pain with me."

She also encouraged a brief escape last February, when they traveled through South Africa for three weeks. It was a crucial trip at a crucial time. "We just totally lost ourselves in the trip," Drew says. "We went on a safari, went wine-tasting, went to a rugby match, dived to see great white sharks in the Indian Ocean. I needed that break."

He also got a dose of perspective when they spent a day in an impoverished Port Elizabeth township. "It was hard to look at: kids on the street with no water, no food, no clothes," Brees says. "It was a slap in the face. After that, how could I not appreciate just having a chance to change things? It made my work easy."

It didn't matter that almost no one expected him to start again for San Diego, just as long as he still believed he would. With every month of work he felt his burden lifting. Even after the Chargers acquired fourth pick Philip Rivers in a draft-day trade with the Giants, Brees remained confident. Preparation was his salvation. So when Rivers missed the first 29 practices of training camp during a contract dispute, Brees's hard work paid off with a starting job he has refused

to cede. "He showed tremendous resolve," Flutie says. "His career was on the line, and he prepared like it. And it's nice to have help."

Indeed, it's no coincidence that Brees's dominance has dovetailed with the rise of second-year tight end Antonio Gates, a budding star who never played college football. After arriving at Michigan State with the intention of playing both basketball and football, the 6'4", 260-pound Gates was offended by a suggestion from Nick Saban, then the Spartans' coach, that he drop basketball altogether. "He'd just come from the NFL, and he told me I was a guy the league would want," Gates says. "If I'd listened to him, I probably would've been a first-round pick. But I was a young kid with a rebellious streak."

So Gates left East Lansing, gave up football and attended two more schools before ultimately landing at Kent State, where as a senior he was an honorable mention basketball All-America. Still, a future in the NBA seemed unlikely. "When there are more NFL scouts at your games than NBA scouts," says Gates, "you get the message."

Gates was passed over in the NFL draft but was courted by several teams. He finally signed with the Chargers because "they were the only ones who told me the truth—that if I worked hard, I'd have a chance."

He has become one of Brees's favorite targets, catching five passes, three of them for touchdowns, against the Saints. A speedy, soft-handed receiver whose size makes him a mismatch for safeties and whose speed creates a mismatch for linebackers, Gates leads all NFL tight ends in catches, yards and touchdowns. "We've always had LT," says Brees, making a nod to LaDainian Tomlinson, his close friend and the team's leading rusher. "But now I have so many other options."

Indeed, as good as Brees has been, the Chargers' turnaround is a team affair. Brees got another weapon with San Diego's mid-October trade for former Tampa Bay wideout

The Chargers' acquisition of Philip Rivers left Brees with a tenuous grasp on the starting quarterback position.

Keenan McCardell, who caught 15 balls for 209 yards and a score in his first three games with the club. All but one of the starters on the offensive line are new, and that unit has allowed only 12 sacks. The defense, revitalized under new coordinator Wade Phillips and his 3–4 scheme, is the NFL's second-ranked unit against the run. And just think: Tomlinson, last year's lone bright spot, has been nursing a groin injury and has yet to hit his stride.

No matter. Brees has become the team's unquestioned leader, and it's impossible to argue with the results: A career 59% passer, in mid-November Brees had completed a gaudy 66.1% of his throws. His 108.7 passer rating puts him in the league's top three. Not bad for a guy the Chargers didn't want—and probably won't have for much longer. Brees will be a free agent when the season ends, and the Chargers would seem to be unlikely to re-sign him, given their $40 million investment in Rivers.

But Brees demurs when asked about his future. He's still focused on the most important item on his wish list: a Super Bowl win. "But you know what was never on that list?" he asks. "Be the starting QB. Because I expected that. Even if no one else did." ●

DREW BREES

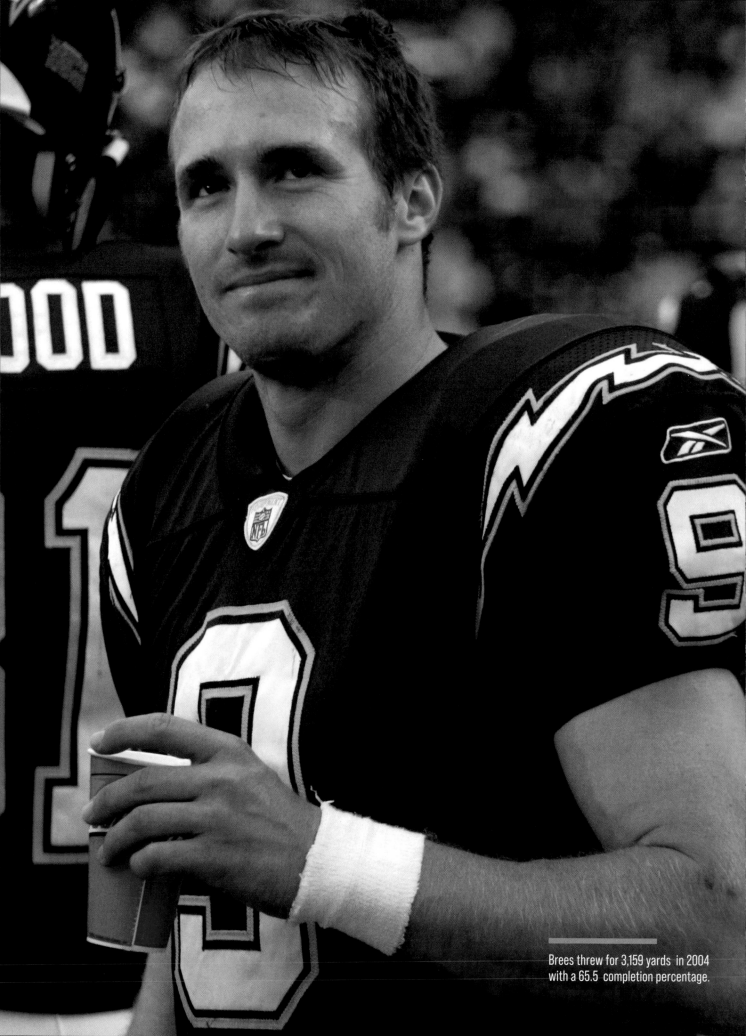

Brees threw for 3,159 yards in 2004 with a 65.5 completion percentage.

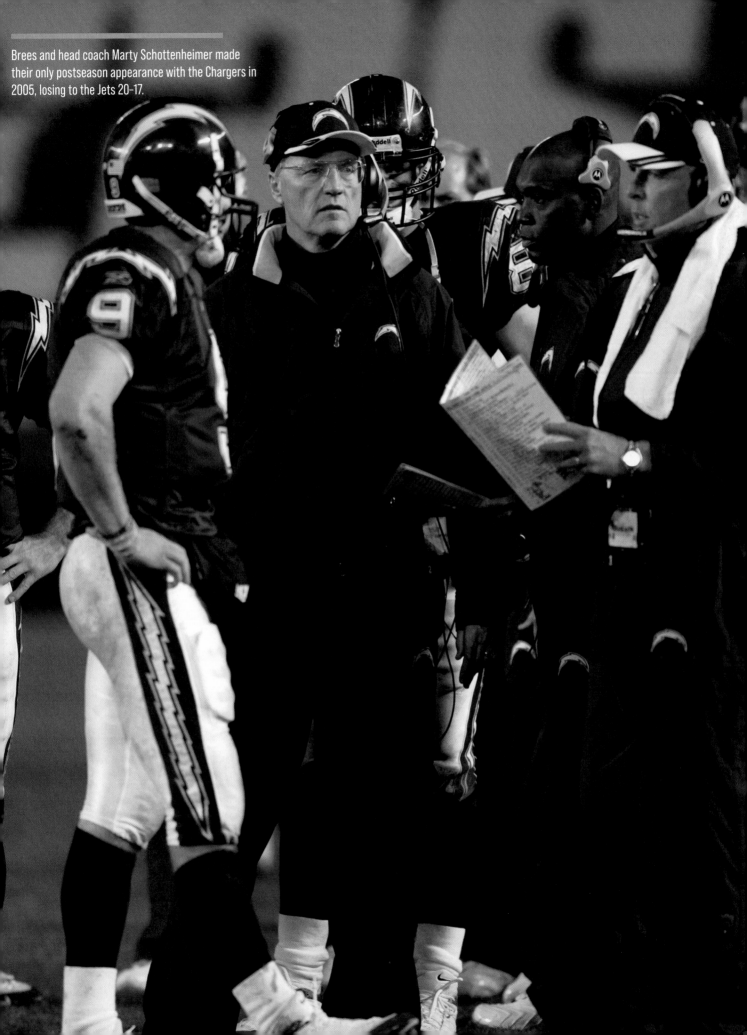

Brees and head coach Marty Schottenheimer made their only postseason appearance with the Chargers in 2005, losing to the Jets 20–17.

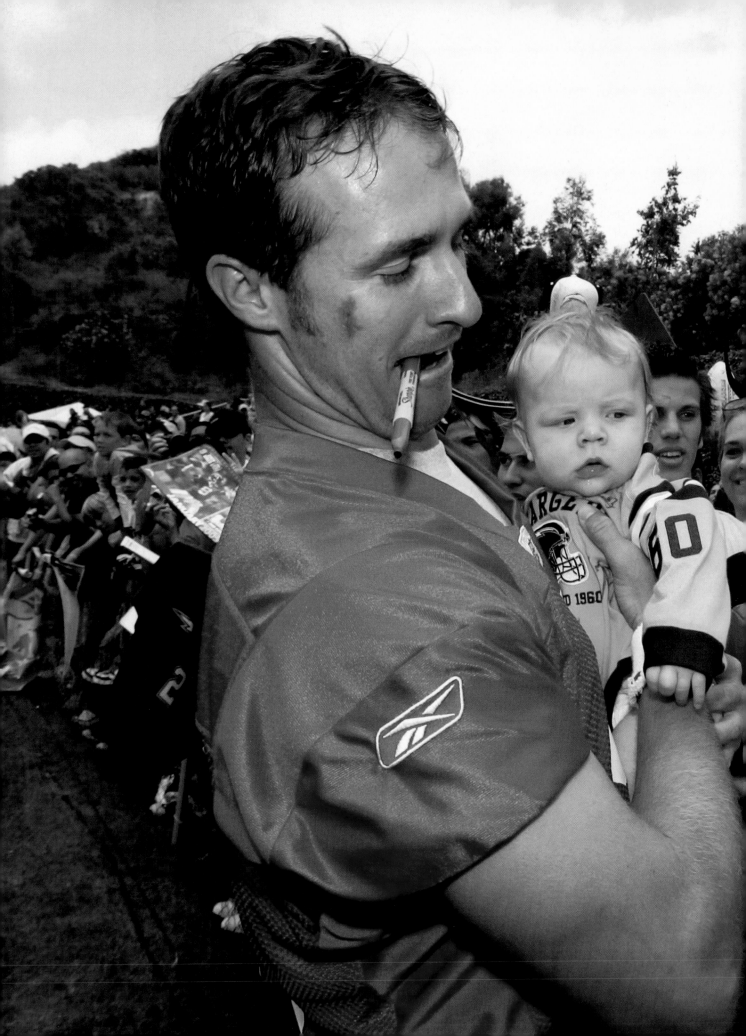

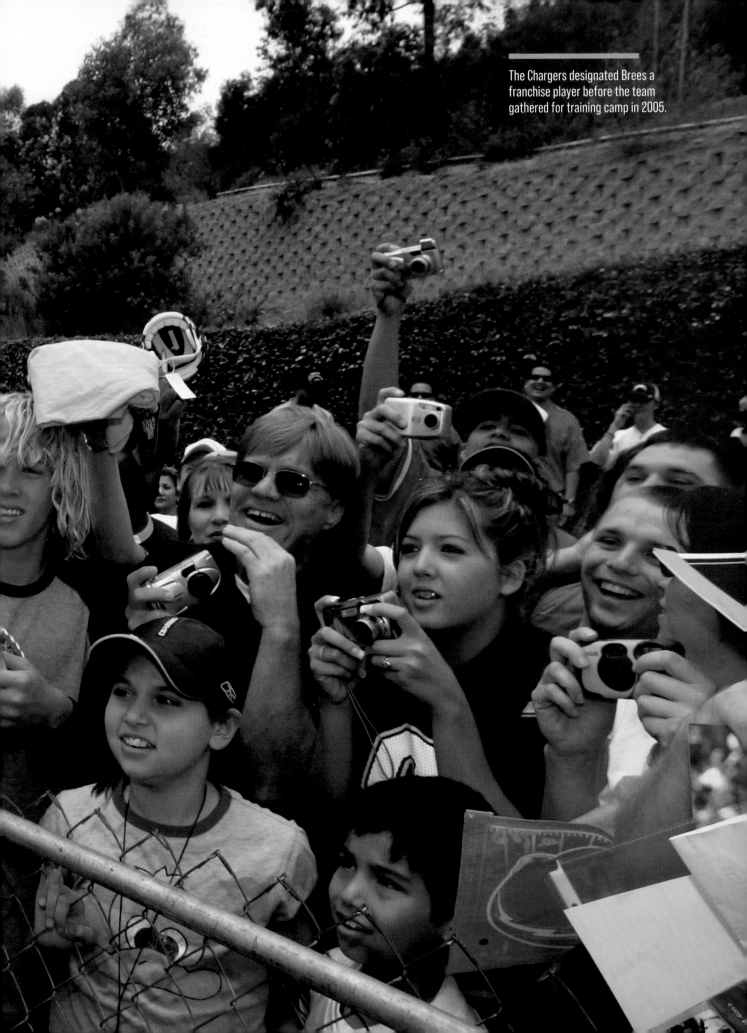

The Chargers designated Brees a franchise player before the team gathered for training camp in 2005.

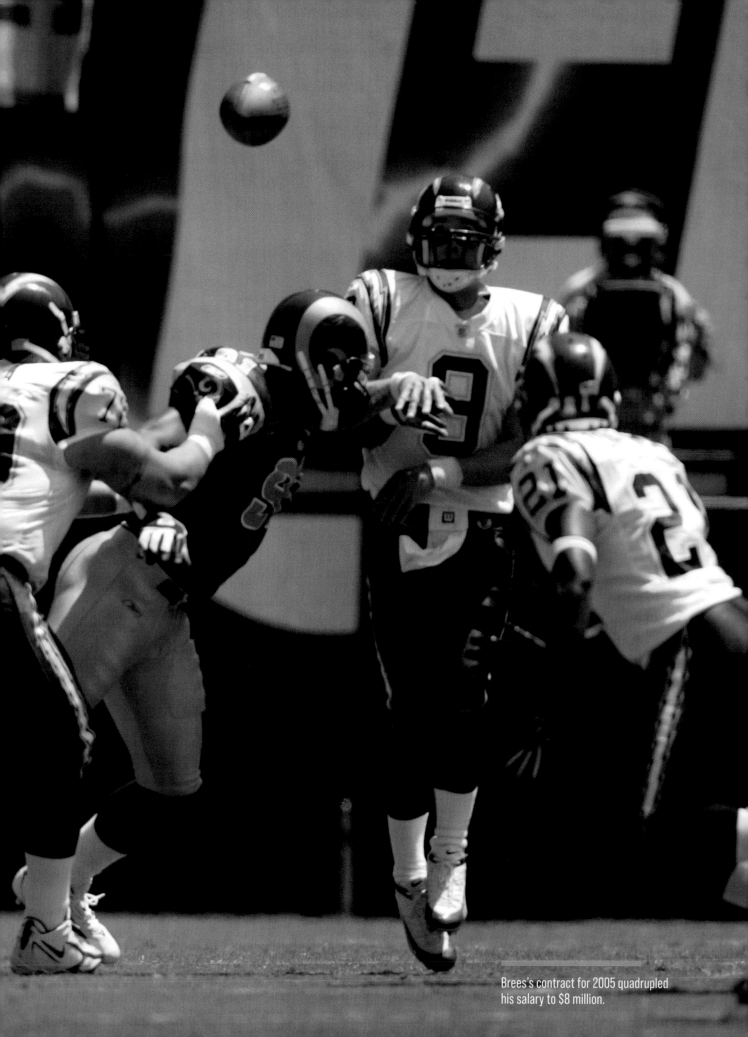

Brees's contract for 2005 quadrupled his salary to $8 million.

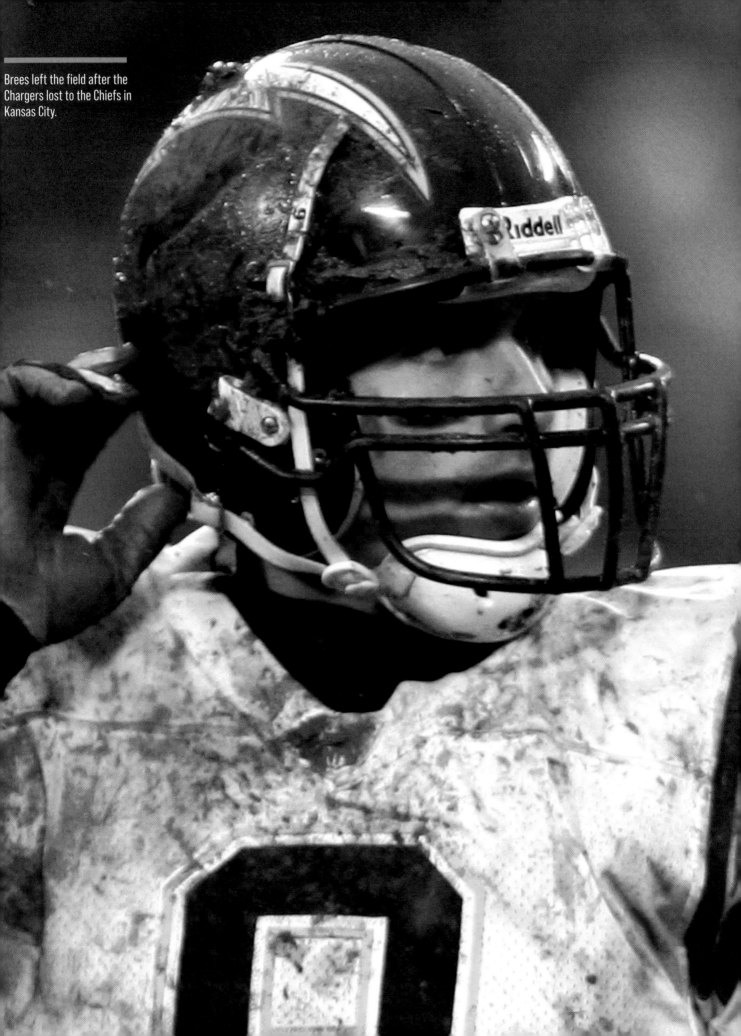

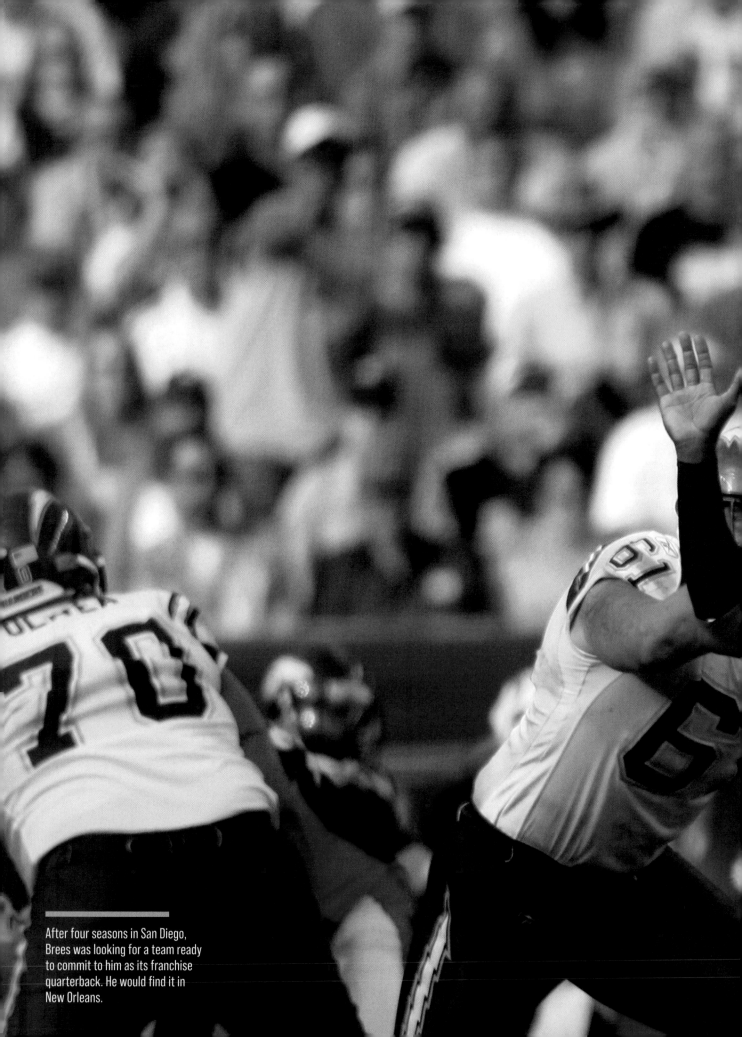

After four seasons in San Diego, Brees was looking for a team ready to commit to him as its franchise quarterback. He would find it in New Orleans.

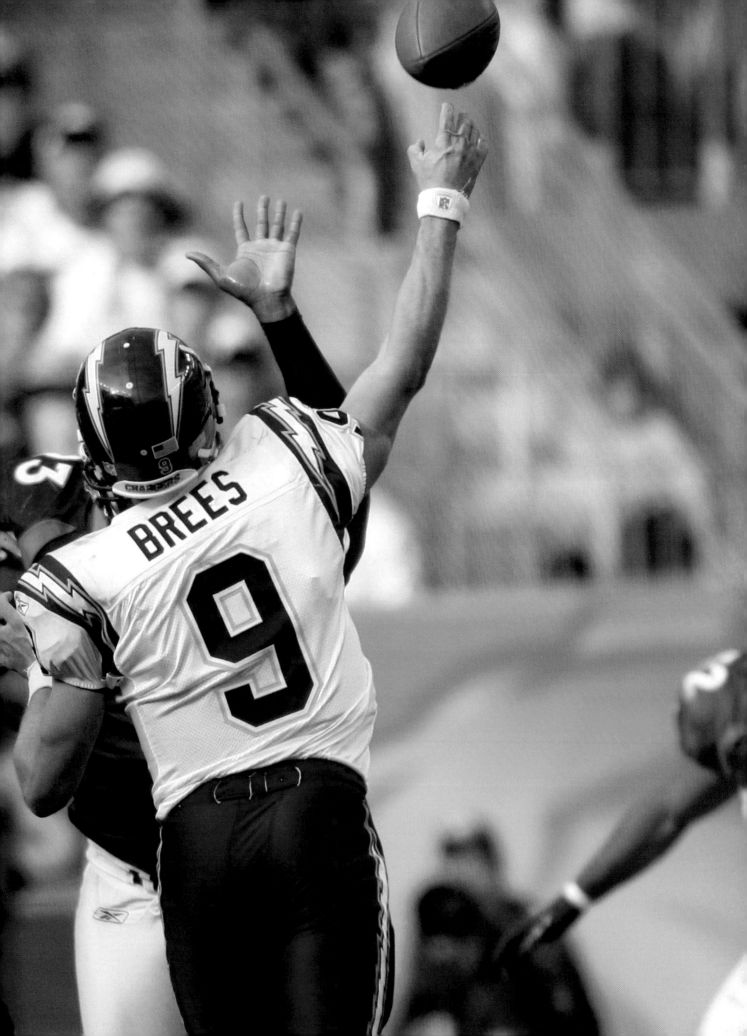

HELLO NOLA!

Brees took the Superdome field before a game against the Cowboys during the 2009 championship season.

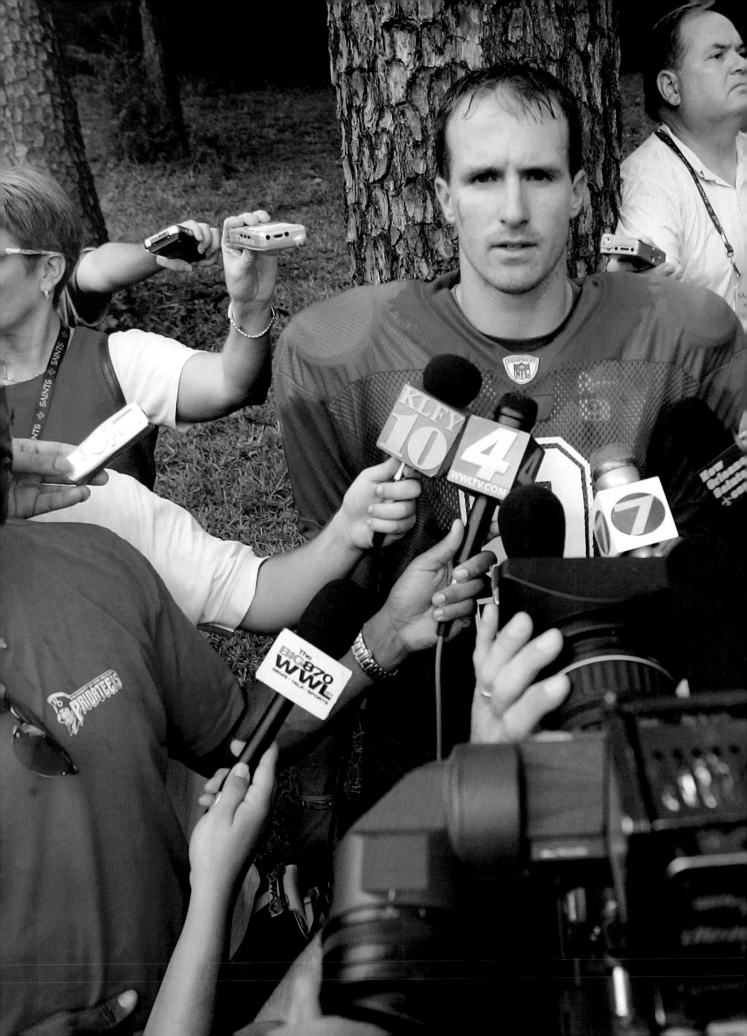

All eyes were on Brees as he met the media after the first day of training camp for the Saints in 2006.

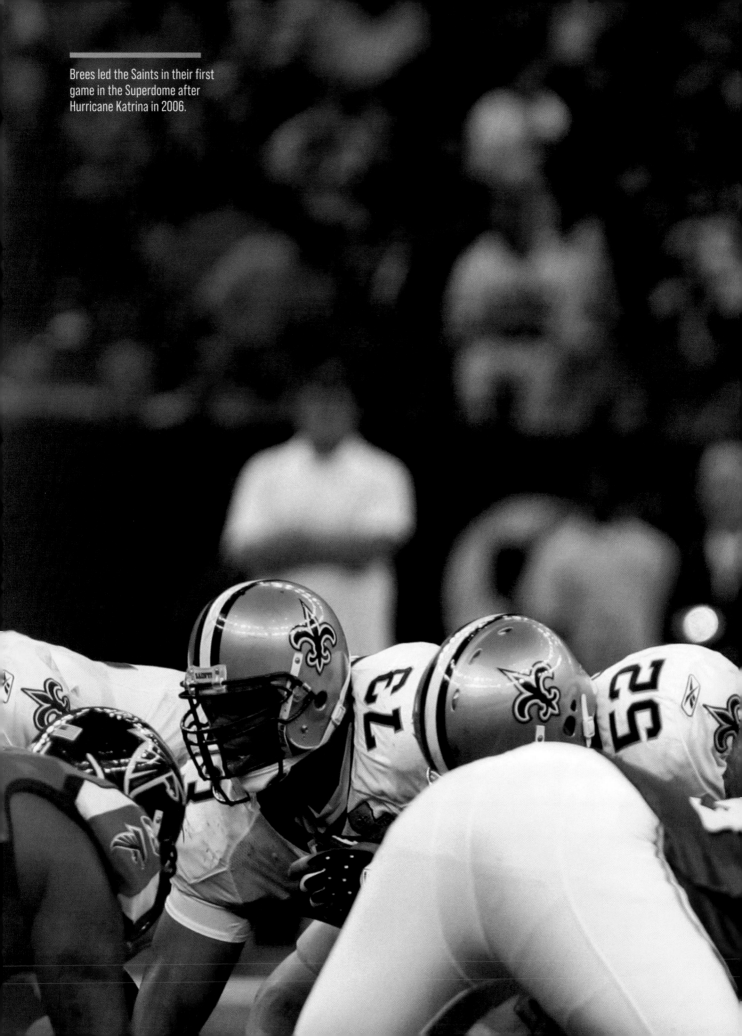

Brees led the Saints in their first game in the Superdome after Hurricane Katrina in 2006.

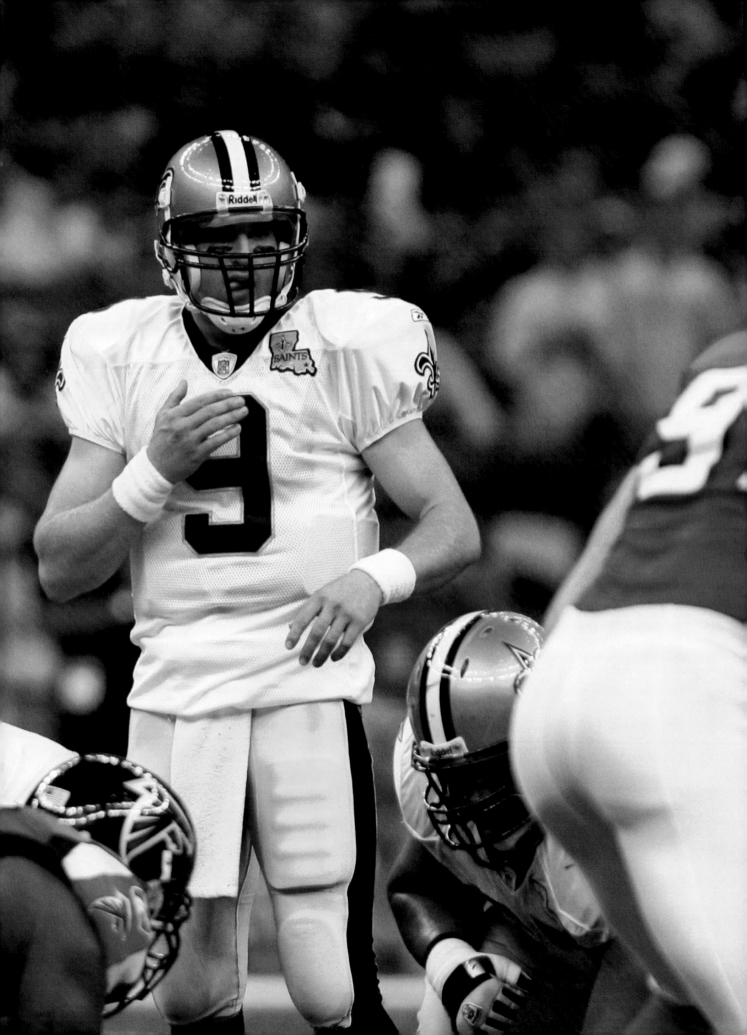

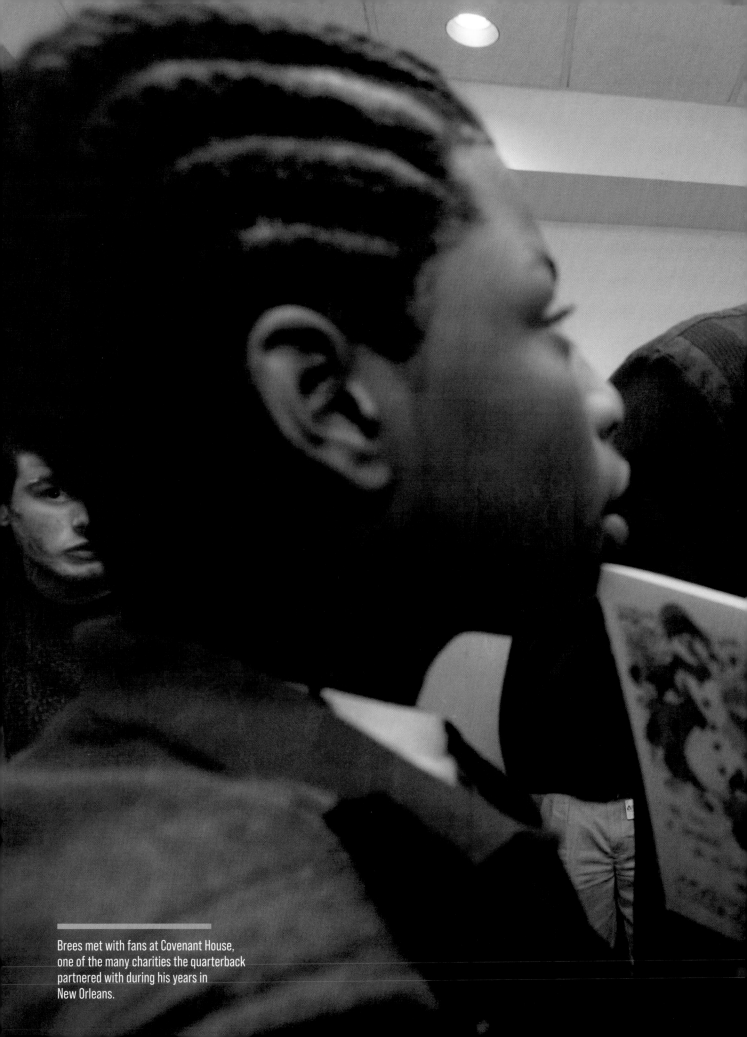

Brees met with fans at Covenant House,
one of the many charities the quarterback
partnered with during his years in
New Orleans.

Unsure about the status of Brees's injured shoulder, the Miami Dolphins decided to sign Daunte Culpepper to a free-agent contract. That left the door open for the Saints to walk through.

Excerpted from Sports Illustrated, January 22, 2007

Where He Belongs

A playoff win left no doubt that Drew Brees's shoulder
was fully healed and that the Saints had made
themselves a free-agent signing for the ages

BY TIM LAYDEN

The man has something important to say to Drew Brees. It is a warm afternoon early in the new year, and Brees, the 28-year-old quarterback of the Saints, is walking through Audubon Park, a 400-acre preserve not far from the century-old home that he and his wife, Brittany, bought last spring in New Orleans's Uptown.

The man is walking with his wife and pushing an infant in a stroller. He extends his right hand to Brees as they pass on a walking path. "Thank you for what you've done for this city," he says. "I want you to know that we appreciate it." Brees squeezes the man's hand and nods. "You're welcome," he says. "And thank you." Now a red SUV passing on St. Charles Avenue honks its horn twice, and the driver leans out the window in slow-moving traffic. "Thanks, Drew!" she shouts, waving.

Brees smiles and waves back. "That happens 10 times a day, at least," he says. "And it's never 'Good game,' or 'Can I have your autograph?' It's always somebody saying thank you." He looks at the ground and shakes his head, as if again humbled by the remarkable place where he has landed.

"He is a god down here right now," says acclaimed chef Emeril Lagasse, owner of three New Orleans restaurants and a Saints season-ticket holder for two decades. "He is the miracle man."

A year ago the quarterback was wounded and the city reeling. Brees lay in a hospital bed with a shoulder injury so severe that even his surgeon wondered whether he'd play again. The Chargers, who'd drafted him out of Purdue in 2001, had cast him aside with what Brees considered an insulting contract offer, and he and his wife were reconsidering their plans to start a family. New Orleans, meanwhile, lay in ruins, struggling to find traction after Hurricane Katrina. Now they are joined. Brees is steering the Saints on an improbable ride toward their first Super

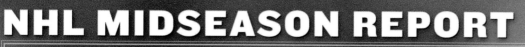

SIDNEY CROSBY

Sports Illustrated

NFL PLAYOFFS

More Than Football

Drew Brees and the Saints lift the city of New Orleans to higher ground

BY TIM LAYDEN

The Lost Photographs *of* **Muhammad Ali** *by* NEIL LEIFER

HAPPY BIRTHDAY, CHAMP

JANUARY 22, 2007 www.SI.com
AOL Keyword: Sports Illustrated

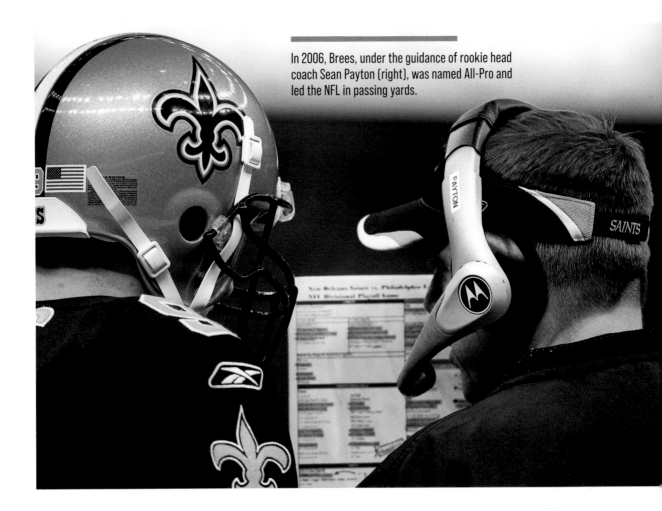

In 2006, Brees, under the guidance of rookie head coach Sean Payton (right), was named All-Pro and led the NFL in passing yards.

Bowl—"Without him we just wouldn't be here," says right tackle Jon Stinchcomb. "It's that simple"—an emotional journey that has given New Orleanians weekly respite from the otherwise unrelenting work of recovery.

"I play football for a job," says Brees. "But all this, it goes way beyond football."

Although the football can be pretty good. On this Saturday night the reborn Louisiana Superdome was filled again, as it had been for every home game during the season, quivering with a desperate, ear-splitting energy as the Saints won just the second playoff game in their 40-year history, a 27–24 victory over the Eagles. The win gained New Orleans an opportunity to play for the conference championship against the Bears at Soldier Field.

Brees completed 20 of 32 passes for 243 yards and a touchdown. He did not throw an interception and has thrown just one in the last seven games. It was yet another solid performance in an All-Pro season when he led the NFL with 4,418 passing yards. Yet Brees did nothing of greater value for his team on this night than put the ball in the hands of Deuce McAllister.

Selected 23rd by the Saints out of Ole Miss in the 2001 draft, nine spots ahead of Brees, McAllister rushed for 143 yards and one touchdown and scored another on an 11-yard swing pass from Brees. And after the Eagles punted with 1:56 to play, trailing by three with two

timeouts left, McAllister carried three times to earn the first down that sealed the victory as 70,001 fans roared *Dooooooooce!*

McAllister is the Saints' all-time leading rusher, but he'd never been in a playoff game before. Last year he tore his right ACL and missed the final 11 games; this season he had to sublimate his ego by sharing his position with Heisman Trophy–winning rookie Reggie Bush. But the load-sharing has had its benefits. "I haven't had to carry this team," McAllister says. "Now my body is in the best shape it's ever been in at the end of a season. And you've got to run the ball in the playoffs."

Bush ran it, too, as part of a wild night that began for him with a crushing hit from Eagles cornerback Sheldon Brown that left him crawling across the turf in pain. He returned to rush for 52 yards on 12 carries, including a 25-yard scamper in the first quarter and a four-yard touchdown in the second, both on signature cutback moves. "I find myself getting ready to block whenever he's got the ball," says Brees. "It's never dull with Reggie."

It wasn't dull when Bush misplayed a pitch from Brees as the Saints were trying to kill the clock late in the fourth quarter, giving Philly one last chance—which was snuffed out by the New Orleans defense. The safe move would have been to keep the veteran McAllister in, but throughout the second half he was racked by dehydration cramps. Still, when the Saints needed that final first down, McAllister was back on the field.

"Deuce is absolutely a warrior," Brees says. "At the end of that game the Eagles earned themselves a big dose of Deuce McAllister."

It's no surprise that Brees has brought a team this far in the playoffs. The surprise is that the team is the Saints. Brees was the quarterback on San Diego teams that won a combined 21 regular-season games in 2004 and '05. With All-Pro running back LaDainian Tomlinson, whom the Chargers took fifth in that 2001

draft, the franchise seemed loaded for a string of postseason runs.

But in the final game of 2005, with the Chargers out of playoff contention, Brees dived for a fumble in his own end zone, and Gerard Warren, the Broncos' 325-pound tackle, landed on him. When Brees stood he held his right arm as if he were resting the elbow on a fireplace mantel, his shoulder gruesomely dislocated.

More than 1,700 miles away in Birmingham, renowned orthopedic surgeon Dr. James Andrews watched a replay of Brees going down. "I thought, my God, what an injury," says Andrews. Four days later he examined Brees and diagnosed a rare 360-degree tear of the labrum, the ring of cartilage around the entry to the shoulder joint. During surgery Andrews discovered a deep, partial rotator cuff tear. He says the damage in Brees's shoulder joint represented "one of the most unique injuries of any athlete I've ever treated."

Andrews and two other surgeons mended the labrum with the unheard-of total of 11 surgical anchors (three or four is common) and repaired the rotator cuff.

Afterward, Brees faced an arduous rehabilitation, with long odds. "Lord, I was just hoping to give him a functional shoulder," says Andrews. "An average athlete would not recover from this injury."

Andrews handed Brees off to Kevin Wilk, a physical therapist and clinical director at Benchmark-Champion Sports Medicine in Birmingham who has been rehabbing Andrews's patients for 18 years. "Dr. Andrews told me, 'You've got your work cut out for you,'" Wilk says. "I had never seen an injury this severe in any elite-level throwing athlete. We were in uncharted waters."

Brees attacked his rehab voraciously. He moved in with his in-laws, Pete and Kathie Dudchenko, who live in Birmingham, and spent four months of seven-hour days at Wilk's clinic.

DREW BREES

Told he could be out of his sling in four weeks, he lost it in two and a half. Told he would have full range of motion in 12 weeks, he achieved it in eight. Told he would throw a football in four months, he was outside on the lawn of the clinic playing catch with Giants safety Will Demps, who was rehabbing an ACL, in a little more than three months.

"His recovery has been one of the most remarkable of any patient I've ever treated," says Andrews. "And the biggest thing was Drew's motivation and toughness."

Brees's football future was not unfolding as favorably. The Chargers, who put a franchise tag on him for 2005 and paid him $8.1 million, offered him an incentive-laden deal for '06 with only $2 million guaranteed. Brees saw this as general manager A.J. Smith's attempt to run him off and finally play Philip Rivers, whom Smith had acquired in the shrewd Eli Manning trade on draft day 2004. "They didn't think I could come back," says Brees, "and the injury was their excuse to get rid of me."

Smith says, "People say the offer was an insult. I don't care what people think. If [Brees] wanted to come back, he would have accepted the offer."

Brees wanted desperately to return to San Diego. "I was supposed to be the guy to take that team to the next step," he says. "But then I started thinking, *How can I go back when that's what they think of me?*"

He declared himself a free agent, and his first visit was to New Orleans. The Saints were a football team in transition, coming off a 3–13 season when they'd played "home" games in New Jersey, San Antonio and Baton Rouge. There was also a new coach, 43-year-old former Cowboys assistant Sean Payton, and a roster that would include 27 new players. Payton and general manager Mickey Loomis knew all about Brees's shoulder. "The injury was the only reason we had an opportunity to sign him," says Payton.

They drove Brees through the city in March and gave him the pitch: You can be part of the rebuilding. Greg Bensel, the Saints' vice president of communications, then took the Breeses on a real estate tour that included the areas most devastated by Katrina. They did not flinch; instead, they embraced the possibilities. "I'm very faith-driven in my life," says Brees. "At some point in the process I started to believe that maybe God put me in this position for a reason. Maybe we were supposed to come to New Orleans and do more than just play football."

In fairness, the difficulties presented by the city and the team were offset by a one-year offer of $10 million guaranteed (with options for $50 million more over four additional years). As competition Brees had only the Chargers' bid and a shrinking offer from the Dolphins, who told Brees's agent, Tom Condon, that they felt he had only a 25% chance of playing effectively again. (Miami soon turned its attention to Daunte Culpepper.) On March 14, Brees signed with the Saints. "They needed me and they wanted me," says Brees. "And how many people in life get an opportunity like this, to really make a difference?"

There were some hiccups. Although Payton kept Brees on a tight pitch count early in training camp, on the second day his arm was tired. He threw a wounded quail to wideout Joe Horn that dipped after a few yards, and Payton said, hopefully, "Use your legs a little more." Brees recalls, "I know what he was thinking: This guy's arm is not going to be ready." On Aug. 28 the Saints traded wideout Donte' Stallworth to the Eagles, leaving Brees with a receiving corps that, after Horn, was woefully short on experience. His targets would include Devery Henderson (22 career receptions entering '06), Terrance Copper (eight career receptions) and Marques Colston, a seventh-round rookie out of Hofstra. But Brees has adjusted: Bush led the team in the regular season with 88 catches, and the three newbies combined for 125, led

> On March 14, Brees signed with the Saints. "They needed me and they wanted me," says Brees. "And how many people in life get an opportunity like this, to really make a difference?"

by Colston's 70. Brees has been a solid fit for Payton's West Coast–based system, with its heavy diet of half rollouts and bootlegs.

"We had a whole new offensive line, a rookie split end, and a bunch of other guys with little experience," says Payton. "That's a lot of new pieces to the puzzle, and Drew has been the guy to bring them all together."

Inside the locker room, Brees was an even sweeter fit. "I called [Chargers fullback] Lorenzo Neal to get the word on Drew," says Horn. "He said great things about him. And he's been a great leader from Day One."

Brees's work ethic remains his mainstay. One example: He finishes every day by watching practice film. Eight days before the playoff win, Brees flipped on the lights in an offensive meeting room at the team's practice facility in suburban Metairie and spent 30 minutes running through the day's workout. Before each snap he softly spoke the formation and play he was about to run, a habit he learned under San Diego offensive coordinator Cam Cameron. "If this is the last thing I do every day," he said, "I feel like I've accomplished something positive, even if it wasn't a great day otherwise."

Brees has been a ubiquitous presence in the city, donating time and money to charities. He also made his commitment known by living Uptown, where few Saints have ever resided. (Most on the current team own homes in suburbs or near the practice facility.) "The community's view of Drew is that he knew what he was getting into when he came here, and he came here anyway," says Michael Whelan, 32, a New Orleans commodities trader who has played golf with Brees and is a friend of Loomis's and Payton's. "We really have a long, long way to go in the city, but the Saints are a part of the fabric of New Orleans, and Drew has just been unbelievably visible."

On the night before the Eagles game, Brees watched the movie *Crank*—"I can't even remember who was in it," he said later—at the airport hotel where the team stays on the night before games. He thought back to his first game at the Superdome, when he got caught in traffic and was 30 minutes late despite an escort that had him driving on sidewalks approaching the stadium. And he remembered his only previous playoff game, a three-point loss to the Jets in January 2005.

It was past 11 p.m. when Brees left the locker room. In the Superdome labyrinth he stopped to embrace Tom Benson, the Saints' 79-year-old owner, who raised two fingers as they separated. "Two more games for the Super Bowl," said Brees as he walked away, again speaking in wonder. "What a year." ●

Brees directed
a win over the Packers
in 2006; his 181 victories
rank fourth all-time
among quarterbacks.

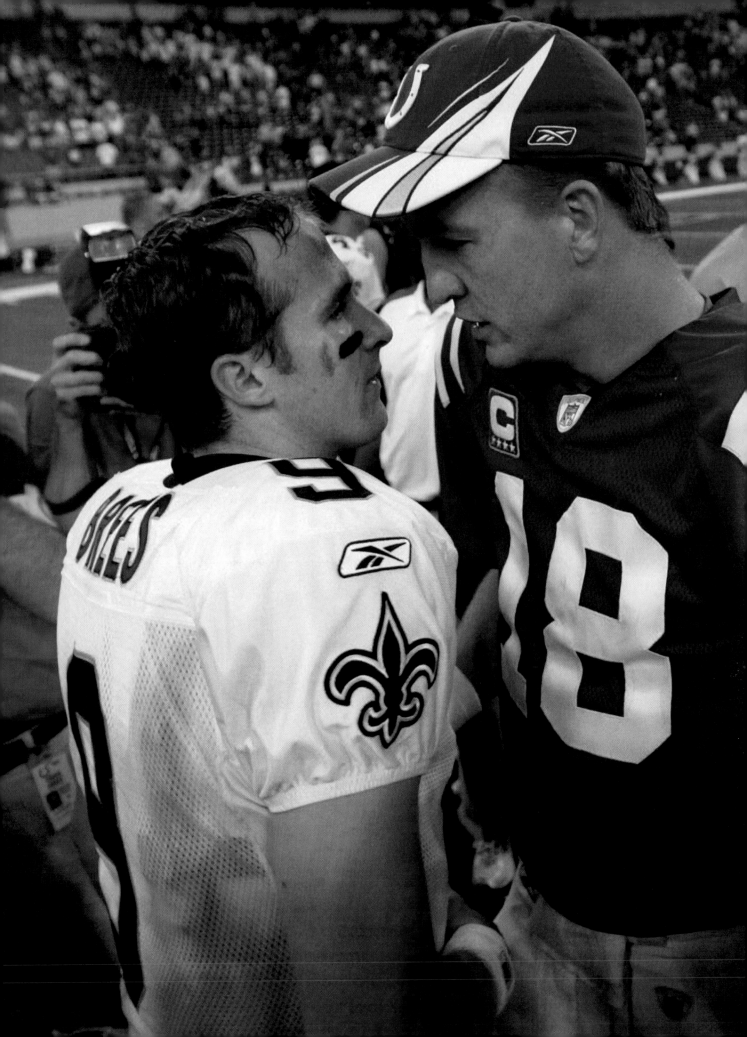

Colts quarterback Peyton Manning spoke with Brees after Indianapolis beat New Orleans in 2007. Years later, the two woluld meet again in the biggest game of Brees's career.

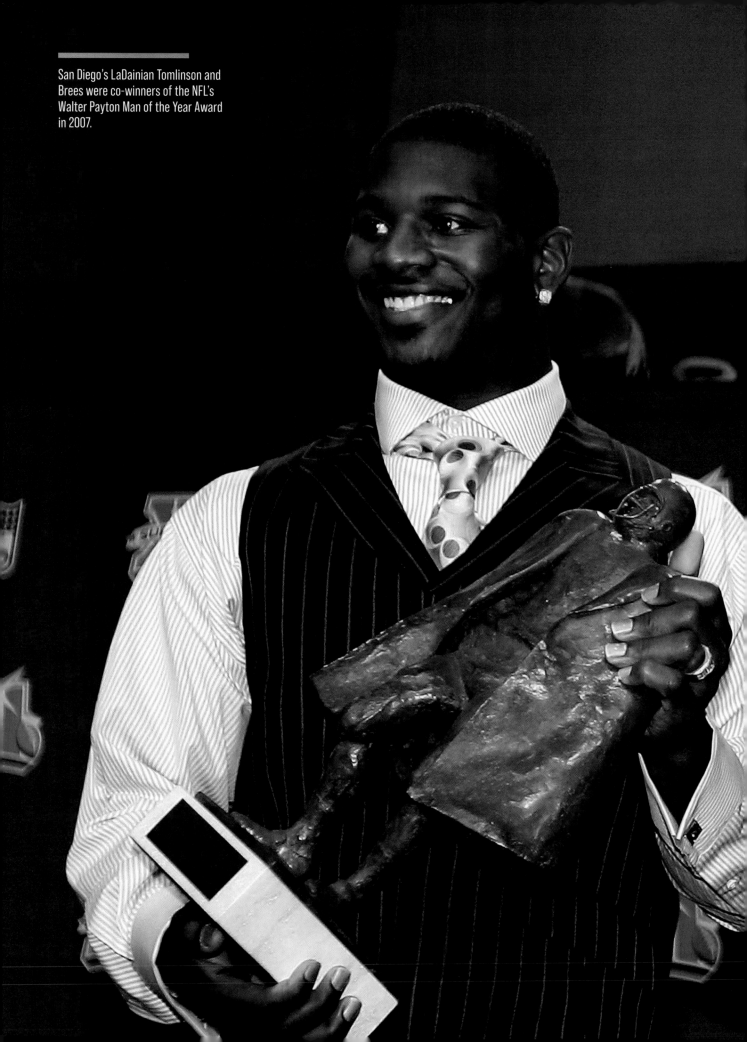

San Diego's LaDainian Tomlinson and Brees were co-winners of the NFL's Walter Payton Man of the Year Award in 2007.

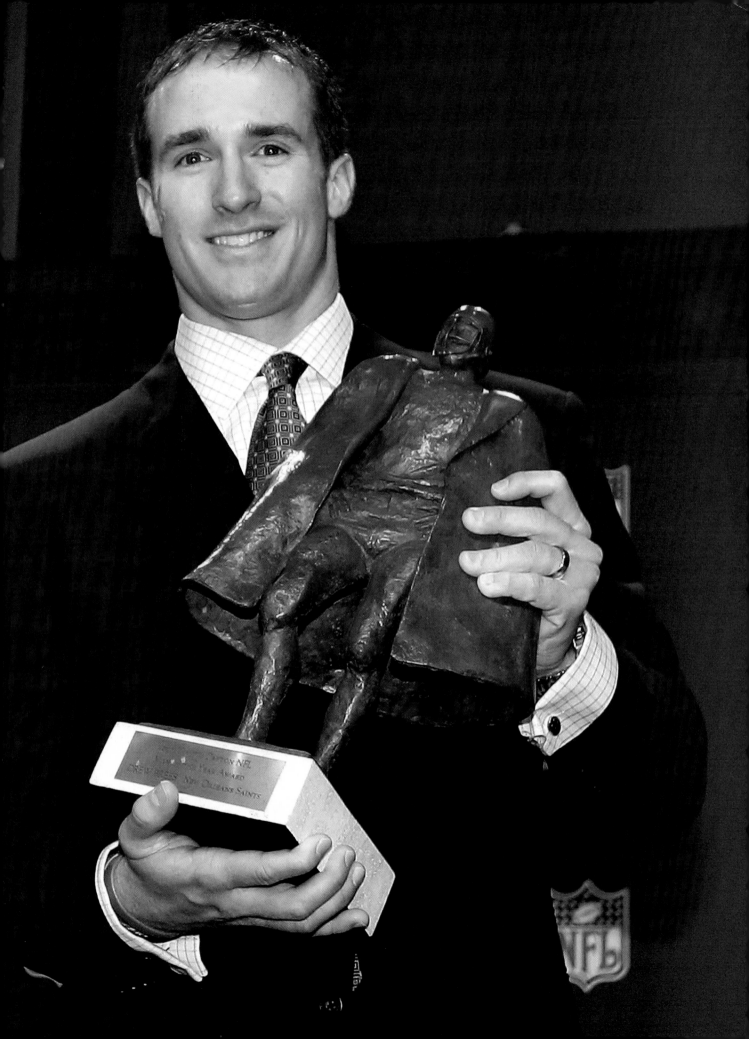

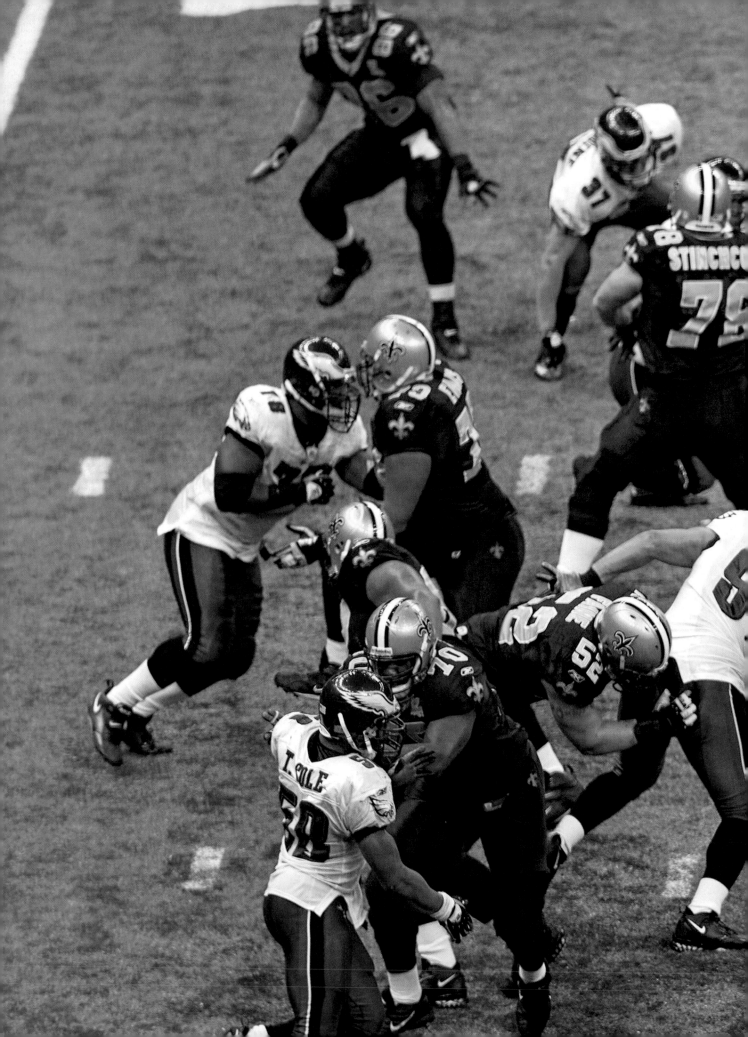

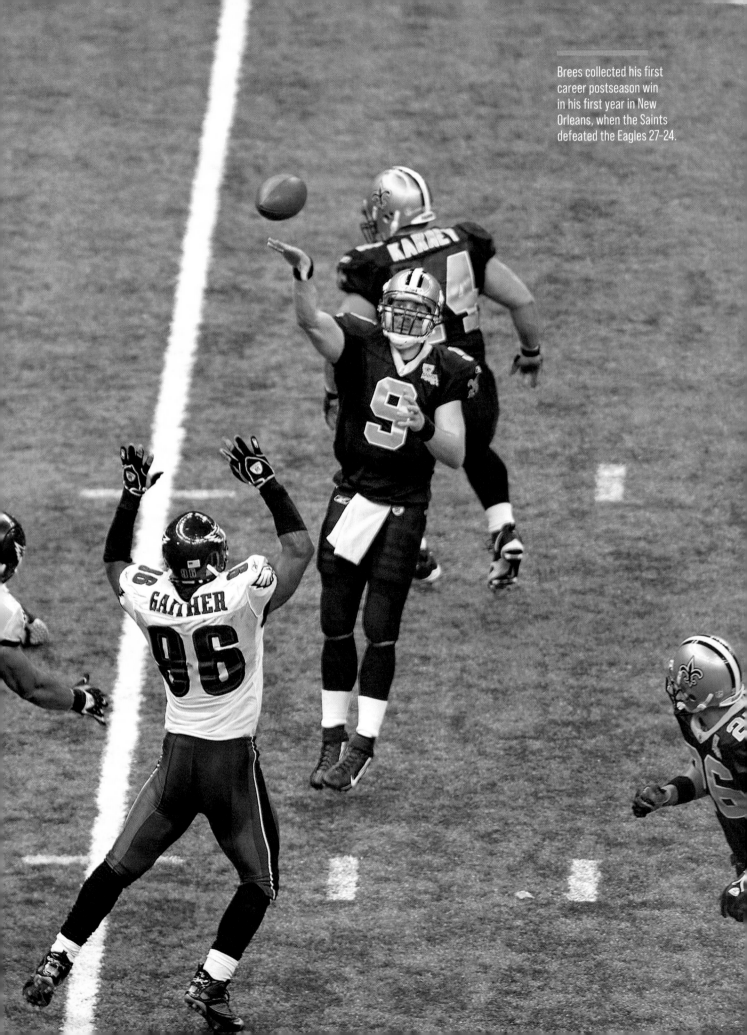

Brees collected his first career postseason win in his first year in New Orleans, when the Saints defeated the Eagles 27–24.

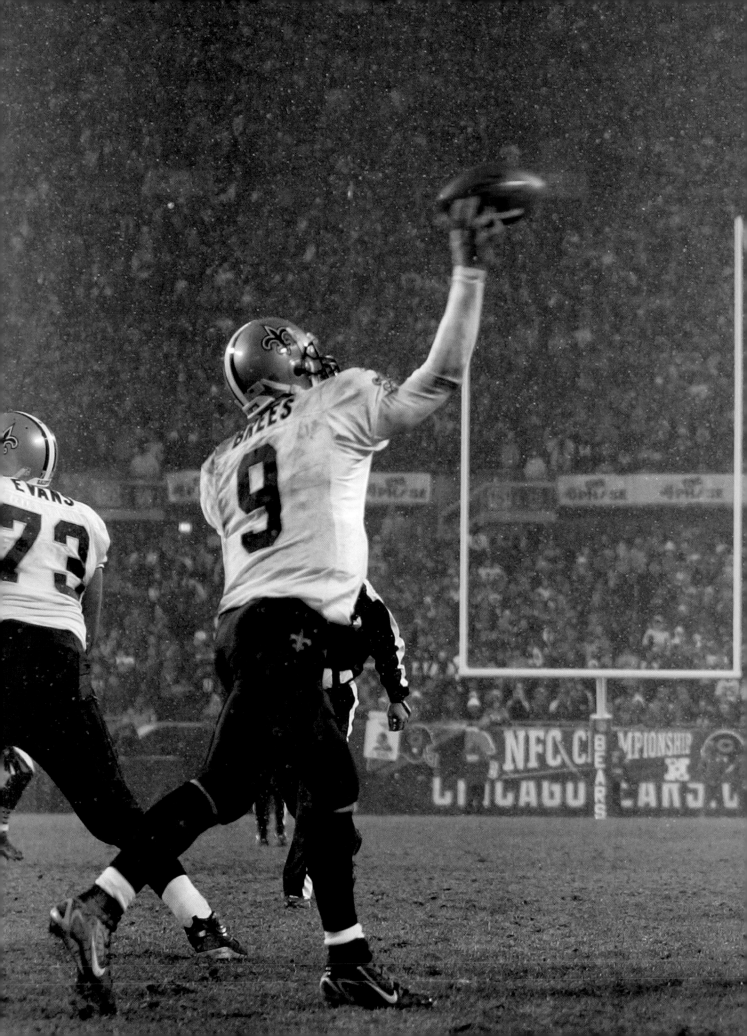

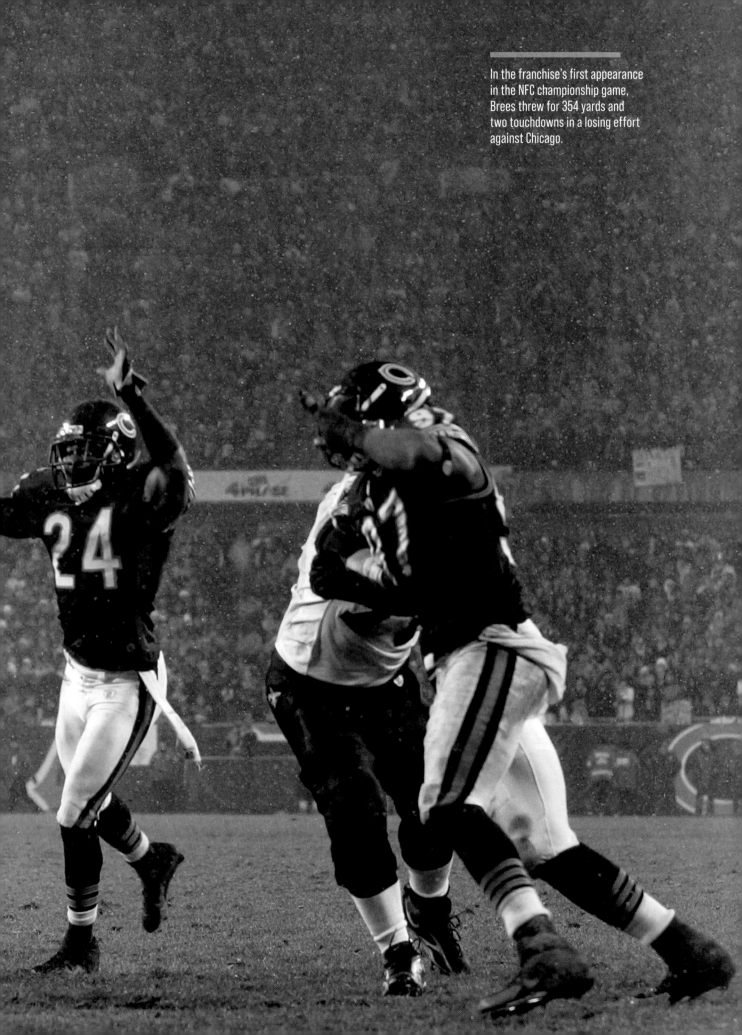

In the franchise's first appearance in the NFC championship game, Brees threw for 354 yards and two touchdowns in a losing effort against Chicago.

After missing the playoffs for two straight seasons, Brees was ready to drive the Saints to the Super Bowl in 2009-10.

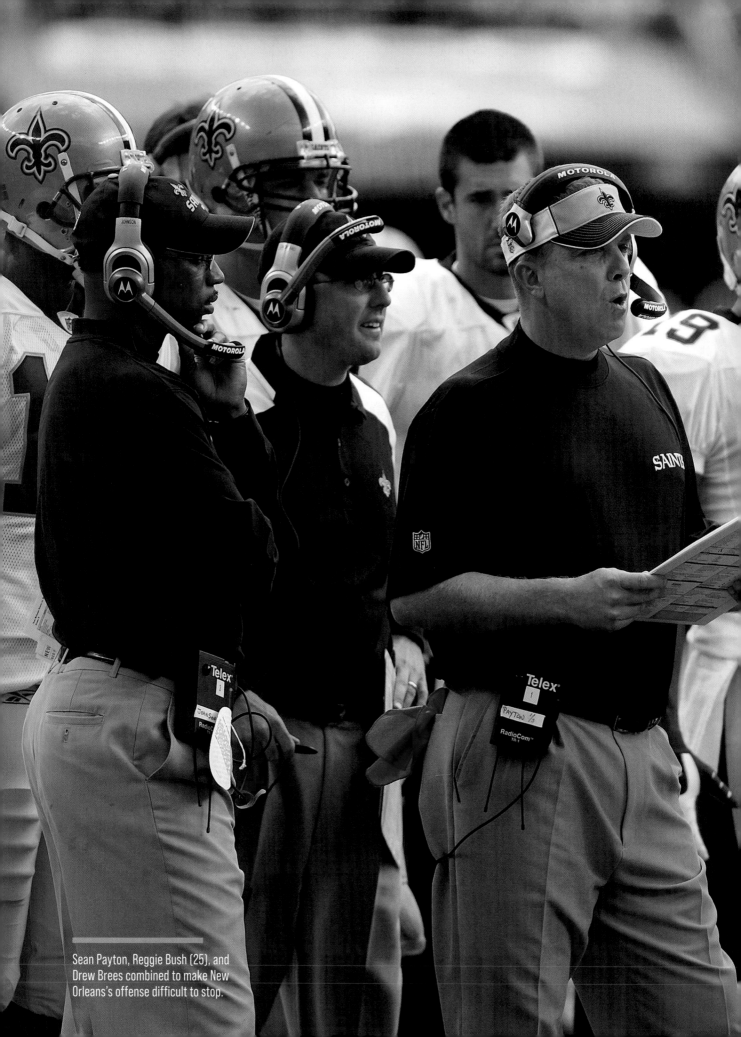

Sean Payton, Reggie Bush (25), and Drew Brees combined to make New Orleans's offense difficult to stop.

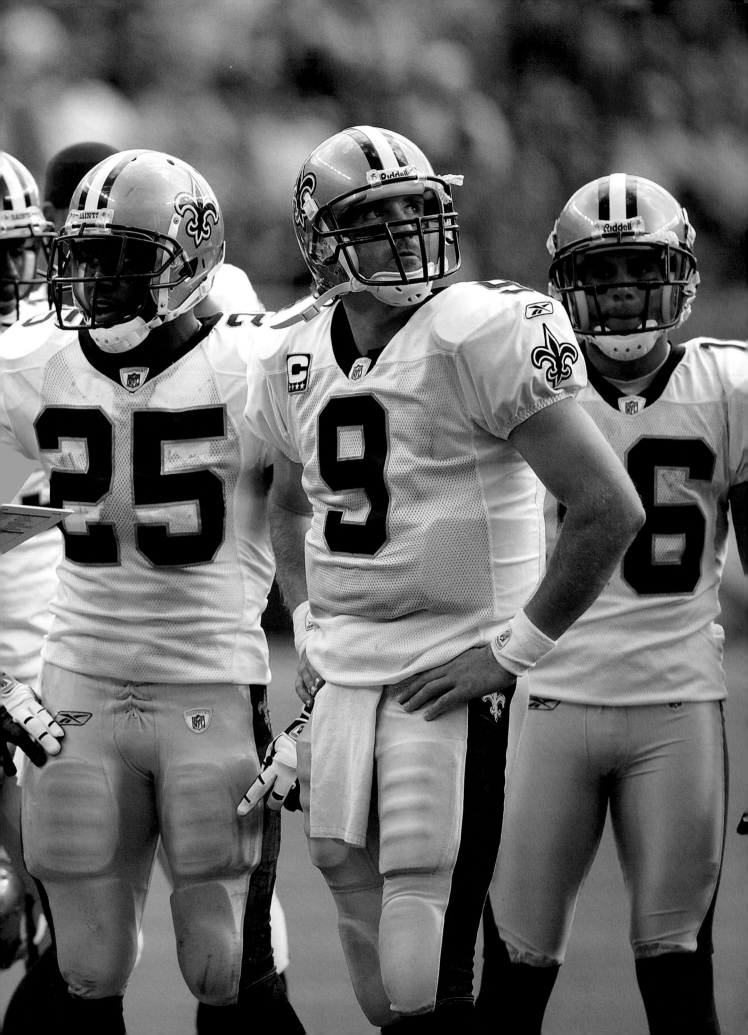

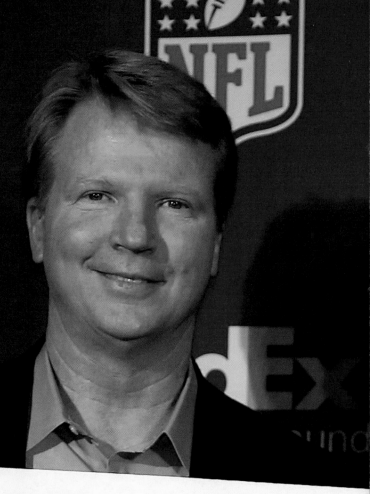

Brees and former Giants quarterback Phil Simms pose with the FedEx Air Player of the Year donation check in Tampa in 2009. Brees threw for more than 300 yards 10 times during the 2008–09 season.

FedEx | NFL

PAY *** TWENTY-FIVE THOUSAND DOLLARS
TO
THE
ORDER
OF *Safe Kids Louisia*

⑆3891299⑆ ⑈0641015501

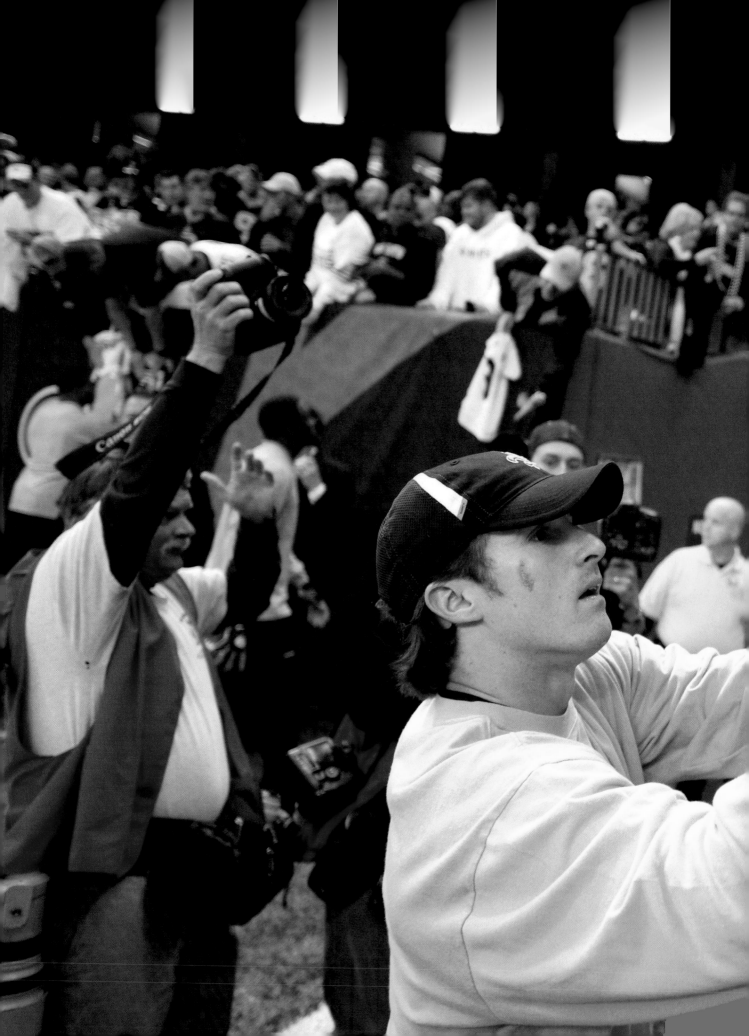

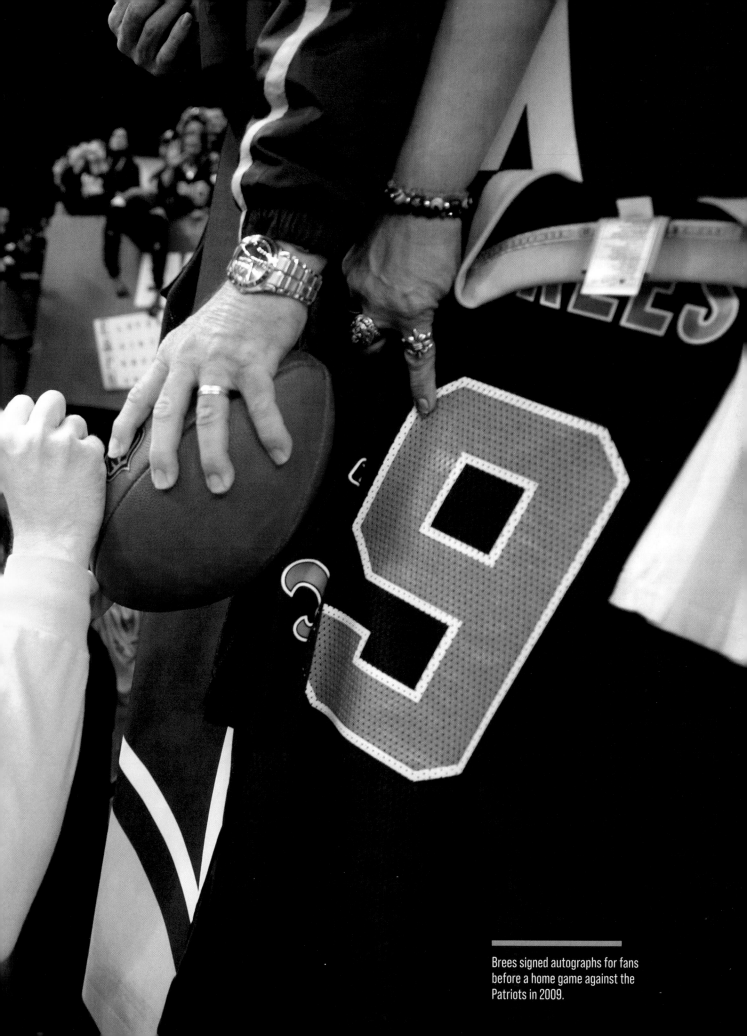

Brees signed autographs for fans before a home game against the Patriots in 2009.

Excerpted from SPORTS ILLUSTRATED, January 18, 2010

Man About Town

As the playoffs neared and the Saints geared up for a championship run, Drew Brees spent his free time working to help New Orleans become a better place

BY PETER KING

On the Thursday of his playoff bye week, in a private upstairs room at Commander's Palace, the landmark New Orleans restaurant, Drew Brees convened what he calls his "secret society." In the dining room were seven of the city's richest men and biggest boosters, power players who have anonymously teamed with Brees for such post-Katrina causes as the refurbishment of Tad Gormley Stadium in City Park and the funding of the New Orleans Ballet Association's flagging after-school program.

Brees calls the group (two of the members were absent that night) the Quarterback Club. As a token of thanks for contributions past—each man gave at least $25,000 in 2009—and future, Brees dispensed black-and-gold cuff links engraved with QB.

"I'd like to propose a toast," he said, lifting his champagne flute. "All of you care so deeply about the future of this city, not just from a business perspective but from a philanthropic perspective, and it's so desperately needed right now. A toast to you, and to New Orleans!"

"Hear, hear! To New Orleans!" the group responded.

Earlier in the bye week, the quarterback had spent two hours working on another of his pet projects, the Lusher Charter School, for which he'd help raise the money to build a new football field, weight room, scoreboard and running track after the September 2005 hurricane had devastated the facilities and the surrounding Uptown neighborhood. Now, nine days before New Orleans's playoff opener against the Cardinals in the Superdome, Brees chatted

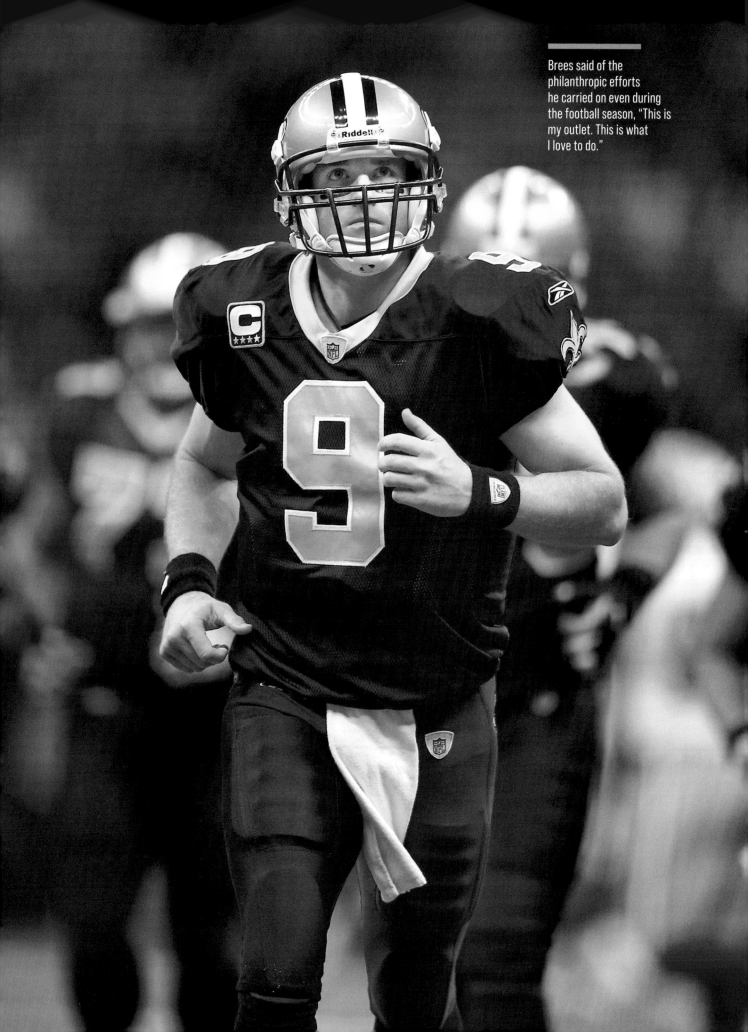

Brees said of the
philanthropic efforts
he carried on even during
the football season, "This is
my outlet. This is what
I love to do."

up and rubbed elbows with the people he knew could help him do real good for the city.

"Some guys might be playing 10 hours of *Madden* today, which is cool," Brees said as he took his seat after his toast. "But this is my outlet. This is what I love to do."

History can turn on the cruelest of events. Four years ago Brees, then with the Chargers, was playing against Denver in San Diego's season finale. He had been franchised by San Diego in 2005 and was set to become a free agent when the final whistle blew. In the second quarter Brees's right shoulder was dislocated, and the resulting damage—a total tear of his labrum and a partial tear of the rotator cuff—made the Chargers' offseason decision an easy one: They let Brees walk, and Philip Rivers became the starting quarterback.

Two teams, the Dolphins and the Saints, were interested in him as a free agent. But Miami ultimately didn't trust that Brees's shoulder would heal in time for him to start the 2006 season.

Imagine the difference—for football and for New Orleans—if Miami coach Nick Saban had ignored the medical prognosis. He would have had Brees, not Daunte Culpepper, at quarterback, and he might have stayed with the Dolphins rather than bolting for Alabama. Quite possibly the Crimson Tide wouldn't have been hoisting the national championship trophy last week. And the Saints might well be playing in San Antonio or Los Angeles instead of packing the refurbished Superdome for a playoff game.

"I can't even think about that," says Owen Brennan, executive director of the Krewe of Bacchus, which runs the most storied Mardi Gras parade. Brees has been appointed the King of Bacchus for the 2010 edition, the first athlete so honored. "It's a nightmare. Don't even say it. *Ooooo.* What he's done for this city is absolutely immeasurable."

On the measurable side the Brees Dream Foundation has raised $1.85 million for its Rebuilding Dreams campaign. Some of the money goes to Katrina-related causes, such as athletic-field reconstruction. Some of it goes to needs that would otherwise not be addressed because so much funding has been diverted to hurricane relief. The latter projects include a home for families of cancer patients, and the Samuel J. Green Charter School's "edible schoolyard," in which students grow food on campus while studying nutrition and agricultural science. The produce they grow ends up on the school menu.

One of Brees's favorite causes is the Lusher School, a battered, 76-year-old facility four miles southwest of the French Quarter. Like the Superdome, Lusher was damaged by wind and water, and it served as a shelter for those made homeless by the storm. Some lived for weeks in the school, which might never have reopened if not for the ambitious efforts of New Orleans educators.

"Drew realized that nothing breathes life into a city neighborhood like kids playing," says Lusher CEO Kathy Hurstell-Riedlinger as she conducts a tour of the school and its grounds. "We had to rebuild the field, which was dangerous, and show the community that this school was here to stay."

Brees's foundation and two corporate sponsors donated $671,000. In New Orleans, where more than four years after Katrina so much remains to be done, it's a measure of progress that the once-ravaged Lusher looks for the most part like any average American school. BREES FAMILY FIELD, as the scoreboard reads, would be the envy of many athletic programs.

"Before, it was a death trap out here," says senior Pierce Wisdom during a break in soccer practice. "I remember wondering if I made the right decision to come back here instead of going somewhere with better facilities. We all appreciate what Drew did so much."

Brees knew that to be competitive, Lusher's football program would also need a weight room. Drew and Brittany picked up the $38,000 tab for that (with some big price breaks from fitness-equipment manufacturers). Last week, while walking through the school, Brees stopped into the 15-by-40-foot weight room as some football players were lifting. When he saw junior linebacker Jeremy Bailey using the wrong technique on squats, Brees, dressed in business clothes and dress shoes, showed him the proper method—sitting straight down, not leaning forward. "Think about tightening your core," Brees said as he shouldered the bar and did a squat. "Technique. Always remember technique."

"He's like an uncle who donates a lot of toys," says junior noseguard Caleb Windsay. "The field and the weight room give us a chance to compete. It's an incredible thing for him to do for us."

As Brees left the room, one of the kids yelled out, "Win the Super Bowl!"

"One game at a time," Brees said over his shoulder. "One game at a time."

That philosophy has served Brees well since he signed a six-year, $60 million contract with the Saints. Over the last four seasons no quarterback has thrown for more yards than Brees (18,298), and only one has as many touchdowns. (He and Peyton Manning each have 122.) In 2009 Brees set an NFL record for accuracy—his 70.62% besting Ken Anderson's 27-year-old mark by .07 percentage points.

It's not just pinpoint passing that has made Brees such a good match for coach Sean Payton's offense—the NFL's short-passing culture has spawned a slew of dink-and-dunk chain movers. In a 38–17 statement-game thrashing of the Patriots on Nov. 30, Brees threw three long downfield passes, each on a dime. "An amazing display," Payton calls it.

"To throw it that deep that accurately is something that sets Drew apart from every quarterback out there."

When New Orleans takes the field to open its postseason against the Cardinals, however, Brees won't be concerned with those numbers, but with fixing problems. It has been weeks since the Saints played like the best team in the NFC. After winning 13 in a row, the highest-scoring club in the league lost its last three games, putting up just 17 points each in a Week 15 loss to the Cowboys and a Week 16 defeat to the Buccaneers, then resting Brees and many other starters in a 23–10 loss at Carolina. For the Saints to fulfill the wishes of those Lusher kids and the rest of the city, Brees will have to awaken the dormant offense and hope the pass blocking is significantly better than it was when Dallas linebackers DeMarcus Ware and Anthony Spencer used Brees as a tackling dummy.

The Saints are convinced that by tweaking some protections, they can keep Brees clean and rewire the slumping offense. The tricky part will be combining the varied looks of Payton's schemes that keep defenses off-balance with more secure blocking.

"All the time since we've played a good all-around game, it sort of feels like going into a bowl game in college," Brees said. "It's been a while. But I feel like the more you win, the harder it gets. You go 11–0, 12–0, 13–0, and the teams you play treat it like the biggest game of the year. We felt that down the stretch. I can confidently say we can fix the things that got us beat, because I know this offense so well. I can tell you I'm not worried."

In a town that once worried about so much, including keeping its NFL team, that message should calm a nervous fan base. Especially when it comes from an athlete as adored and appreciated as any in an American city today. ●

DREW BREES

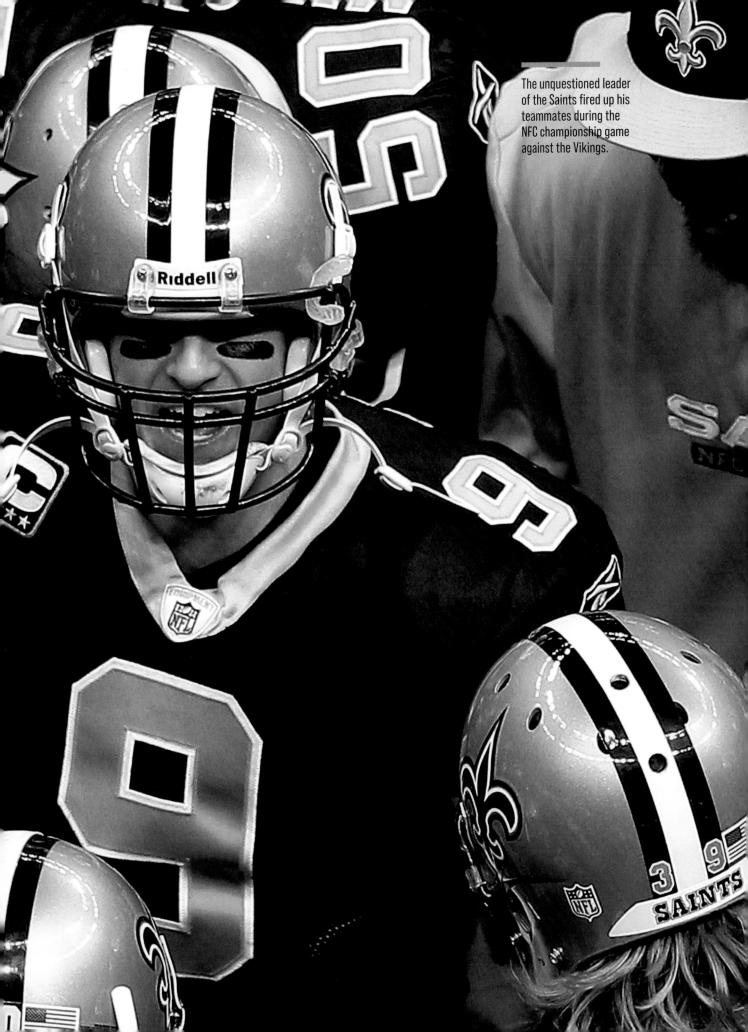

The unquestioned leader of the Saints fired up his teammates during the NFC championship game against the Vikings.

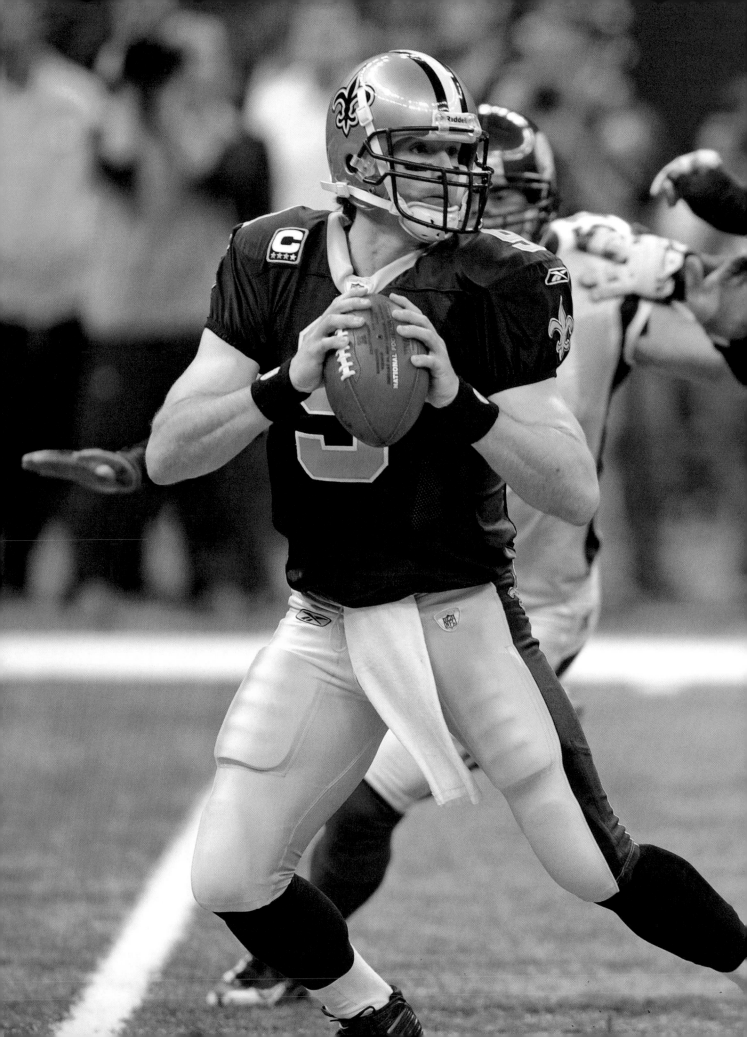

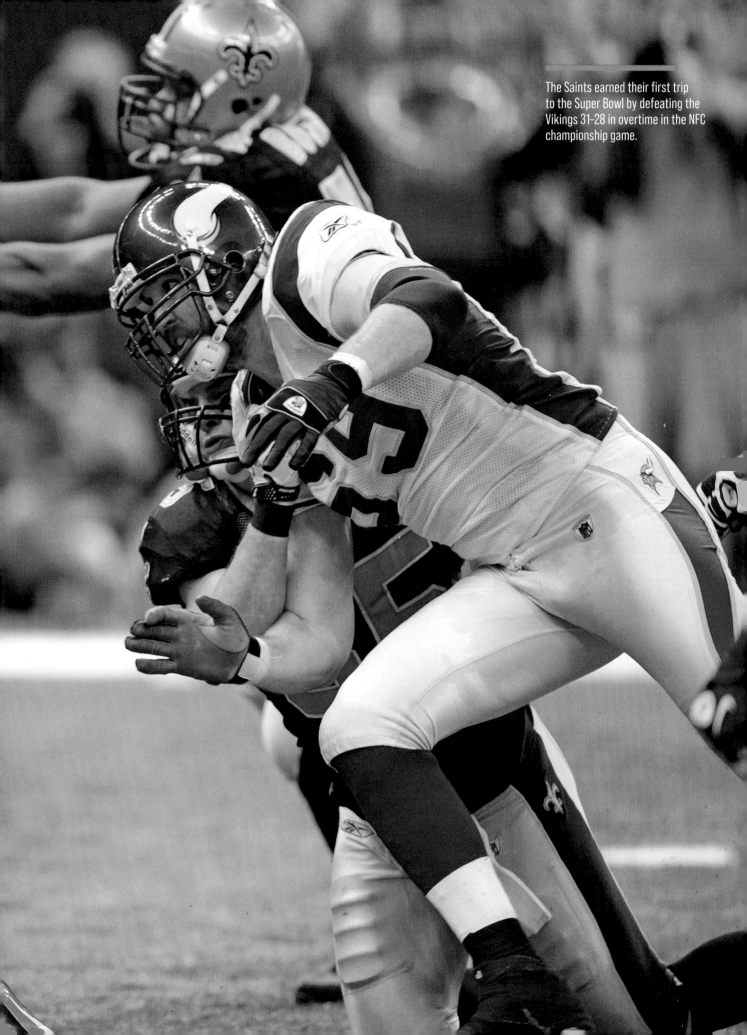

The Saints earned their first trip to the Super Bowl by defeating the Vikings 31–28 in overtime in the NFC championship game.

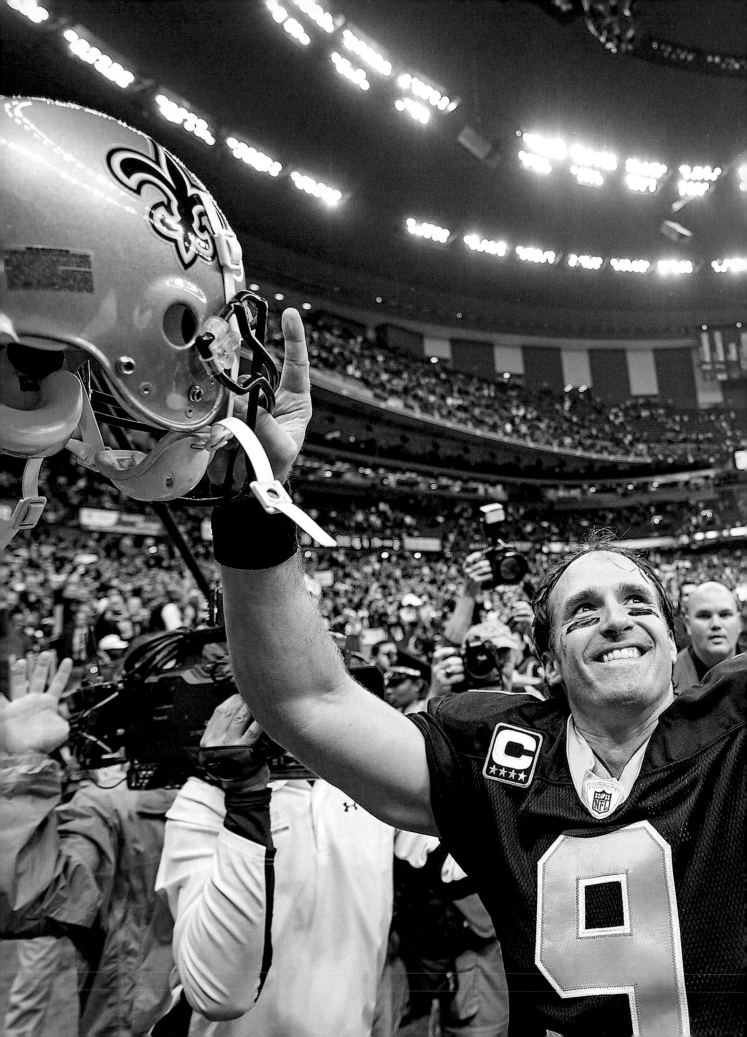

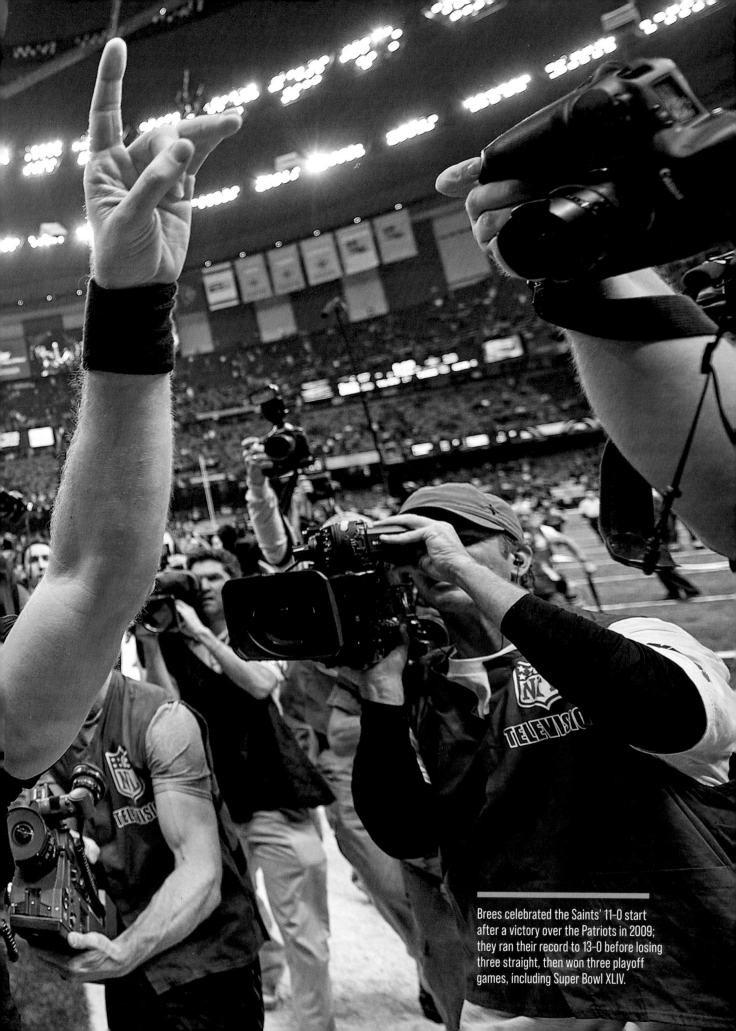

Brees celebrated the Saints' 11–0 start after a victory over the Patriots in 2009; they ran their record to 13–0 before losing three straight, then won three playoff games, including Super Bowl XLIV.

Brees had become a local folk hero
by the time the Saints reached
Super Bowl XLIV.

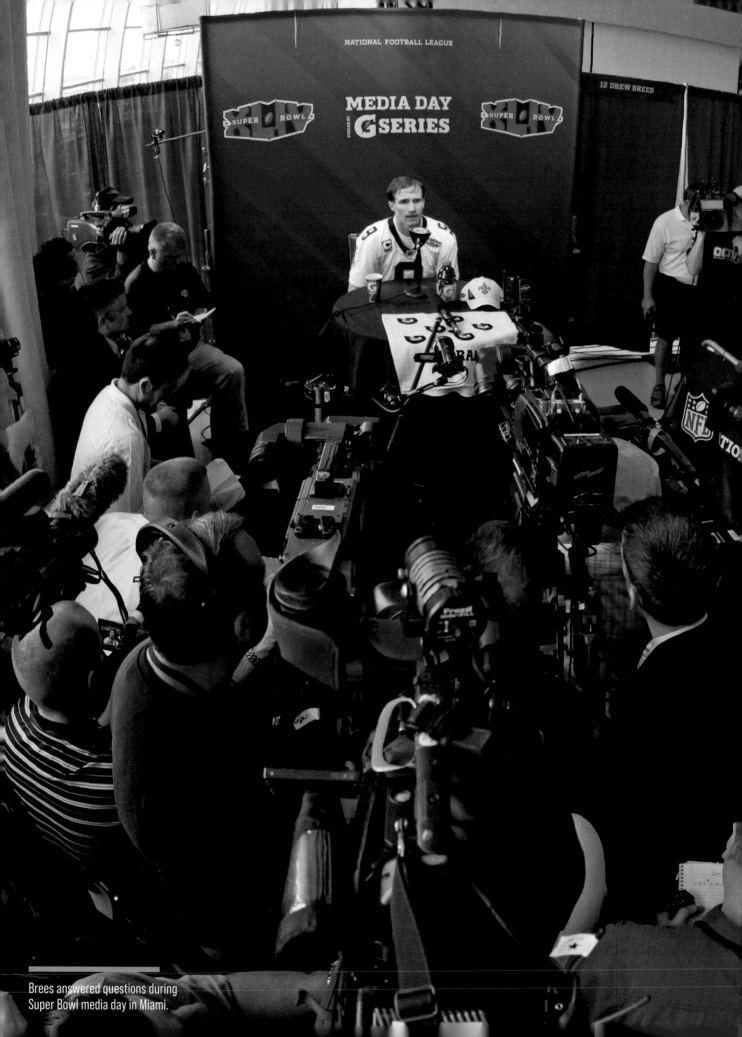

Brees answered questions during
Super Bowl media day in Miami.

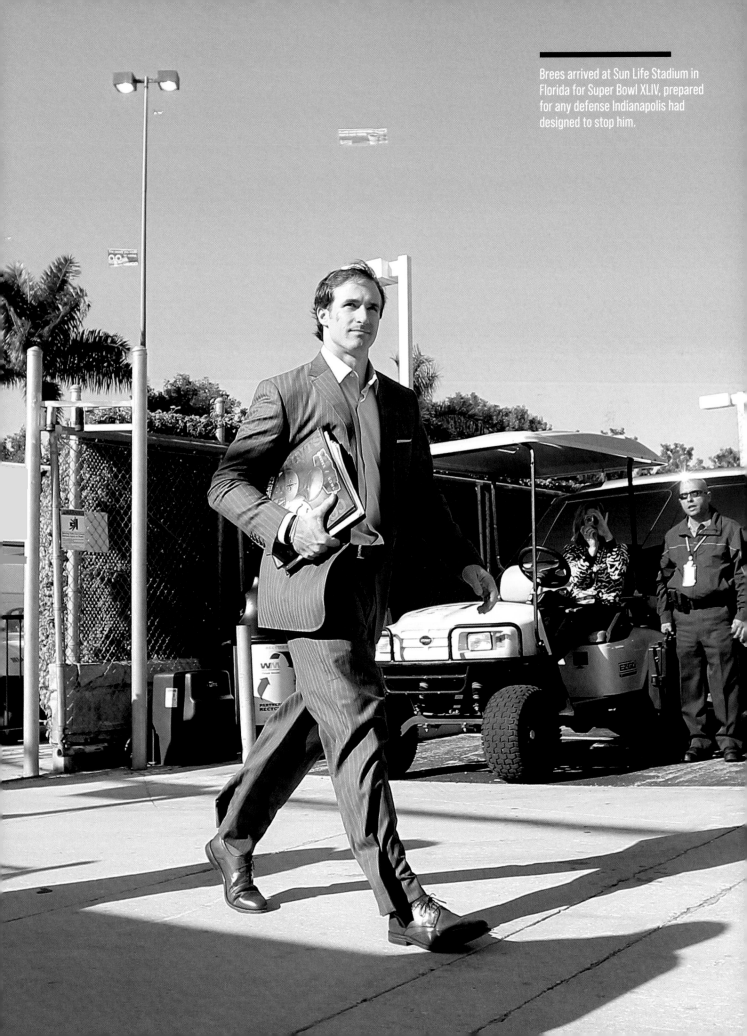

Brees arrived at Sun Life Stadium in Florida for Super Bowl XLIV, prepared for any defense Indianapolis had designed to stop him.

Excerpted from SPORTS ILLUSTRATED, February 15, 2010

Winning the Big One

After an MVP performance from Drew Brees, a daring onside kick and a pick-six by the defense, the Saints stood atop the football world, and partied

BY LEE JENKINS

At a rollicking house party in the Ninth Ward, a 24-year-old security guard named Timothy Washington danced a two-step in the living room. On the first floor of the Superdome, a 59-year-old electrician named Bruce Bruder sat in silent astonishment in a quiet control room.

At an overflowing restaurant on Bourbon Street, a 43-year-old sous-chef named Charles Emery raised a glass of champagne with his coworkers in the kitchen. And in the middle of the field at Sun Life Stadium in Miami, 31-year-old quarterback Drew Brees held one-year-old son Baylen in his arms, looked up at the night sky and felt confetti falling down on him like raindrops. Brees's wife, Brittany, wiped tears from cheeks already stained with her husband's eye black. "My only wish," she said afterward, "is that everybody from New Orleans was here with us right now."

They would have seen coach Sean Payton lifting the Lombardi Trophy to the stands behind the end zone so that fans could touch it; safety Roman Harper donning black-and-gold Mardi Gras beads as big as grapefruits; and cornerback Reggie Jones modeling boxer shorts in the locker room—"The official drawers of tonight," he called them—emblazoned with the ubiquitous WHO DAT. Players took turns shouting names of towns in the Gulf region, from big ones like Baton Rouge to tiny ones like Taylorsville, Miss. The celebration was underway in those places and in so many others, punctuating a 31–17 win over the favored Colts and a season that at times felt more like a fairy tale. "I'm going to be drunk for a month!" said linebacker Scott Fujita, proving that the Saints really do have a common bond with their bibulous fan base. "I don't know that people in New Orleans are going to go to work for a month," Brees said with a grin. "Not that I condone that."

The best victory party was in the French Quarter, where it was a veritable Fat Sunday, but

Sports Illustrated

FEBRUARY 15, 2010 SI.COM

NASCAR PREVIEW

HAMLIN TIME?
DENNY TAKES
AIM AT JIMMIE
PAGE 50

HEART AND SOUL

New Orleans Lives The Dream

By LEE JENKINS
PAGE 30

Saints QB
Drew Brees
savors the 31–17
win over the
Colts with son
Baylen and
wife Brittany

the runner-up had to be on the second floor of the InterContinental Hotel in Miami, where the Saints were greeted by a blues band when they arrived near 1 a.m. The crowd was supposed to be confined to a ballroom, but when several thousand people showed up, the party spilled out onto the breezeway and into the lobby.

After 43 years of brown bags at the Superdome and ostrich races at Tulane Stadium, of Archie Manning on his backside, Tom Benson under his parasol and Ricky Williams in his wedding veil, it happened. The parades will be marching in, and the big glass box at the Saints' Hall of Fame, which collects tissues wet with Tears of Joy, will soon be full. If there was a moment at which this beleaguered franchise crossed the threshold, it came with 10:39 left in the game, when Brees jogged onto the field trailing by a point, the best quarterback in the world fidgeting on the opposite sideline. The first time Brees gathered the Saints in a huddle, when he was a freshly minted free agent with a surgically repaired shoulder, receiver Joe Horn said the new QB let his teammates know: "I'm here to lead you to a Super Bowl, and anything else is despicable." This time he said only, "Let's be special."

The line was borrowed from New Orleans native and former NBA coach Avery Johnson, who spoke to the Saints during Brees's first training camp in the summer of 2006 at Millsaps College in Jackson, Miss., and returned again on Sunday morning to address them in a meeting room at the InterContinental. A video played that morning, highlights from the 2009 season, nifty catches and devastating hits, spliced with footage from Hurricane Katrina—homes in ruins, families crowding through the doors of the Superdome to seek shelter. "It placed us in history," said cornerback Greg Fassitt. "It gave this game a context. The room was dead quiet. You could hear people breathing hard. You could hear sniffling. Those were the only sounds." When the video ended, players started yelling as if they were ready to charge out the tunnel. "If anything," said running back Lynell Hamilton, "I was worried it would make us peak too soon."

With that one sentence—"Let's be special"— Brees brought the Saints back to that meeting room, and then took them to a place they'd never been. If it was not the best game-winning drive in Super Bowl history, it was the most democratic. Brees threw seven passes to seven receivers, completing every one of them. For the two-point conversion he threw an eighth pass, to an eighth receiver, Lance Moore, and completed that one as well. He will never have Tom Brady's height or Brett Favre's arm or Peyton Manning's pedigree, but in the four years since Brees joined the Saints, he has been more accurate than any of them. After the first quarter, when Brees's stomach finally settled, he completed an unfathomable 29 of 32 passes. He made his

> **"**
>
> With that one sentence—"Let's be special"—Brees brought the Saints back to that meeting room, and then took them to a place they'd never been.

Super Bowl debut look like a seven-on-seven drill and the Colts' defense look like a fraud. "If Drew Brees has not been in the discussion of the best quarterback in the league," said Saints tackle Jon Stinchcomb, "he is now."

Brees was the game's MVP, but with the Saints the story is never one person or one game or even one season. Said injured defensive end Charles Grant, the longest-tenured player on the team, "You have to look at how far we've come." This odyssey began 4½ years ago in San Antonio, when, in the weeks after Katrina, the Saints practiced on a high school football field, dressed in a baseball team's locker room, lifted weights under a tent in a parking lot and bused across town to the convention center to watch film. Their facility in Metairie served as local FEMA headquarters. Their stadium had a morgue in the basement. When the Saints won the first game of the 2005 season, at Carolina, the loudest *Who dat?* chant might have been inside the Reliant Center in Houston, where evacuees were watching on television.

The 2009 Saints were born in the wake of disaster, when general manager Mickey Loomis turned a last-place team into what would be a division winner in a span of four months. In January 2006 he hired Payton; in March he signed Brees; and in April he drafted running back Reggie Bush, safety Roman Harper, guard Jahri Evans and receiver Marques Colston. When Harper first drove to New Orleans from his home in Prattville, Ala., he crossed over the Twin Span Bridge and saw a wrecked Walmart, a church missing its spire and rooftops covered with blue tarps, laid out in front of him like an ocean. "This," he thought to himself, "is home."

Loomis built the league's best offense in a single spring, but it would take three years to create its complement. When defensive coordinator Gregg Williams arrived after the 2008 season, he greeted his new charges by making them all do 40 up-downs after each minicamp practice. He ordered them to pick up every incomplete pass and run it back like a fumble. He installed an 11-man blitz and called it during training camp. And when it came to voluntary workouts, Williams had an ironclad philosophy: "If you voluntarily choose not to be here, then I'll voluntarily choose to pick other people."

Williams is tough but flexible. On Oct. 25, the Saints trailed Miami 24–3 when Grant ran to the sideline and told his coordinator that the defense needed to change schemes. "Fine," Williams said. "Then do it." The players made the switch, and the Saints rallied for a 46–34 win. As Brees looked around the locker room after that game, he thought to himself, *This is the feeling we want a couple months from now, on Super Bowl Sunday.*

The term *happy to be here* has a negative undertone in sports, implying satisfaction and complacency. The Saints and their supporters were happy to be here, and it did not hurt them in the least. After the NFC championship victory over Minnesota, one fan in New Orleans brought Colston a fruit basket, another hung a sign outside center Jonathan Goodwin's house that read, THANKS FOR EVERYTHING YOU'RE DOING FOR US, and another walked up to receiver Robert Meachem on the street and started to cry.

When the Saints arrived in Florida on the Monday of Super Bowl week, Payton and his Pro Bowl players—Brees, Evans, Goodwin, Harper and Stinchcomb, plus safety Darren Sharper and linebacker Jonathan Vilma—dressed as bellhops to greet the rest of the team, a nod to the late Bill Walsh, who did the same before his 49ers won Super Bowl XVI in Pontiac, Mich. At breakfast on Tuesday, Payton asked a waiter to bring saltine crackers and two jars of peanut butter for Williams, hoping to silence the loquacious defensive coordinator who'd made headlines by promising to get some "remember-me shots" on Manning. (Williams would later be suspended from the NFL for a year for instituting a bounty program while with the

Saints.) Payton did not impose a curfew on the Saints until Friday, which was kickback compared with the buttoned-down Colts, who were under curfew starting on Tuesday. Defensive tackle Remi Ayodele cruised down South Beach wearing a hat that read WIERDOZ. Payton was confident in his weirdos, telling them in a meeting, "It's a coach's dream to be an underdog when you've got the better team."

He did not waver when the Saints fell behind 10–0 in the first quarter, or when they failed to convert a fourth-and-goal from the one-yard line in the second. Instead, down 10–6 to begin the second half, Payton became the first coach to call an onside kick before the fourth quarter in the Super Bowl. He asked his defensive players how they would feel if the play backfired and they had to protect a short field. "Coach, we've got your back," one piped up, and others nodded. Thomas Morstead's kick bounced off the face mask of Indy's Hank Baskett and into the arms of Saints backup safety Chris Reis, prompting a dog pile that lasted so long Reis said his "forearms were burning." The decision to onside kick revealed the fundamental difference between the Saints and the Colts: One team was playing it loose, the other playing it safe.

Super Bowl settings can often be sterile, no doubt due to the many corporate ticket holders, but the Saints changed that. Men showed up to Sun Life Stadium in wigs, bras and dresses in homage to the late New Orleans talk-show host Buddy Diliberto, who once pledged to wear a dress and strut down Bourbon Street if the team ever made the Bowl. For the Saints, this was a slice of the Superdome. As Manning lined up in the shotgun with 3:24 left, down 24–17, the energy in the stadium reflected the mood in the rest of the country, anything but neutral.

New Orleans cornerback Tracy Porter, positioned across from receiver Reggie Wayne, saw Austin Collie go in motion. Porter recognized from his film study what that meant: Manning was going to Wayne, and because the Saints were

bringing six and possibly seven pass-rushers, he'd have to get rid of the ball quickly. Porter remembered Williams's words—"I don't want robots; I want players who aren't afraid"—and decided to jump the route. "Everything slowed down," Porter said. "The spiral on the ball slowed down. The guys around me slowed down. The crowd noise stopped. It was just me and the football." Wayne ran a turn-in, but Porter got the better break on the ball. Manning's pass hit his hands so hard that even Saints defensive linemen heard the smack.

Porter had flown his barber to Miami, and two hours before heading to the stadium he asked for a custom trim: an image of the Superdome, the Lombardi Trophy and SB 44 carved out in tonsorial topiary. As he ran 74 yards for the clinching TD, the Saints' sideline erupted. Said cornerback Mike McKenzie, "It was crunk. It was off the chain. It was off the meter. It was off the meat rack." To the Colts the effect was the opposite: "A dagger in the heart," said linebacker Clint Session. "Peyton is always 100% in those situations. I guess it shows that no one is perfect. Even him." As Manning dressed slowly in the locker room after the game, younger brother Eli stood next to him, gently rubbing his back. They'd grown up in New Orleans, sons of a Saints legend, and used to throw balls of tape on the Superdome floor. None of that diminished the sting.

Some say there's no karma in sports, but the Saints were the team of a battered city, and the Colts were the team that stopped trying to win when they hadn't yet lost. At the end of the night Brees walked out of the stadium with a black trash bag slung over his shoulder, filled with treasures he'd collected from the day. Now Joe Lombardi, the team's quarterbacks coach, gets to touch the trophy named for his grandfather. A championship banner will be raised at the Superdome, under the spot where Katrina had torn holes in the roof. Mardi Gras may run all the way to Jazz Fest. Saints be praised. ●

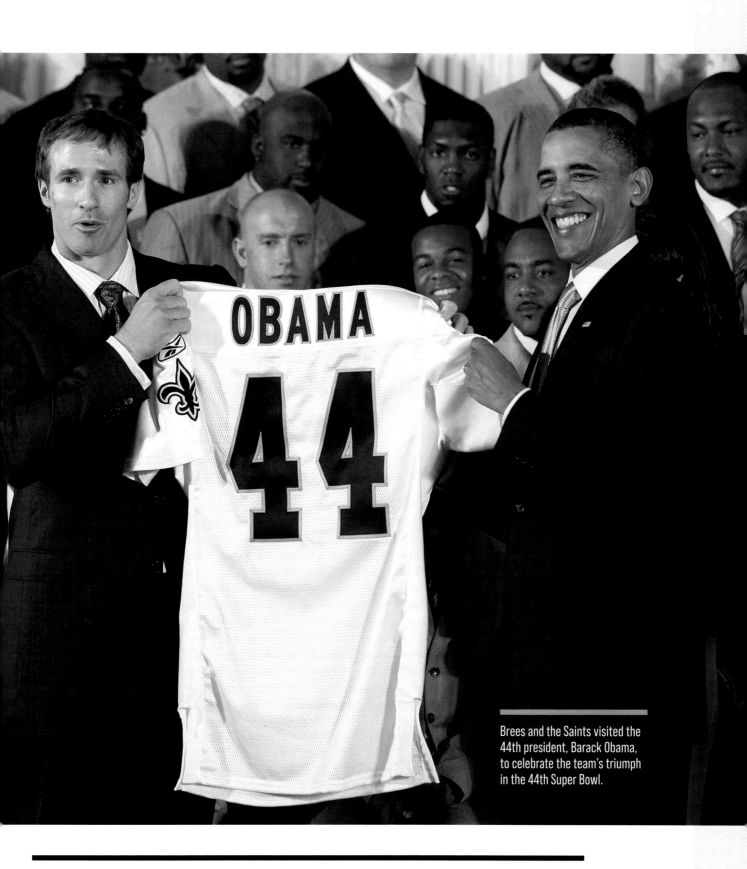

Brees and the Saints visited the 44th president, Barack Obama, to celebrate the team's triumph in the 44th Super Bowl.

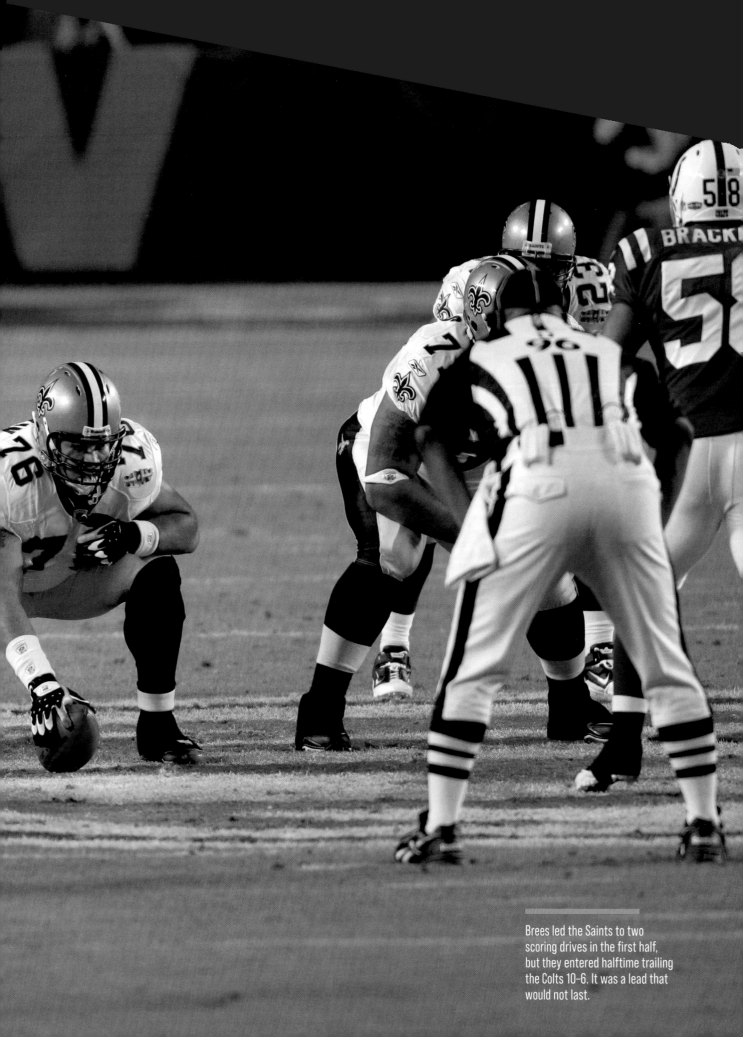

Brees led the Saints to two
scoring drives in the first half,
but they entered halftime trailing
the Colts 10–6. It was a lead that
would not last.

Brees's pinpoint accuracy on the big stage helped put an end to four decades of football frustration in New Orleans.

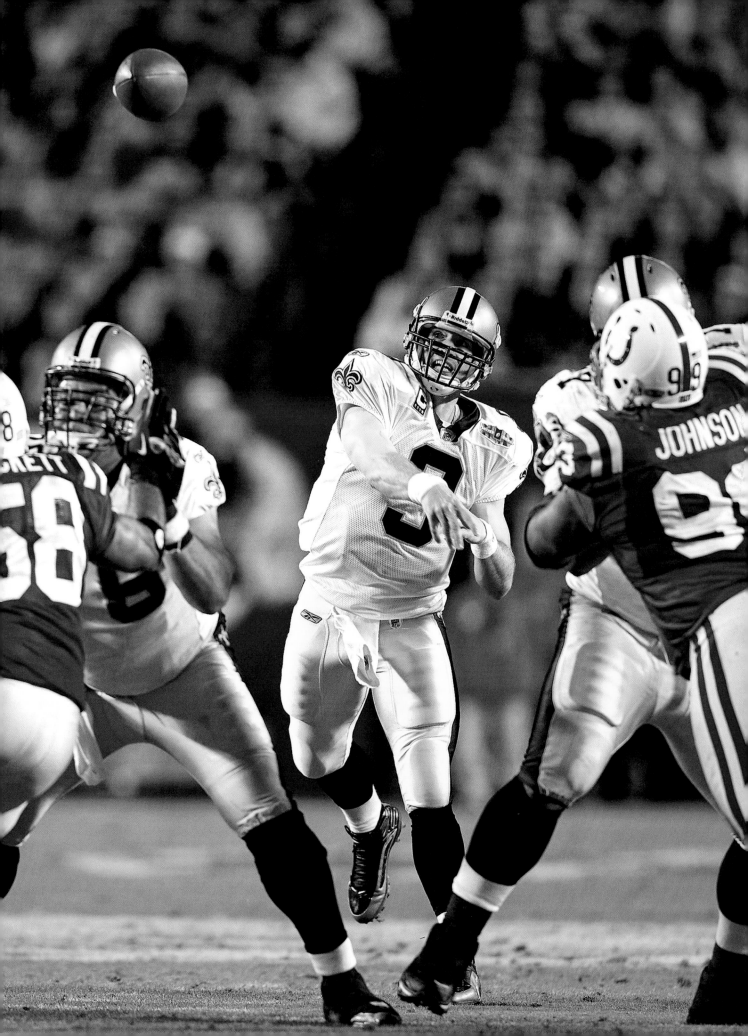

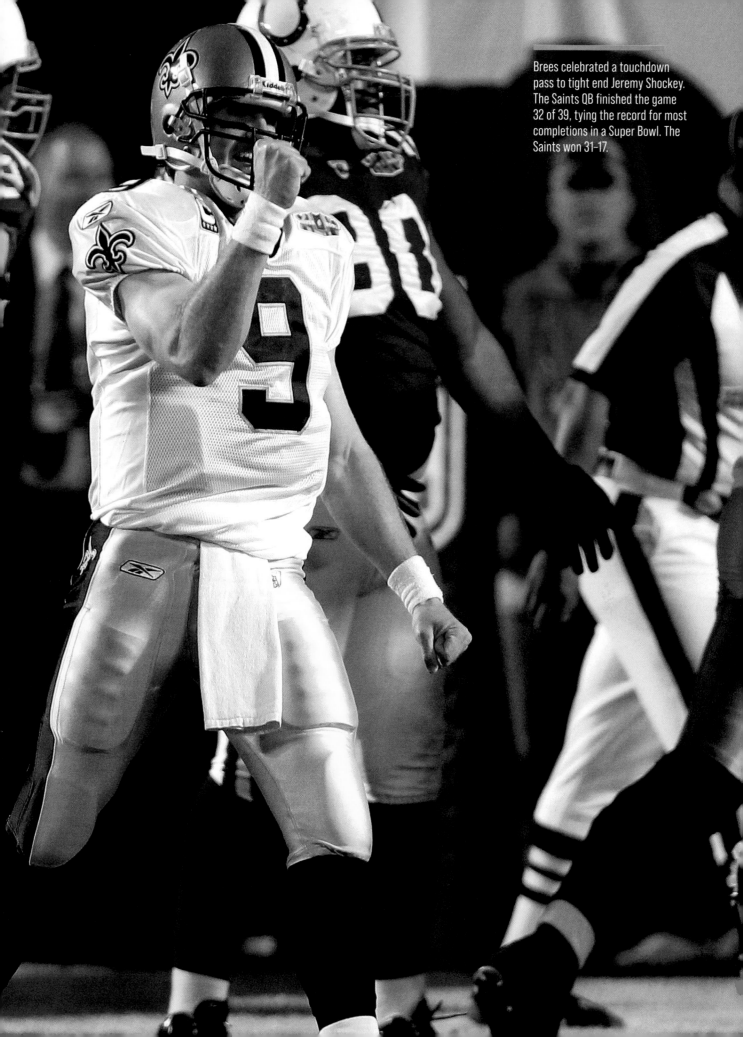

Brees celebrated a touchdown pass to tight end Jeremy Shockey. The Saints QB finished the game 32 of 39, tying the record for most completions in a Super Bowl. The Saints won 31-17.

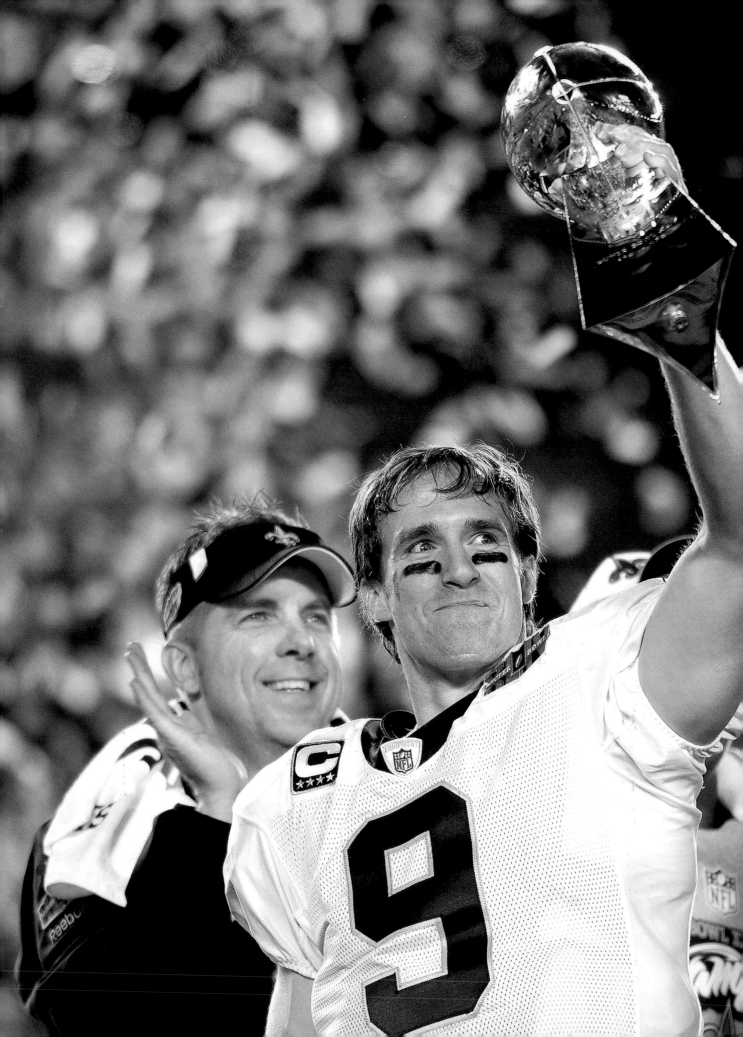

Brees, named the MVP of Super Bowl XLIV, hoists the Vince Lombardi Trophy.

Once questioned for his size and
lack of athleticism, Brees had finally
proved the doubters wrong.

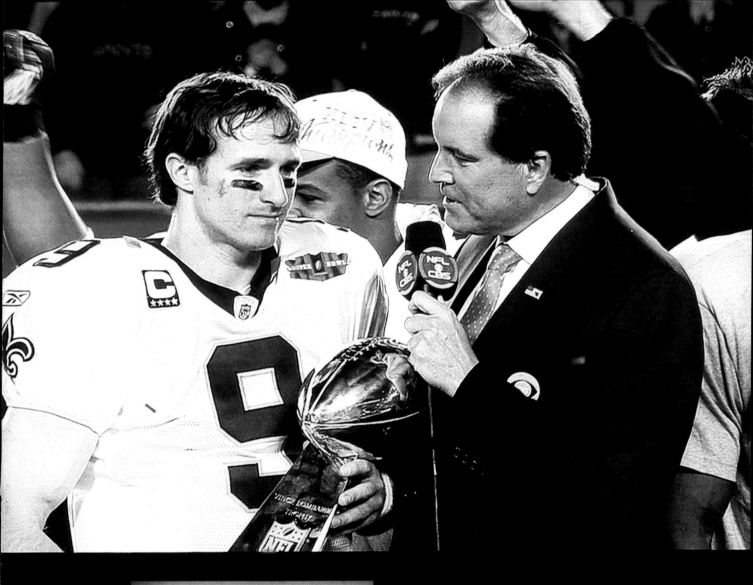

A victorious Brees shared the moment with son Baylen.

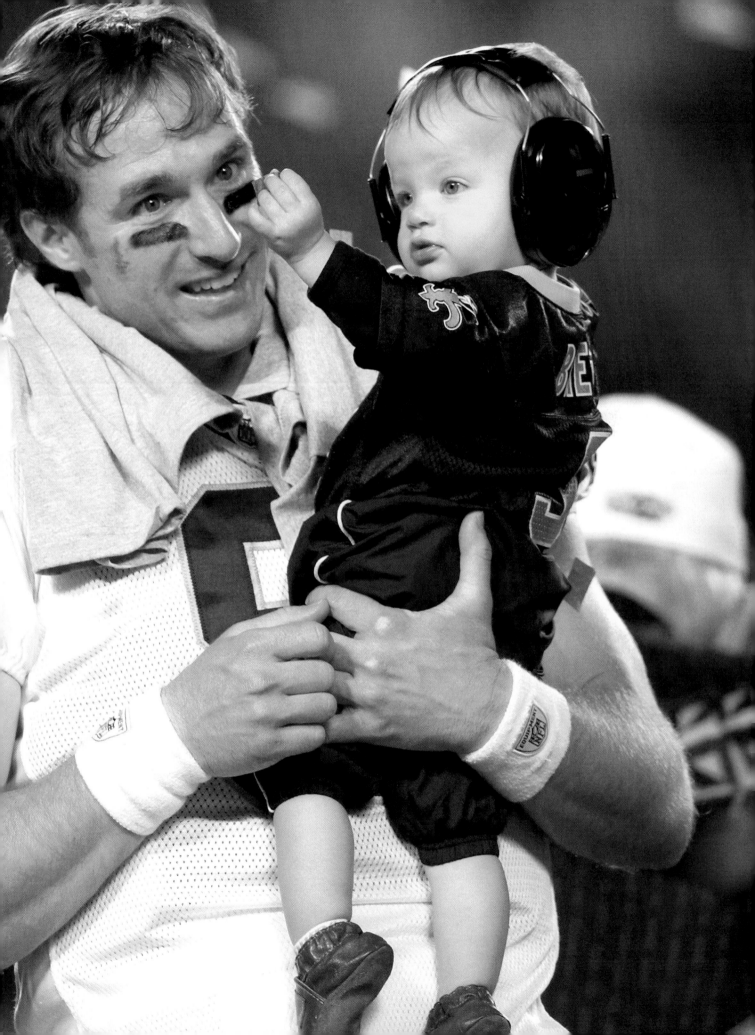

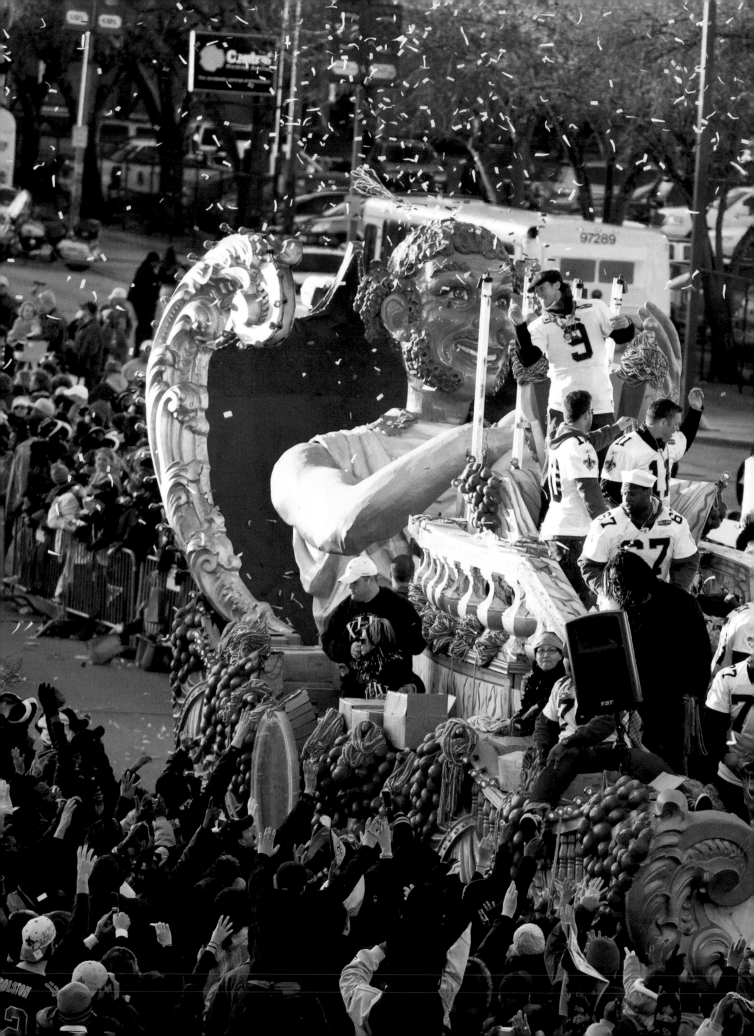

Two days after Super Bowl XLIV, Brees and teammates celebrated during a parade back in New Orleans.

LEAVING A LEGACY

Brees prepared to take the field against
the Giants at MetLife Stadium in 2018.

Brees was asked to announce the Saints' selection during the 2010 NFL draft at Radio City Music Hall in New York City.

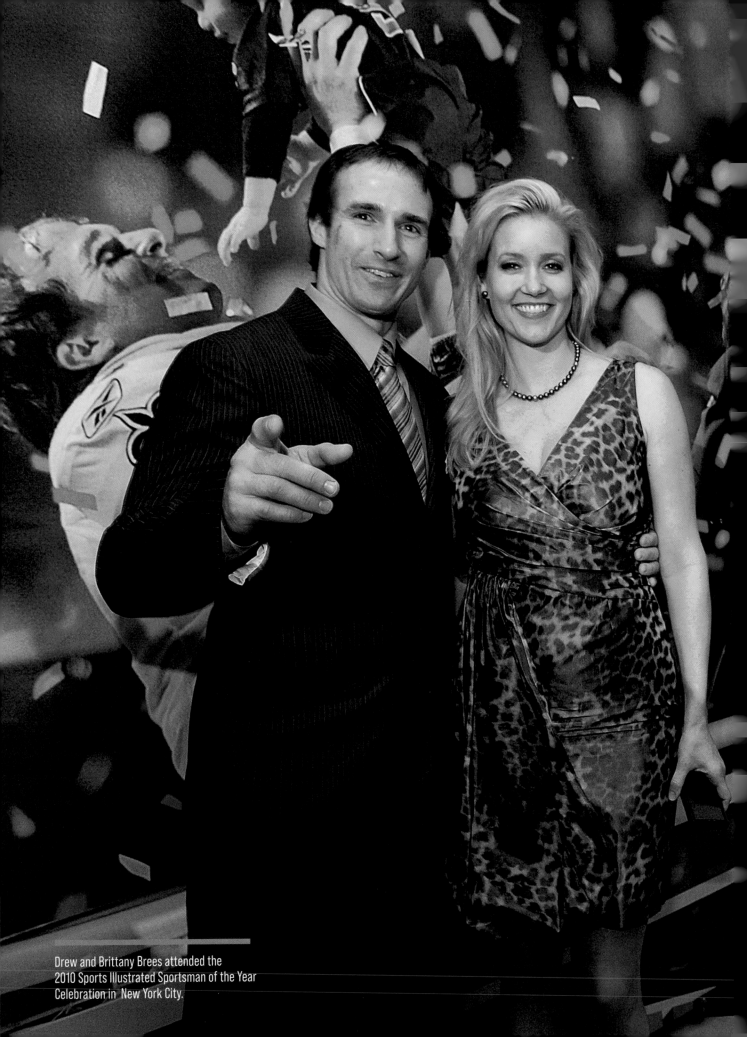

Drew and Brittany Brees attended the
2010 Sports Illustrated Sportsman of the Year
Celebration in New York City.

Excerpted from Sports Illustrated, December 6, 2010

A Man at His Best

For leading the Saints to a Super Bowl and being a force in the rebuilding of New Orleans, Sports Illustrated named Drew Brees its 2010 Sportsman of the Year

BY TIM LAYDEN

The little hired bus rumbles north across Lake Pontchartrain on the longest bridge in the U.S., 24 miles of roadway sucked up underneath the front of the vehicle and spit out the back in a monotonous soundtrack of tires against expansion joints. *Thumpthumpthumpthumpthump.* New Orleans fading in the distance, northern suburbs ahead on the far shore, water everywhere else. Drew Brees, quarterback of the Super Bowl champion Saints, sits idly in a hard seat.

When he came to Louisiana five years ago, so much of this was foreign. Now it is deeply familiar. "New Orleans surprised me so much," says Brees. "People told me it was like the Vegas of the South. That's so wrong. This place is in people's blood, and they want you to feel that, too." It is the Thursday morning of the Saints' bye week, and players have scattered in a precious escape from the routine and the violence. Brees remains behind for two extra days because there is more to his work than throwing touchdown passes.

Here the bus comes to a stop in front of Magnolia Trace Elementary School, in Mandeville, where Brees will speak to the students as part of an NFL-sponsored community program. Shrieks of joy rise from the sidewalk, where excited children and swooning teachers have gathered to greet their celebrity guest. Brees bounces out of his seat, pulls a black No. 9 game jersey over his head and steams toward the front of the bus, clenching both fists. "The kids are pumped!" he shouts. He signs a collection of memorabilia in the principal's office

Sportsman of the Year

Sports Illustrated

SI.COM

DOUBLE ISSUE DECEMBER 6, 2010

DREW BREES

LEADER OF THE SAINTS, INSPIRATION TO HIS CITY

By Tim Layden

and then hustles down the pristine hallways of the school. Cafeteria worker Julia Collins of nearby Lacombe sticks her hand in Brees's path; he slaps it emphatically, and Collins runs back to work, squealing. Teacher Laura Cangiamilla, seven months pregnant, poses for a photo with Brees. "This is Baby Drew," she says, pointing to the belly stretching her Saints jersey.

Now Brees stands on a stage in the school's gymnasium, and more than 400 students are spread across the tiled floor. He leads them in the Saints' traditional cheer. "Every time I say, 'One, two, three,' you say, 'Who Dat!'" implores Brees. He shouts it half a dozen times or more, cupping his hand next to his ear, and the response is ever louder. Then he asks for quiet, pressing his palms downward against air as if trying to suppress the noise with his hands. There are questions from the kids. What is the greatest challenge of your career? Is it easy to work as a team? Did you do a dance in the locker room after the Super Bowl? This one Brees turns back on the students. "Everybody who thinks they can dance," he shouts, "stand up and give me your best Super Bowl touchdown dance!" Instantly the floor is a beehive of jumping, gyrating, spinning kids, filling the air with celebratory screams. Brees watches like a proud father, or a mischievous coconspirator.

Then there is another question. A little girl stands and reads nervously from a slip of yellow paper while a teacher holds the microphone. "What is your empowering word?" she asks, then timidly casts her eyes to the floor.

On the stage Brees raises a microphone to his mouth. Not laughing now. "My empowering word," he says, "is *faith*."

It is a word that in modern times can polarize—or politicize—an audience, ingratiating some listeners and repelling others. (Not this audience, the adult portion of which gasps in approval.) It's a word that the children have been taught but can't yet fully understand. For Brees the word is more than religion and spirituality,

although it has been both of those, increasingly, through the years. Faith is more than Brees's empowering word. It is the central force in his life, slicing across family, football and community, carrying him to the top of his profession and to an iconic status in a still-wounded city that he has helped lift from despair.

When Brees blew out a knee in 11th grade and college recruiters largely abandoned him, it took faith to believe he would someday play college football. When the entire NFL passed on him in the first round of the 2001 draft, when the Chargers benched him four times and then brought in a young quarterback to replace him, when he tore up his shoulder in December '05, it took faith to believe he would be a star in pro football and lead a team to a Lombardi Trophy. When only New Orleans—the doormat franchise and the ravaged city—believed in him, he believed in New Orleans. When his estranged mother ended her life in the summer of 2009, it took faith for Brees to embrace and understand the complicated and sometimes fleeting power of a family's love. When he rises every weekday at 5:15 a.m., it takes faith to look a cynical public in the eye and nakedly embrace the earnest values of fidelity, fatherhood, service, selflessness and sportsmanship, knowing that the slightest error in behavior will bring a furious blowback.

Yet is faith not also the essence of sport? A fan's unwavering faith in the home team. A player's faith in the workaday value of practice done hard and right to extract the most from their physical gifts. A team's faith that its members can do more together than each could do alone. On the night of Feb. 7, 2010, Drew Brees led the Saints to the first Super Bowl championship in the franchise's star-crossed history, a 31–17 victory over the Colts in Miami. He completed 32 of 39 passes for 228 yards and two touchdowns, did not throw an interception and was named the game's most valuable player. For Brees it was the culmination of a four-year climb to a place among the best quarterbacks in football,

and for the Saints the crowning moment in a 44-year romance with their home. For that city, nearly lost to a terrible storm, it was a critical step on a very long and ongoing path to recovery. "I needed New Orleans just as much as New Orleans needed me," says Brees. "People in New Orleans needed somebody to care about them. And it was the one place that cared about me."

And cares deeply still, every day. "People come up to Drew and don't say, 'Congratulations,'" says Saints veteran tackle Jon Stinchcomb. "They say, 'Thank you. Thank you for coming here.'"

When the Super Bowl was finished late on that Sunday night, Brees grabbed his one-year-old son, Baylen, and hoisted him skyward into the shower of confetti. The little boy's head was framed by oversize headphones to protect his eardrums from the noise. (He wears them for every game he attends.) Nearby stood Brees's wife, Brittany, unknowingly pregnant with their second child, another boy, Bowen, who would be born in October. And here were a city, a team and a man all reborn, new life reflected in the innocent eyes of a child.

It is for his vital role in that rebirth, for his willingness to immerse himself in New Orleans's recovery while relentlessly pursuing his own, that Drew Brees is SPORTS ILLUSTRATED's 2010 Sportsman of the Year. It is the 57th such honor the magazine has bestowed since its founding in 1954, and in the truest spirit of the award his influence reaches far beyond the walls of the stadium.

It is not a good time to be anyone's hero. Not with the gaping maw of endless news cycles, cellphone camera photos, social media and gotcha blogs. Brees is acutely aware of this reality but unafraid. "People are waiting, if not to catch you doing something bad," he says, "then to catch you doing something that can be twisted into something that looks bad. But I'm aware of my position. Kids hang on your every word and action. You have an influence on their lives. And

I believe this is who I am. It comes pretty naturally to me. I mean, I don't avoid using drugs because kids are watching me; I avoid doing drugs because it's not a good idea to use drugs." In Brees's best-selling memoir, *Coming Back Stronger*, published last July, he wrote of his marriage to Brittany Dudchenko, whom he met in 1999 when both were students at Purdue, " . . . when I put the ring on Brittany's finger, I said, 'For better or for worse, till death do us part.' Period. No matter how bad it could possibly get, I am committed. It's not about happiness. It's not about a feeling. I committed myself to her for the rest of my life, and I promise never to walk away."

Maybe the idolization of athletes has always been a lousy idea, but the concept will not be dying soon or easily. It is very much alive in New Orleans on Halloween, when the Saints will play the Steelers in a Sunday-night game at the Superdome. By mid-afternoon the streets are bustling with costumed revelers—vampires, superheroes and villains, political figures, Troy Polamalu. But the most ubiquitous costume, by far, is a No. 9 football jersey. There are slender women wearing No. 9 in tight-fitting pink and gigantic men wearing No. 9 in the size of parachutes. There are little children in snuggly No. 9s. There is retro No. 9, Pro Bowl No. 9 and camouflage No. 9. There is a cluster of young women with matching T-shirts that say KREWE DU DREW on the back, above a little gold, sequined No. 9.

Part of this is organic: Fans wear jerseys to football games, and a lot of them wear the star quarterback's jersey. And while any city with an NFL franchise claims some degree of connection to the team that plays there on Sundays, there is a special bond between the Saints and New Orleans that predates Super Bowl victories and devastating storms. It goes back to the early days of the franchise, born in the fall of 1967, when veteran players like Billy Kilmer and Doug Atkins would stumble down the beer-and-bourbon-soaked streets and share with the townsfolk

in the futility that comes from playing the first 20 years of existence without a winning season. Plus it is Halloween. Yet none of this fully explains the No. 9 revolution in the city on game day. Says NFL commissioner Roger Goodell, "It's hard to point to a relationship in our league, between a player and a city, that's more meaningful than the Saints and Drew Brees."

New Orleans proper is nearly 70% Black, and, says Ronald Markham, the African American CEO of the New Orleans Jazz Orchestra, "It is a city with many schisms." Yet Black fans wear No. 9, too. "I'll say this: Drew is definitely an honorary brother," says Troy Henry, a Black businessman who finished second to Mitch Landrieu in the mayoral race just before Super Bowl XLIV. "He transcends race, and he does it with class and dignity."

Solid quarterbacking alone might have been enough to deify Brees in New Orleans, so beaten was the city after Katrina and so in need of a rallying force. But it is Brees who has earned the lasting trust and love of New Orleanians.

In the eight years since the Brees Dream Foundation was established to support cancer research and the care and education of children in need, it has contributed or committed more than $6 million in Louisiana, San Diego and West Lafayette, Ind., home of Purdue. The foundation is in the final stages of completing $1 million in funding for the American Cancer Society's Patrick F. Taylor Hope Lodge in New Orleans, a residential facility for patients undergoing chemotherapy, and $100,000 for completion of G.W. Carver High's Field of Dreams in the Ninth Ward.

In total the foundation has worked with nearly 50 New Orleans schools and organizations, providing $300,000 to New Orleans Outreach for after-school assistance; $127,550 to the New Orleans Recreation Department to help with initial costs in the restoration of Pontchartrain Park; $78,000 to Best Buddies Louisiana, which facilitates one-to-one friendships for adults with intellectual disabilities; and $74,000 to the Greater New Orleans Rebuild Child Care Collaborative, to restore child-care facilities lost to Katrina. "A lot of people have a foundation just to have a foundation," says Mark Brunell, an NFL warhorse who was Brees's backup in 2008 and '09. "Drew has a foundation that does all kinds of things. The guy cares. He's genuine."

That infectious sincerity is why LaDainian Tomlinson found himself uncommonly engaged while watching Super Bowl XLIV on TV. The future Hall of Fame running back met Brees in 1997 when they played together on a high school all-star team in Texas—Brees from Austin, Tomlinson from Waco. "The guy's work ethic stood out from the jump," says Tomlinson. "He was smart. He was a leader. You could just see he was going to be special." In April 2001 the Chargers took Tomlinson with the fifth selection in the draft and chose Brees 27 spots later. The two played together for five seasons; when Brees needed a throwing partner on an offseason afternoon, it was often Tomlinson he'd call. So on that February night in Miami, when Brees took a knee to finish the Super Bowl, Tomlinson felt a deep kinship. "I was screaming," he says. "It's like I was right there with him. I called him and told him, 'I'm proud of you, man.'"

That sincerity is also why Billy Miller, who played tight end for four years in New Orleans with Brees, and Miller's wife, Rachael, rewrote their will. If the couple were to die or otherwise be incapacitated, the care of their children—sons Caine and Jaden, and daughter Celeste—would be entrusted to Drew and Brittany Brees. "There is nobody in the world we trust more," says Billy, who now operates the Elite Performance Factory, a gym in Southern California. "Our values line up perfectly."

Miller came to know Brees best not in the locker room or on the field but during USO trips the two have taken together. Brees, in the last five

years, has been on five such trips that were sponsored by the NFL. He visited troops in such locations as Afghanistan, Dubai, Guantanamo Bay, Iraq, Kuwait and Japan. His admiration for the military springs from his relationship with his 85-year-old grandfather, Ray Akins, a legendary Texas high school football coach who fought in Okinawa in World War II and still works 100 head of cattle on a ranch in New Baden, Texas. But Brees's appreciation for soldiers goes beyond his family's legacy. "Think of the sacrifices they make," says Brees. "I'm away from my son for a day, and I can't wait to see him. Some of those guys are gone for 15 months."

Brees has also flown in fighter jets a handful of times, once pulling 9.2 G's in an Air Force F-16 with the Thunderbirds. "It gives those guys a chance to promote what they do," Brees says of the rides, "and they appreciate that you're interested." It's also yet another chance to compete. On a tour of Iraq in 2008, Goodell, Brees and Giants defensive end Osi Umenyiora were roommates in Saddam Hussein's former guest palace, where the commissioner got a sense of Brees's fire. So when Goodell flew with the Thunderbirds during Super Bowl week in 2009, he pointedly told his pilot, "I've got to do 9 G's, and I can't pass out or throw up, or Drew Brees will never let me hear the end of it." (Goodell made it through fine.)

Coach Sean Payton leans forward in his chair, looking at the huge flat-screen wall monitor he uses to watch game tape in his office. "I want to show you something," says Payton. "This is amazing. Watch." He cues up the Saints' 34–3 victory over the Panthers on Nov. 7 and moves ahead to a second-and-five for the Saints from the Carolina 19-yard line with just under three minutes to play in the first half. Brees will take a snap, feign a handoff to running back Julius Jones, turn and roll on a bootleg to his right and then make a series of reads before choosing a target and throwing. Three receivers—Robert Meachem, David Thomas and Heath Evans—are "bunched" at the right side of the formation; rookie tight end Jimmy Graham is alone outside on the left.

At the snap the Panthers blitz three men from the right side of the offense and none is effectively blocked, bringing immediate heat on Brees. After Brees fakes to Jones—"With his back to the blitz," says Payton, no small detail—he turns and shuffles right, looking at Meachem, Thomas and Evans. Abruptly Brees switches direction, backpedaling parallel to the line of scrimmage. He plants his right foot, swivels his head to the left and throws across the field to Graham for a touchdown. "You know how people say a quarterback reads

"

Says NFL commissioner Roger Goodell, "It's hard to point to a relationship in our league, between a player and a city, that's more meaningful than the Saints and Drew Brees."

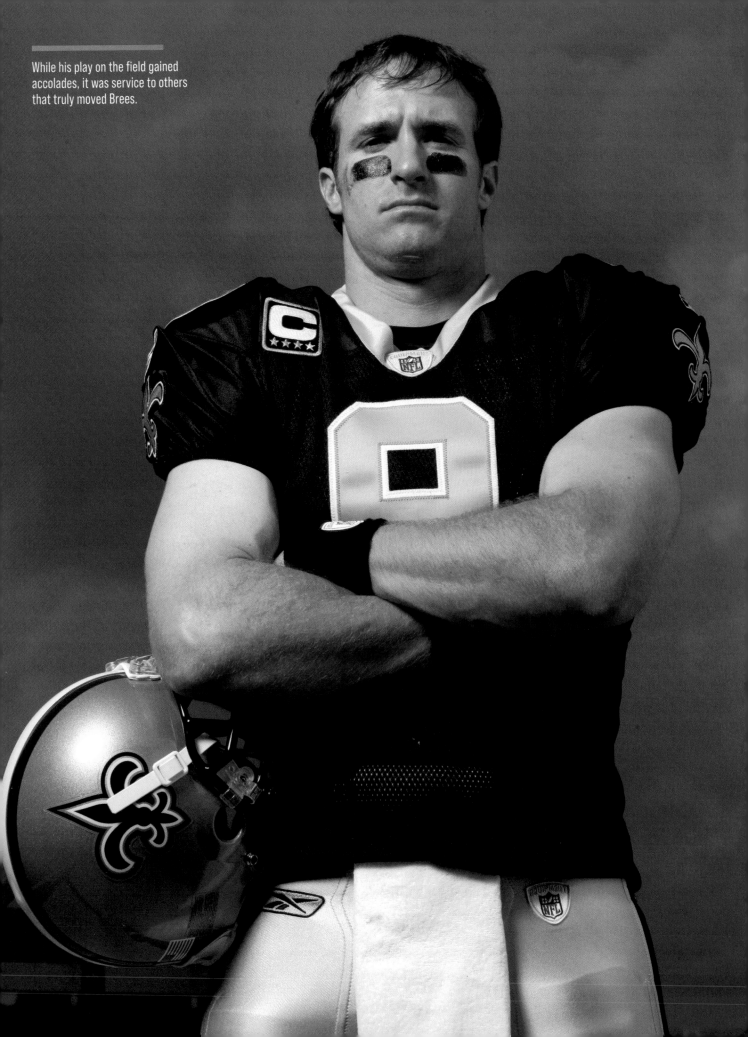

While his play on the field gained accolades, it was service to others that truly moved Brees.

A, B, C, D?" says Payton. "That was, like, G. Or H. It blew my mind."

What Brees saw, even before the snap, was that the 6'6" Graham was going to be single-covered by Richard Marshall, a 5'11" cornerback. Brees was still willing to throw outside to Meachem, except that as soon as Brees snapped his head around from the run fake he saw that the front-side corner was jumping Meachem and that three pass rushers were coming free. "He processed all that in about two seconds," says Payton. "A lot of quarterbacks would have thrown an incompletion toward Meachem or thrown a pick."

It was just one play, but one play can reveal a man. "Follow him around for a day," says Payton. "You'll just go, 'Wow.'" Last July, on the morning after winning four ESPY Awards in Los Angeles and attending parties afterward, Brees met Todd Durkin for a 7 a.m. workout at USC. "We could have done it at 9 or 10, or we could have waited until later in the day back in San Diego," says Durkin, "but Drew wants an edge. 'I'm doing it and they're not.'"

It's Brees who formulates the Saints' raucous pregame chants and leads them like a middle linebacker. It's Brees who stays after practice every day, grooming the Saints' receiving corps, building the communal faith that makes a modern passing offense work.

In the fall of '06 Payton left his office shortly after noon on the bye-week Sunday, and, as he climbed into his car, he noticed a solitary figure on the practice field in gray shorts and a gray practice T-shirt. It was Brees, dropping back, throwing on air, jogging up the field to the next imaginary line of scrimmage and throwing again.

"What are you doing?" said Payton, incredulous.

"We usually play on Sunday, so I don't want to mess up the routine," said Brees.

"Are we winning or losing?" Payton asked.

"We're winning," said Brees.

Last February in the biggest game of his life, Brees outplayed his surefire Hall of Fame counterpart, the Colts' Peyton Manning. Brees's 82% completion rate was the second best in Super Bowl history. With the game on the line it was Manning, not Brees, who threw a killing pick. And long after the end, Brees rode Saints bus No. 1 back to the team hotel, sitting up front with Payton and assistant coaches Joe Vitt, Greg McMahon, Pete Carmichael and Joe Lombardi, whose grandfather's name was etched into the sterling silver trophy they passed around. "What a special moment," says Brees. "I wished it would never end."

It is clearly victory that drives Brees, and service that moves him. He is a richly compensated professional with more than 20 sponsorship deals beyond his football contract. Yet it is family that fulfills him. Late on a bye-week afternoon he rushed to Danneel Park, a half mile from the Breeses' Uptown home. The new playground at the west end of the park was alive with small children— climbing, running, falling and rising again to play more in that indomitable way that only children can. It was a spectacular autumn day in the city, warm without humidity, windless and clear. Brees walked to where Brittany stood over three-week-old Bowen's stroller. The little guy was blissfully asleep. Brees kissed his wife and then darted off to find Baylen; soon the Saints' franchise quarterback was climbing up the side of a playscape, the biggest kid in the park. "Oh, no," said Brittany. "Drew is going to hurt himself. We better walk over there. I don't want to make that call to Sean Payton."

Now the quarterback is standing next to a dusty circle in the park, where two little girls slap at a yellow tetherball. Brees is holding Bowen in his arms; the little boy's brown fleece sleeper with bear ears is unzipped in the warm air. The sun is falling and casting long autumn shadows across the earth. The Saints are winning, the city is alive, the family grows. The father drops his head, closes his eyes and softly kisses the son on the forehead. Everything is sweet. Everything is right. ●

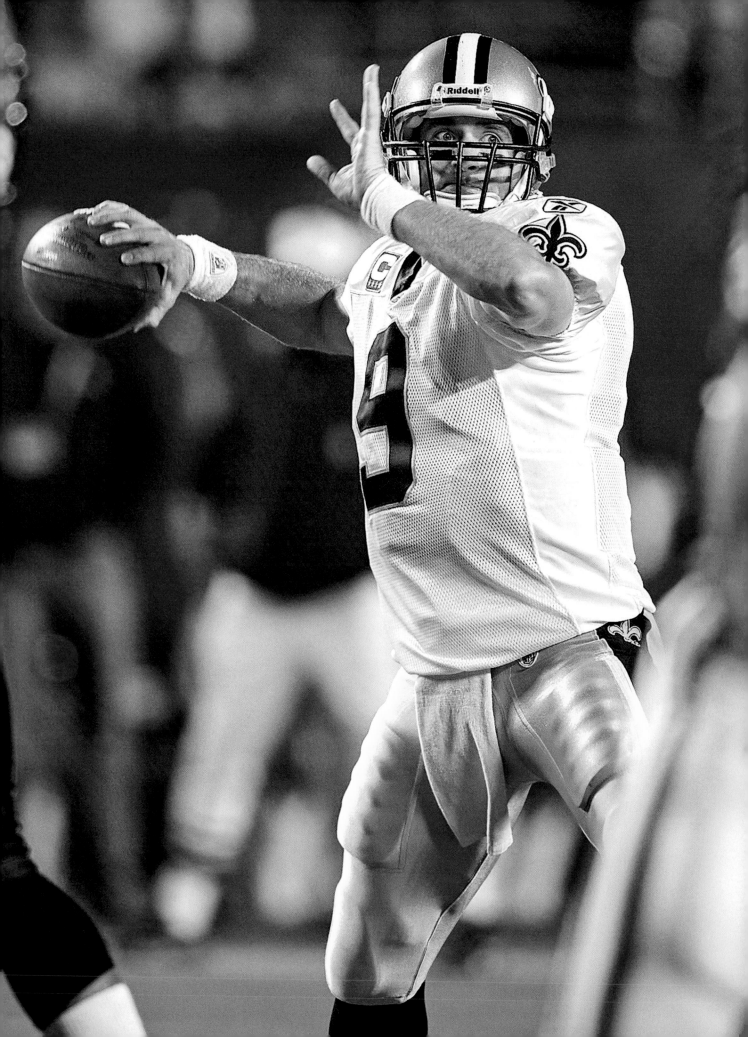

The skills that Brees developed at Purdue and in San Diego culminated in his MVP performance in the Saints' win over the Colts in Super Bowl XLIV.

Brees was an effective
leader both on the football
field and in his community.

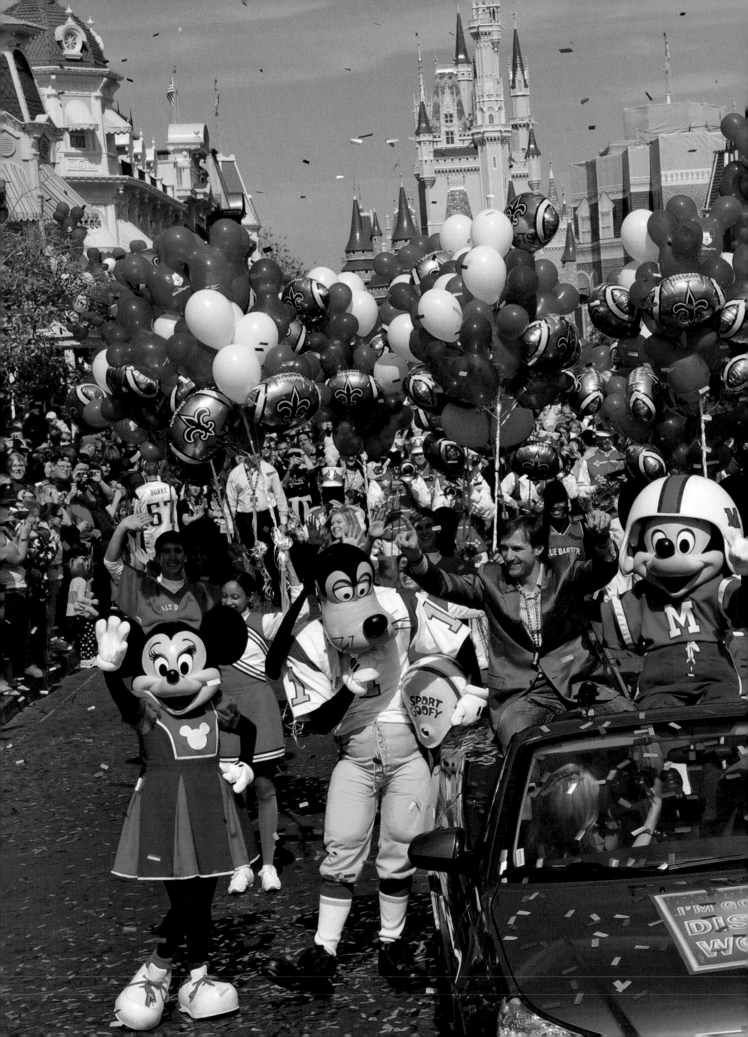

Brees visited Disney World after the Super Bowl in 2010.

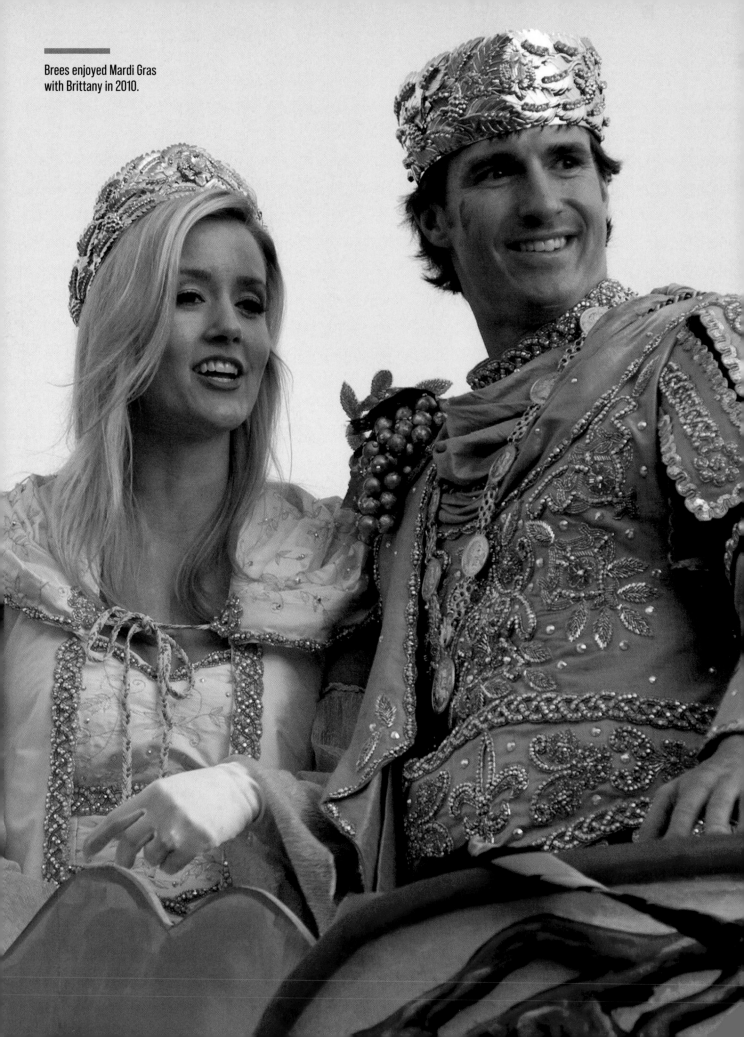

Brees enjoyed Mardi Gras
with Brittany in 2010.

Brees worked on a Habitat for Humanity house in '07 and rallied for oil-spill-affected fishermen in '10.

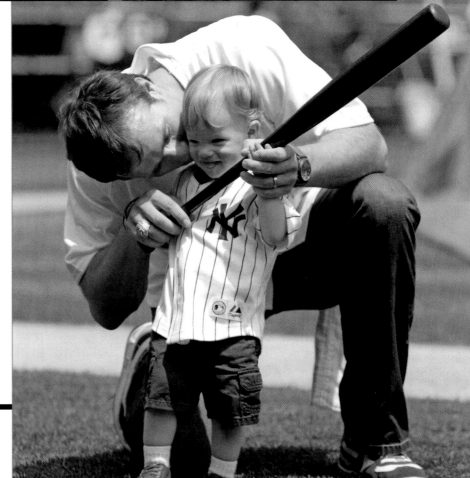

In 2010 Brees spent Father's Day at Yankee Stadium with son Baylen.

Brees took a break from the football field to participate in the AT&T Pebble Beach National Pro-Am in 2011.

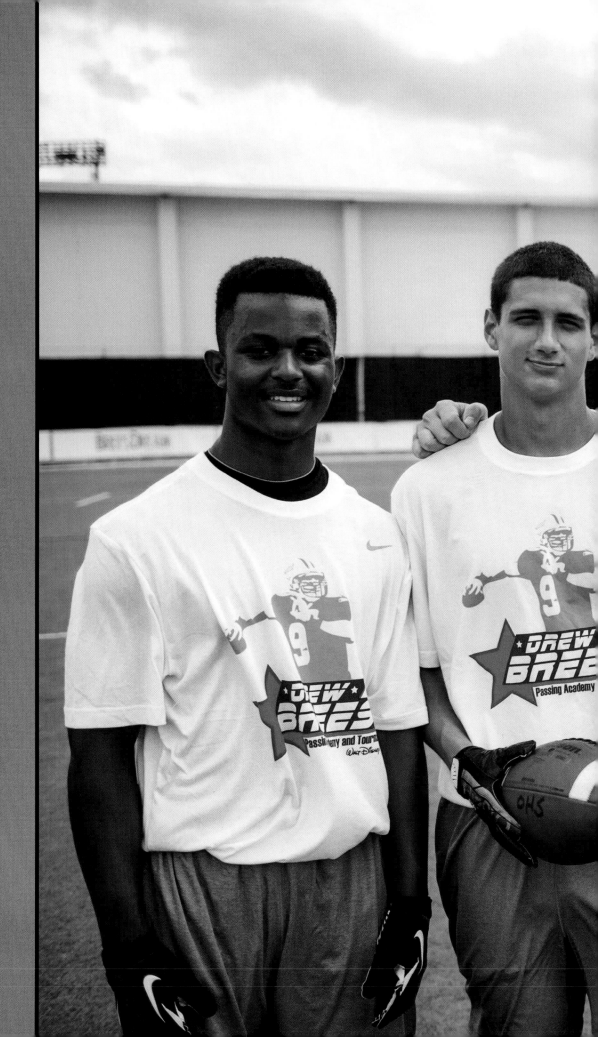

Brees posed with high school players from Florida at his Drew Brees Passing Academy in 2013. Proceeds from the academy benefited the Brees Dream Foundation, established to help improve the quality of life for cancer patients and provide care, education and opportunities for children and families in need.

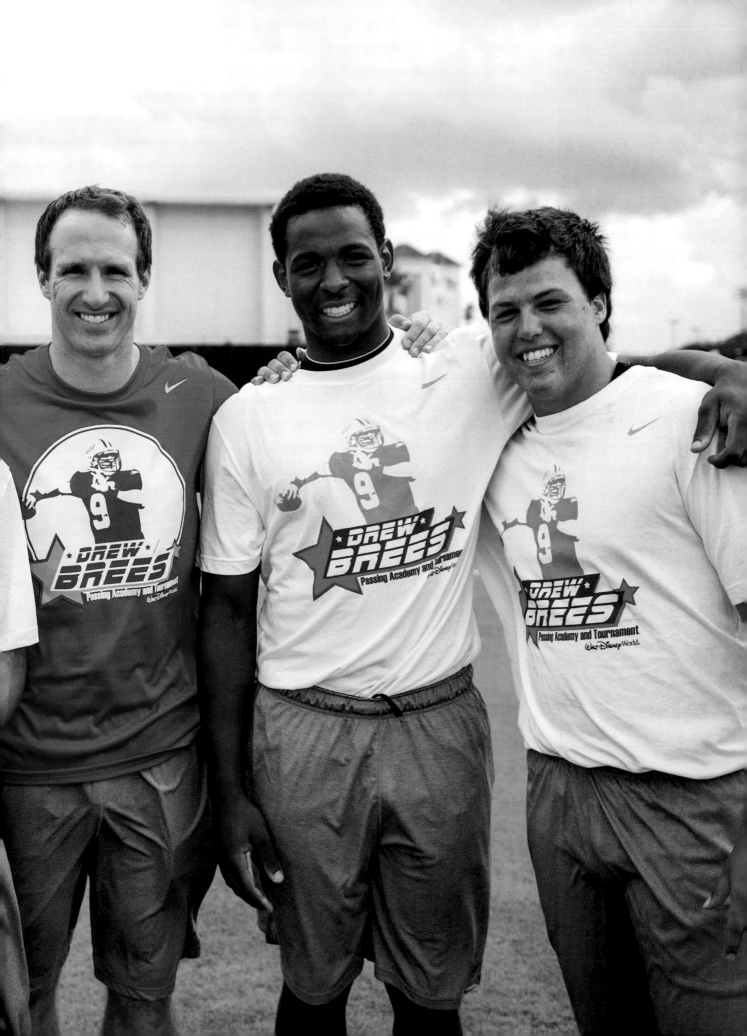

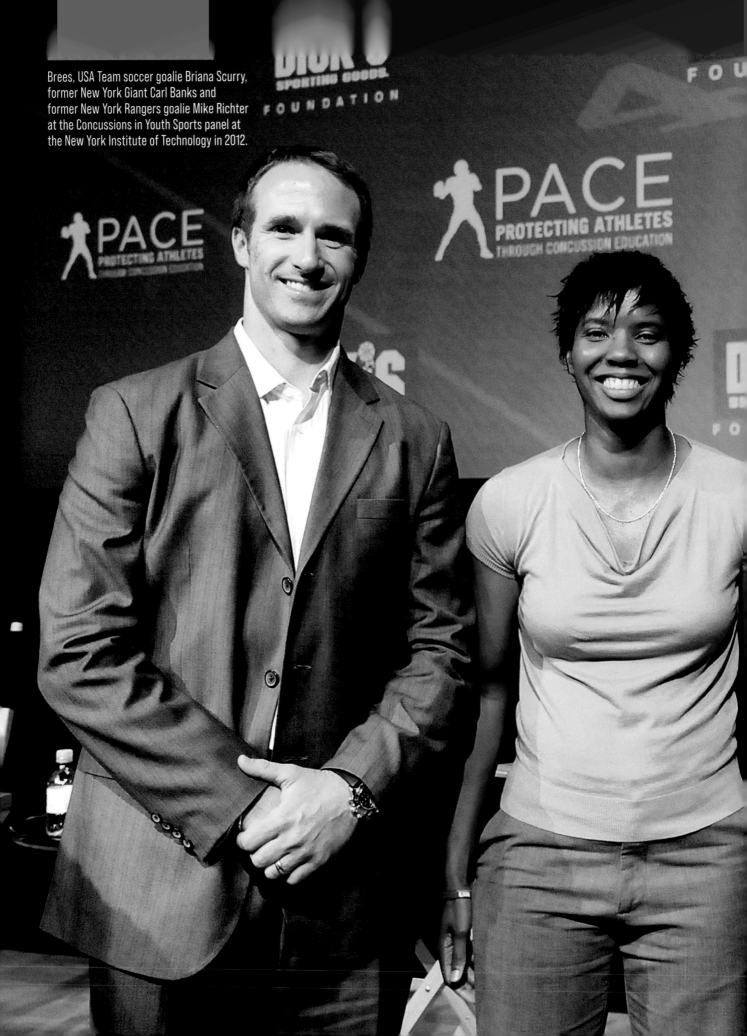

Brees, USA Team soccer goalie Briana Scurry, former New York Giant Carl Banks and former New York Rangers goalie Mike Richter at the Concussions in Youth Sports panel at the New York Institute of Technology in 2012.

Brees swapped a football
helmet for a baseball
bat during the MLB 2016
All-Star Legends and
Celebrity Softball Game in
San Diego.

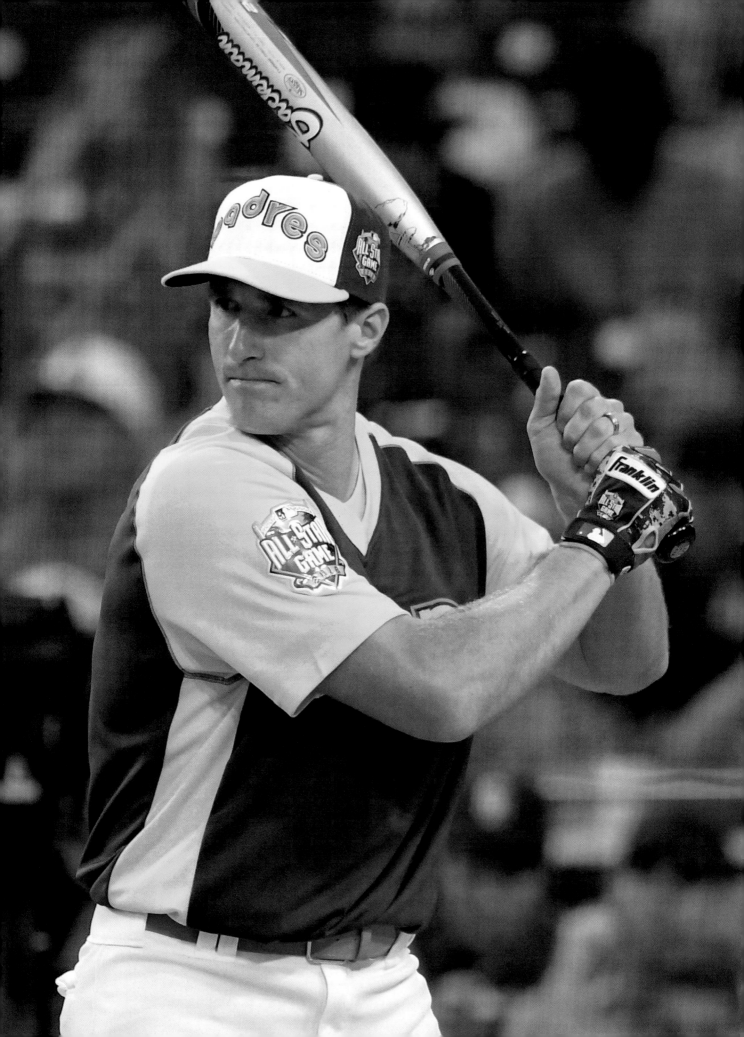

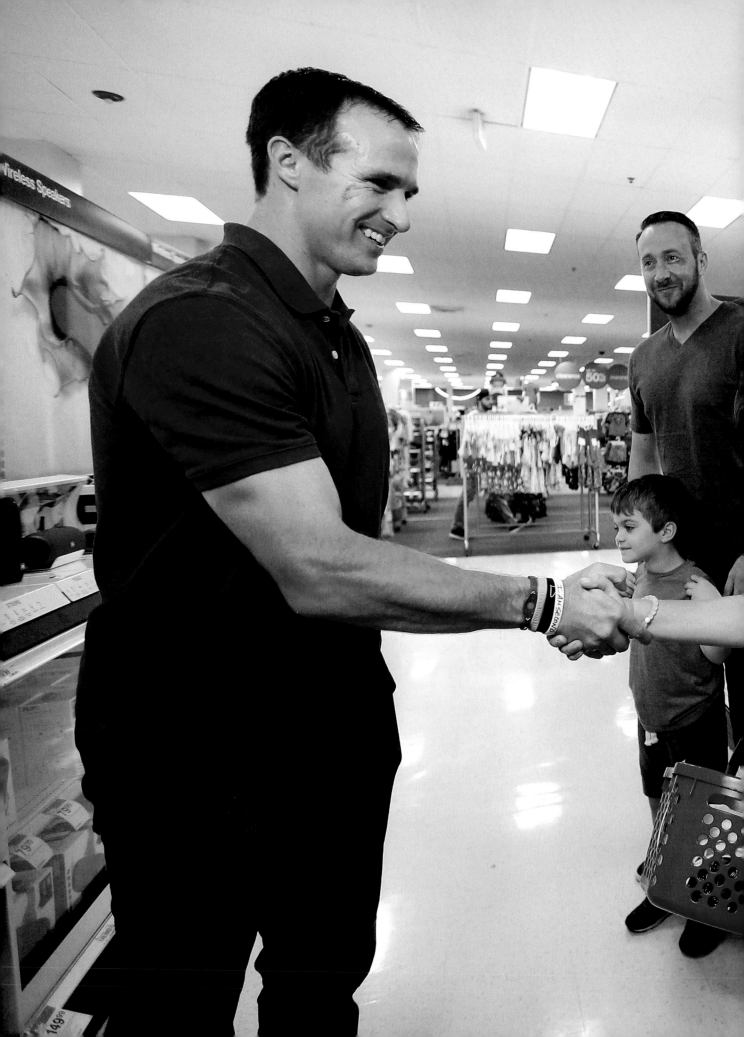

Brees surprised Target shoppers and helped them find Father's Day gifts in 2016 in Metairie, La.

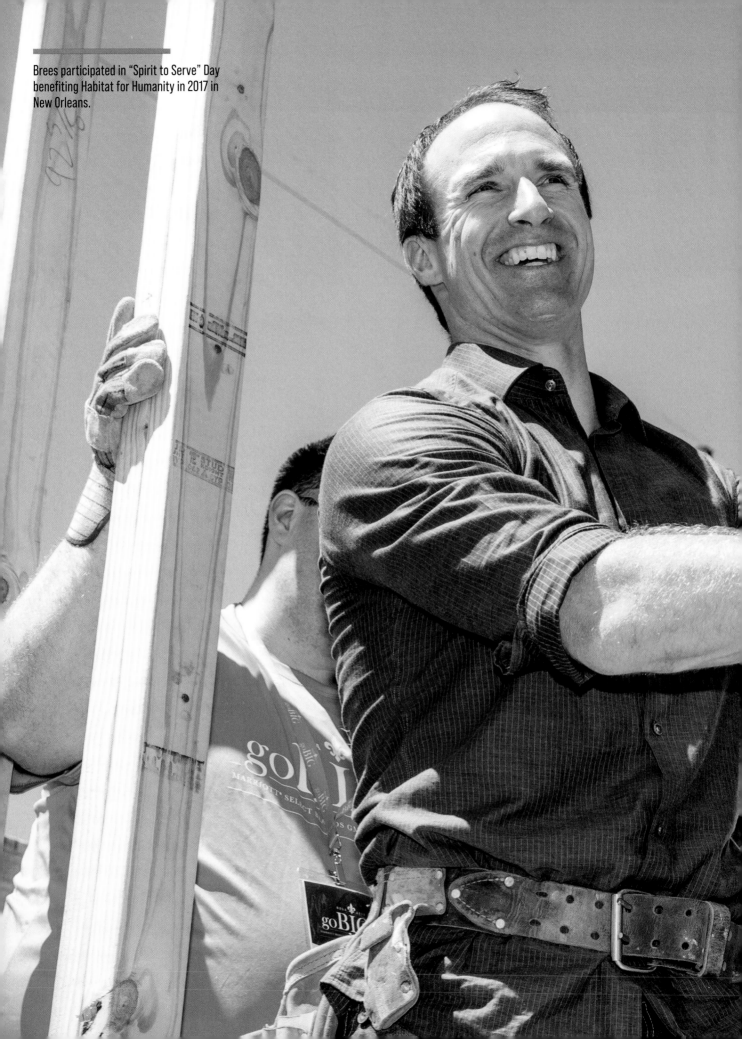

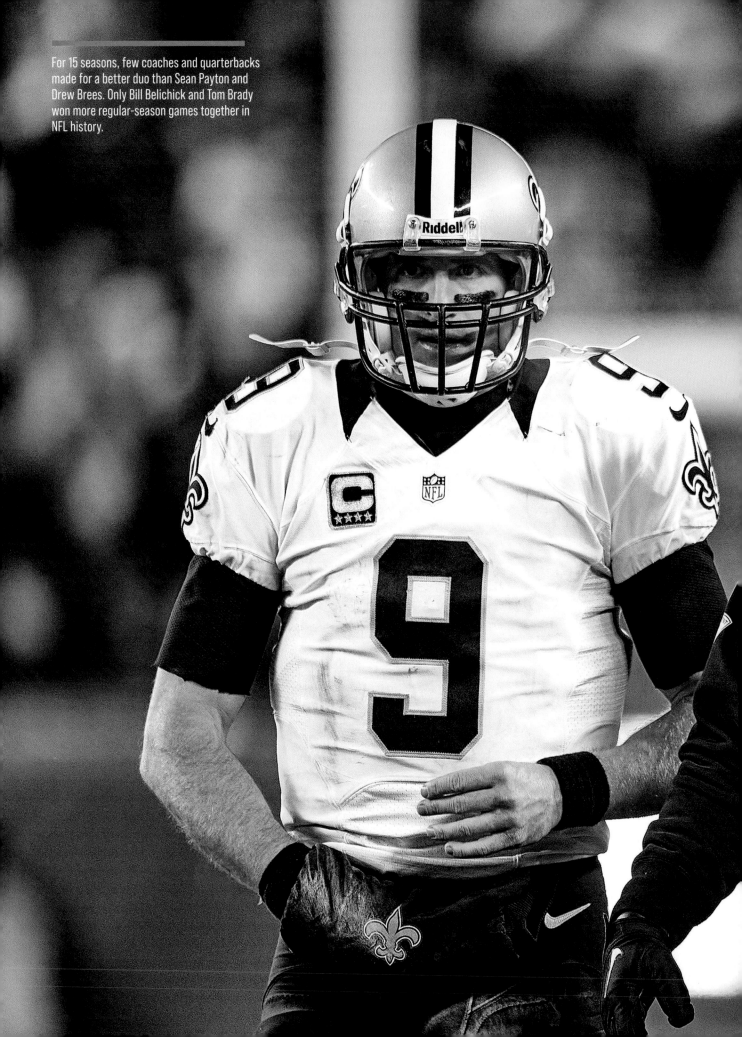

For 15 seasons, few coaches and quarterbacks made for a better duo than Sean Payton and Drew Brees. Only Bill Belichick and Tom Brady won more regular-season games together in NFL history.

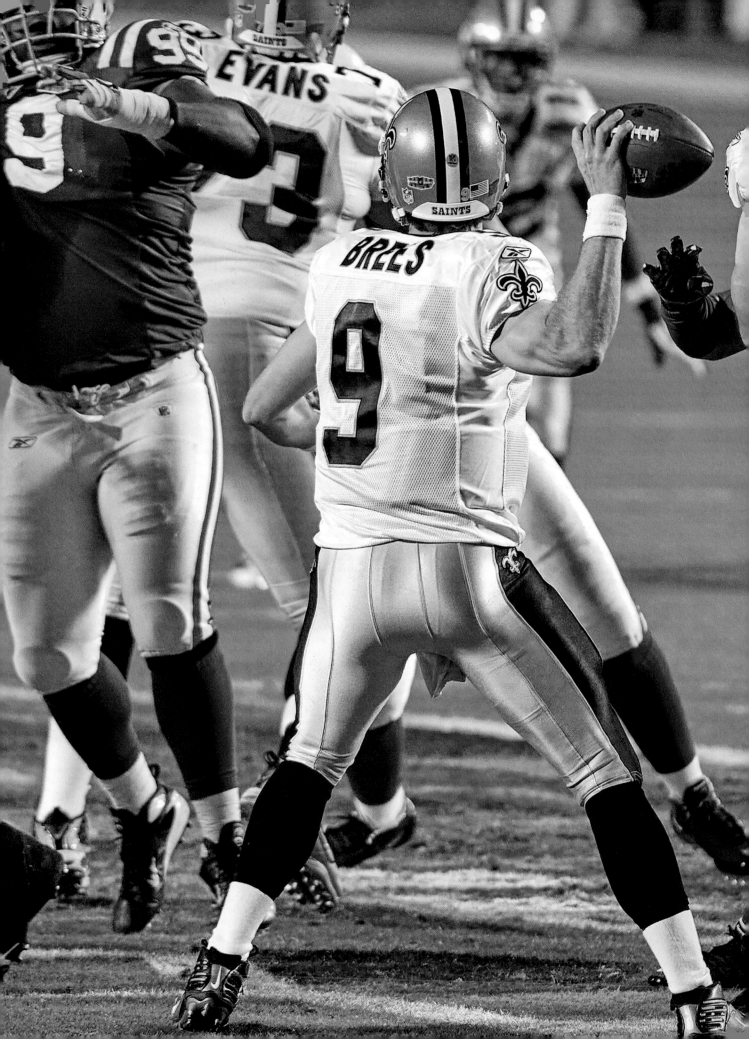

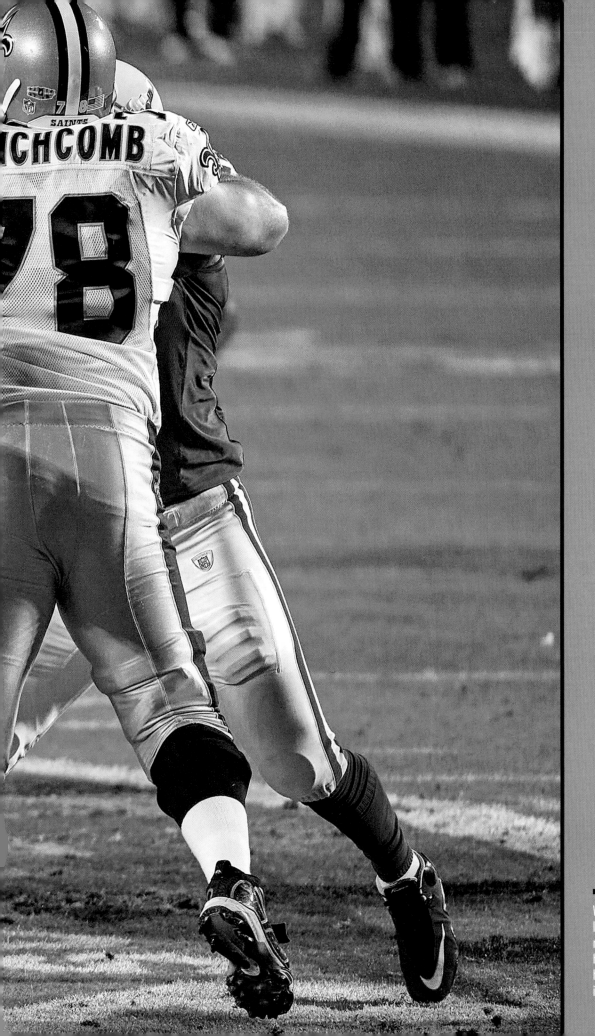

While the NFL's all-time leading passer never won a regular-season MVP award, he did earn hardware for his pinpoint performance in Super Bowl XLIV.

Excerpted from SPORTS ILLUSTRATED, July 28, 2014

Dedicated to the Core

Drew Brees was able to play 20 NFL seasons not just because of his skill but also because of workouts that developed the muscle groups he needed to keep his passing sharp

BY AUSTIN MURPHY

Go ahead, Drew Brees, cut a corner. Cheat just a tiny bit. Make your life easier. On this sultry Southern California morning, the Saints' QB is in the parking lot behind a strip mall facing a brick wall, holding a lunge position—right knee at a 45° angle, left knee hovering an inch above the pavement—arms extended and starting to tremble as he taps 2½-pound medicine balls, one in each hand, on the wall.

Try it. The burn builds quickly in the upper right quadriceps. By lowering his left knee to the ground, Brees could make much of that pain go away. He doesn't, of course, the pain being the point. He holds the pose for 30 seconds before rising, with a grunt, to take on the morning's next torment.

Brees, a former Charger who keeps a home in the San Diego area, doesn't have to be here. It's July 9, 15 days before the Saints report to training camp. He's an eight-time Pro Bowler, a Super Bowl MVP and future first-ballot Hall of Famer who's already in terrific shape. (He's lean at 6 feet and 209 pounds but a little more buff than he'll be by midseason.) He could be home, sipping coffee and reading the paper, or gliding around La Jolla Cove on his stand-up paddleboard. Instead, he has reported to Fitness Quest 10, a slightly cramped health club in north San Diego, for one of his thrice-weekly, offseason sessions with Todd Durkin, whose relentless pep and intensity (*World-class workout today, baby!*) don't seem to make it hurt any less.

The discomfort, like Durkin's workouts, is distinctive, especially different from anything Brees experienced before he turned pro. When he was starring at Purdue, the training focus was on Olympic lifts. "All bench, squats, cleans. That's

NFL Training SI EDGE Camp '14

Sports Illustrated

WORK IT WORK IT

THIS WEEK
DREW BREES
BEGINS HIS 14TH SEASON.
THIS WEEK
HE'LL SHOW YOU
THE ROPES ON
HOW HE STAYS AT THE
TOP OF THE GAME

BY AUSTIN MURPHY
P. 34

MASTERS PREVIEW '15
(WHY WAIT?)
RORY MCILROY
IS A GREEN JACKET
FROM THE
CAREER GRAND SLAM,
GIVES GOLF ITS
POST-TIGER NARRATIVE

BY MICHAEL BAMBERGER
P. 28

The balanced warmup.

just what you did," he recalls. "We've come a long way in our knowledge of training and functional fitness, and Todd's been on the cutting edge of that."

This morning, Brees will spend two hours honing his "functional fitness"—that is, replicating the movements and isolating the muscle groups he most relies on as a quarterback. Rather than trying to bulk up, his focus is on flexibility, core stability and rotational strength. He is joined in this session by Eagles running back Darren Sproles, Browns linebacker Tank Carder and Saints backup quarterback Ryan Griffin.

Brees will report to training camp in peak physical condition—almost as if he's stockpiling fitness. "I'll be in my best shape of the year," he says. "Once we get into camp, then into the season, a lot more time is devoted to the classroom: studying opponents, film work, the mental side of the game."

Sproles is first to arrive at the fitness center, followed by a feisty octogenarian named Ron, who complains that someone has taken his usual parking space, forcing him to walk an extra 50 yards. "I'm exhausted," Ron deadpans. "I'm calling for a congressional investigation."

Durkin, who has worked with scores of professional athletes, many of whose framed jerseys line the walls, has never seen the need to separate the pros from the "Janes and Joes."

Brees arrives 10 minutes before his 9 a.m. session and hops on a treadmill for a kind of warmup before the warmup. He's cordial, reminiscing with a reporter about some of his former Boilermakers receivers. But it's also clear that he's sharpening his focus for the upcoming ordeal.

"Anytime we set foot in this place with Todd," he says, "we have to have our mind right. I don't do things in here at one speed, then do things on the field at another speed. It's all the same. Obviously when I'm doing weight exercises, there's proper form. But once you have that down, you try to do it quickly, with intensity, because that's how it happens on the field."

Durkin's dynamic warmup emphasizes "upper-body joint integrity." It has the feel of a Pilates class. The idea is to work the small muscle groups around the joints in general, and Brees's right shoulder in particular. Nine years ago he suffered a severe dislocation of that joint, as well as a partially torn rotator cuff and a 360° tear of the labrum, after which he signed with the Saints as a free agent.

Brees, a longtime Pilates practitioner, breezes through the exercises, his form flawless, his flexibility downright yogi-like. "He's really meticulous about doing the movement perfectly," says Carder. "I'm trying to model that because obviously he's been in the league a long time."

Durkin has divided the main body of the workout into four quarters, each with its own exhortation: Believe! Be passionate! Be focused! Be great! The first quarter brings Brees to an apparatus called the TRX Suspension Trainer, a pair of resistance cords with foot cradles. His feet in those stirrups, Brees knocks out several sets of 15 push-ups. Though they're much more difficult than normal push-ups, he makes them look absurdly easy. For the next set he inverts himself into a pike position. At this point it's as if he's just showing off.

What makes the TRX so challenging, Brees says after the session, "is that you're creating an unstable environment." Between holding a plank position, then doing push-ups, then folding into a pike, "you're recruiting every muscle in your body. A full workout on the TRX can absolutely destroy you."

For the second quarter, Durkin leads the quartet into the parking lot to the aforementioned lunging wall. Pressing on through the back of the strip mall, Brees & Co. climb a flight of stairs, then set up outside another Fitness Quest 10, this one above a taco shop. The players attach elastic bands to the railing for overhead extensions, pressdowns and a move known as the Travolta.

A quarterback at William & Mary, Durkin aspired to reach the NFL. In 2000 he did—as a massage therapist for the Chargers. That same year he started his training business. San Diego running back LaDainian Tomlinson signed on as a client in '03 and soon brought Brees along. "The thing I remember most," says Durkin, "is how weak Drew's core was. During a set of BOSU side-ups, Brees's core just gave out. And I remember thinking, *I can make this guy better*."

Eleven years later, Brees could no doubt star in an infomercial on the benefits of a powerful core. His greatest strength—a lightning release as well as the zip and accuracy of his passes—have been sharpened by the work he's done with Durkin. "You don't throw with your arm; you throw with your core," says Brees. "It's the focal point of the whole body."

Highlight of the third quarter: The guys generate waves with a set of thick ropes. Based on the rate and volume of Brees's grunts, it's harder than it looks.

Next up, the TRX Rip Trainer. Holding a three-foot pole tethered to a resistance cord, the athletes perform a series of rotational exercises that gives the impression that they are bludgeoning an invisible adversary. It looks like fun!

But it's *serious* fun. The pace is torrid; these guys need every breath they can get, so there's not much laughter, though Brees tried

to derail Sproles midway through the second quarter by rocking out to "Teach Me How to Dougie." Sproles almost cracked up but regained control and finished the set. A Saint for the last three seasons, Sproles was traded in March to the Eagles.

They finish with a contest Durkin has dubbed the Rebounder Game, played not with a basketball but with what appears to be a very large Everlasting Gobstopper smuggled out of Willy Wonka's chocolate factory. It's similar to handball, but the rules on getting in an opponent's way are hard to discern. Most disputes are resolved by Durkin's declaring, "Do-over." The Gobstopper's irregular bounces hone reaction time and hand-eye coordination. So it's more than just a game, which is important to Brees. "There's no wasted movement, no wasted exercise," he says. "Everything has a purpose."

The challenge of sustaining his superb level of play—he's joked with Durkin about playing until he's 45—is not Brees's only incentive for staying ultra fit. When the treadmill wasn't occupied by Sproles, it was being used by a tall, blond woman also doing speed work. Two things you noticed right away about Brittany Brees, Drew's wife and the mother of their three sons: She's very fast, and very pregnant. Their fourth child, a girl, is due in August. ●

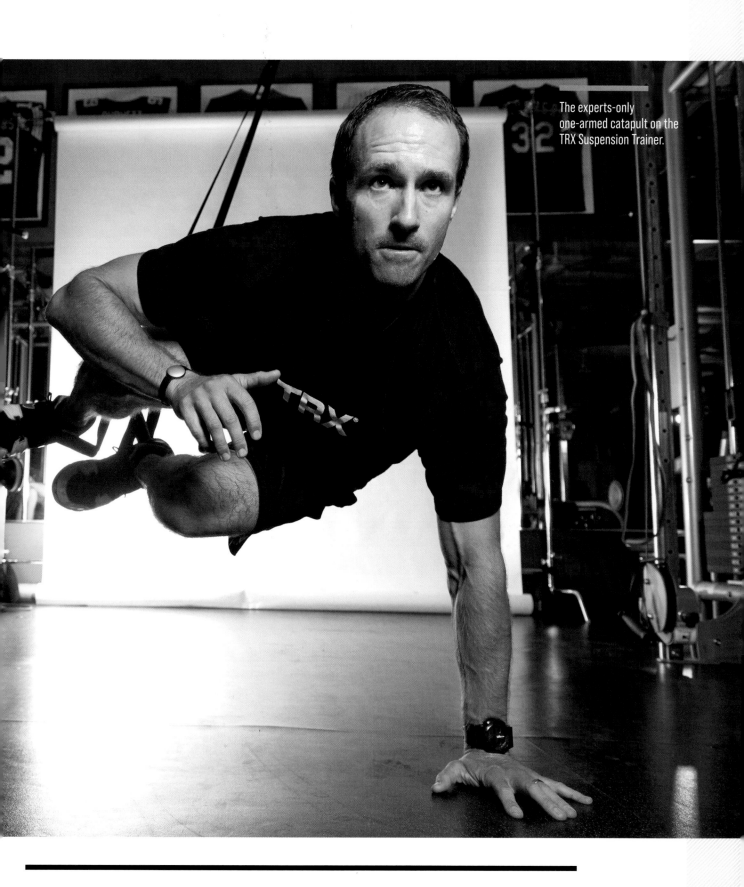

The experts-only one-armed catapult on the TRX Suspension Trainer.

Though seven years
removed from his
Super Bowl triumph, Brees
never lost sight of the
ultimate goal.

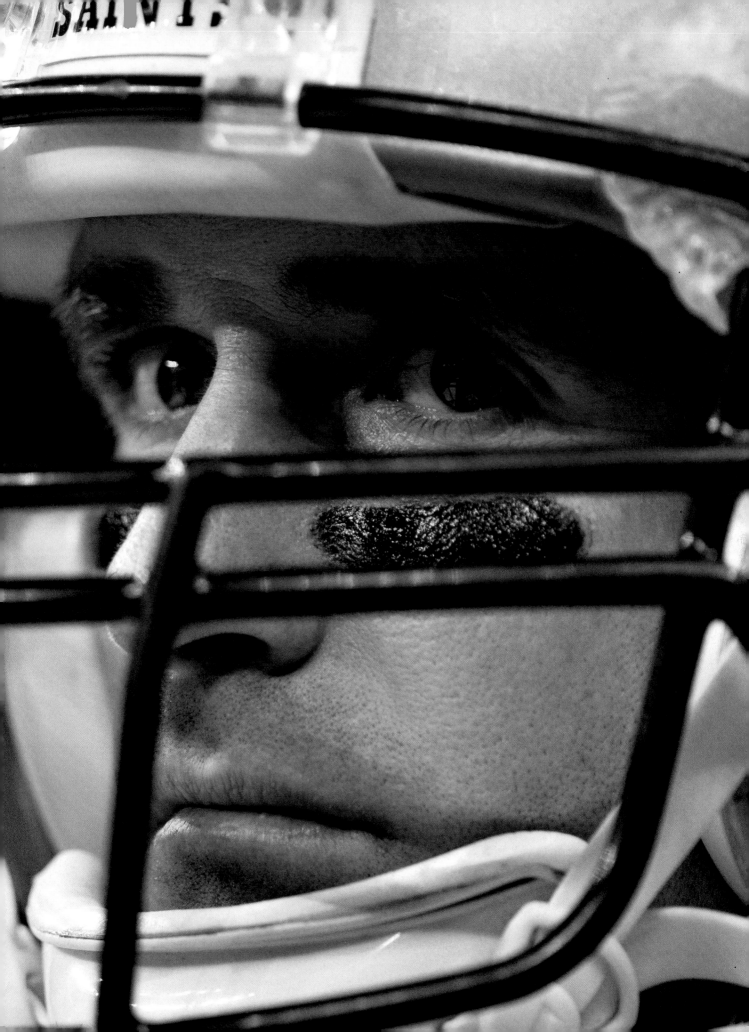

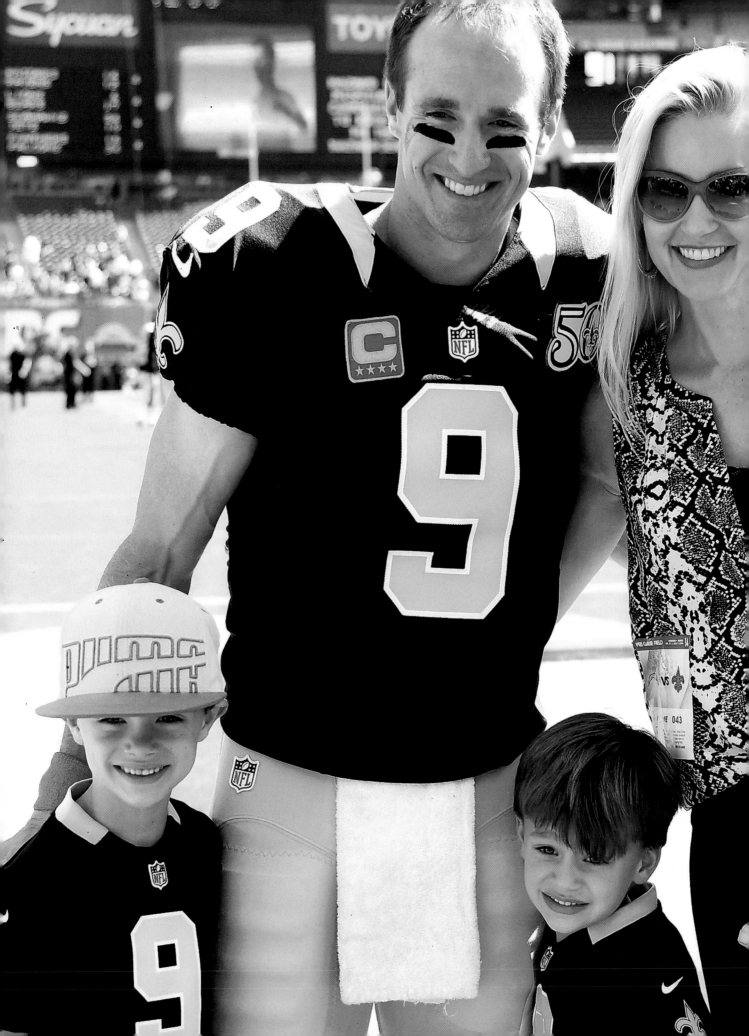

The Brees family posed for a photo before the Saints took on Brees's old team, the Chargers, in San Diego in 2016.

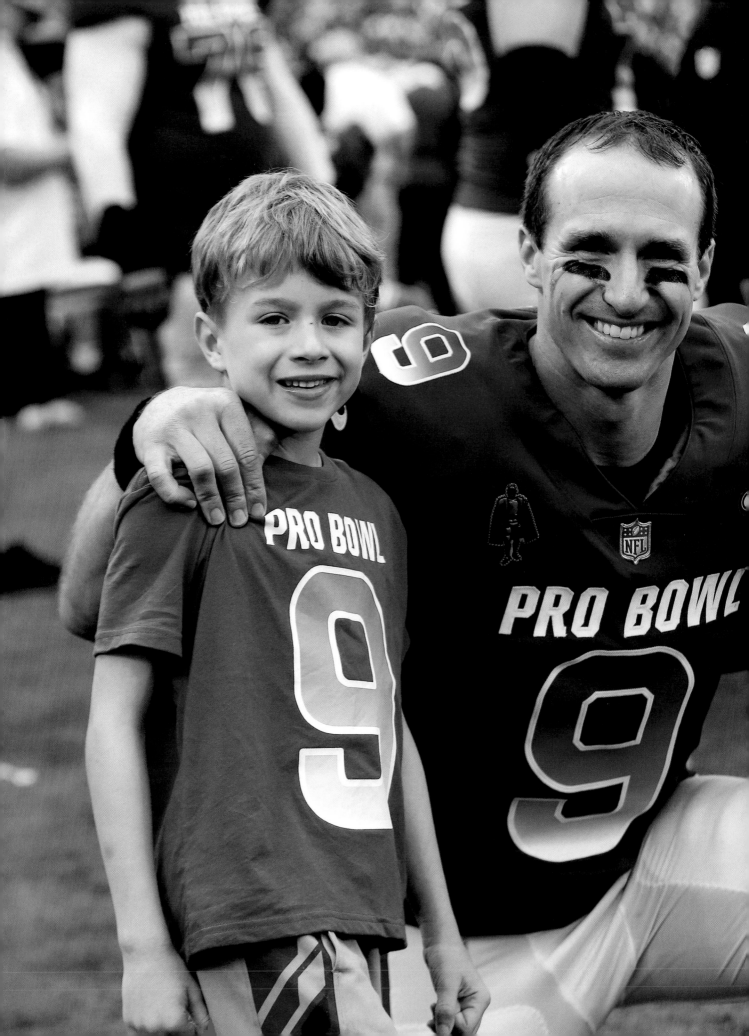

Brees posed with sons Bowen and Callen during the Pro Bowl in 2018. Brees was selected for the postseason honor 13 times during his incredible career.

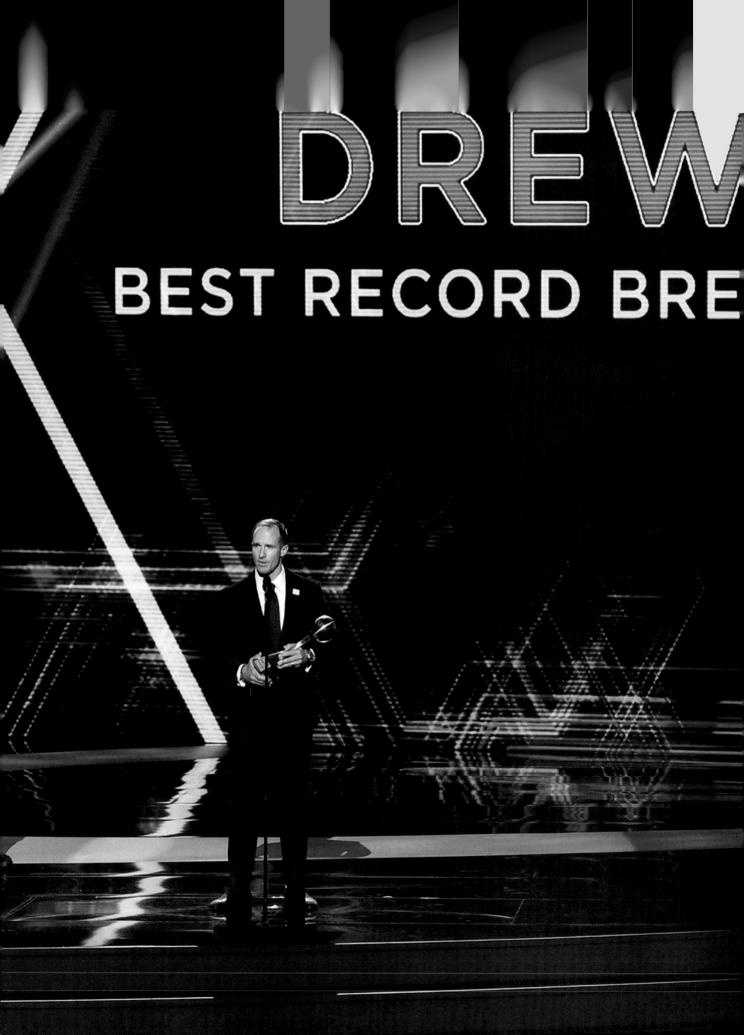

BREES
KING PERFORMANCE

Brees earned the Record Breaking Performance award at the 2019 ESPYs. The quarterback was honored after becoming the NFL's all-time leader in passing yards.

Excerpted from SPORTS ILLUSTRATED, December 2, 2018

The Final Analysis

The humbling aspects of Drew Brees's story—undersized, lightly recruited, doubted after an injury—surely obscure the fact that he is one of the greatest quarterbacks ever

BY GREG BISHOP

Drew Brees spies the bouncy house—the friggin' bouncy house—and grimaces. He's on the field at the Saints' indoor practice field in mid-October, holding an inch-thick black playbook and rifling through pages of plays named after video games (*Fortnite*) and superheroes (Black Panther, Captain America).

He turns to address the Boilermakers, the team of first- and second-grade flag footballers he coaches every Monday. He's oblivious to the parents seated in their lawn chairs, to the dogs roaming the sidelines and to the most repeated question of this 2018 NFL season: What record did Brees break this week?

The kids, though, are not oblivious. They're distracted. By the parents and the dogs and, most of all, by the giant bouncy house now being inflated across the field for the birthday party of Coach Brees's middle son, Bowen, who is turning eight. Sure, Brees may have vaulted the Saints into Super Bowl contention while expanding the footprint of his youth flag league, Football 'N' America; he may have toppled the NFL marks for career completions and passing yards, thus (slowly) altering the prism through which we view his remarkably consistent and still-not-yet-fully-appreciated career. But right now the 39-year-old is competing for attention against more than Tom Brady or Aaron Rodgers or Peyton Manning, or even the overcooked notion that he's some sort of football underdog success story. Now it's Brees vs. the Bouncy House, too.

Deterred? *Please.* This is a man who takes his flag football so seriously that he cornered LaDainian Tomlinson over breakfast at the Pro Bowl last January and discussed flag formations, with a particular focus on motioning backs—second-graders!—out of the shotgun. If Brees can overcome shoulder surgery, short-quarterback problems and the aftermath of Hurricane Katrina, surely he can wrangle a bunch of kids through practice. *Right?*

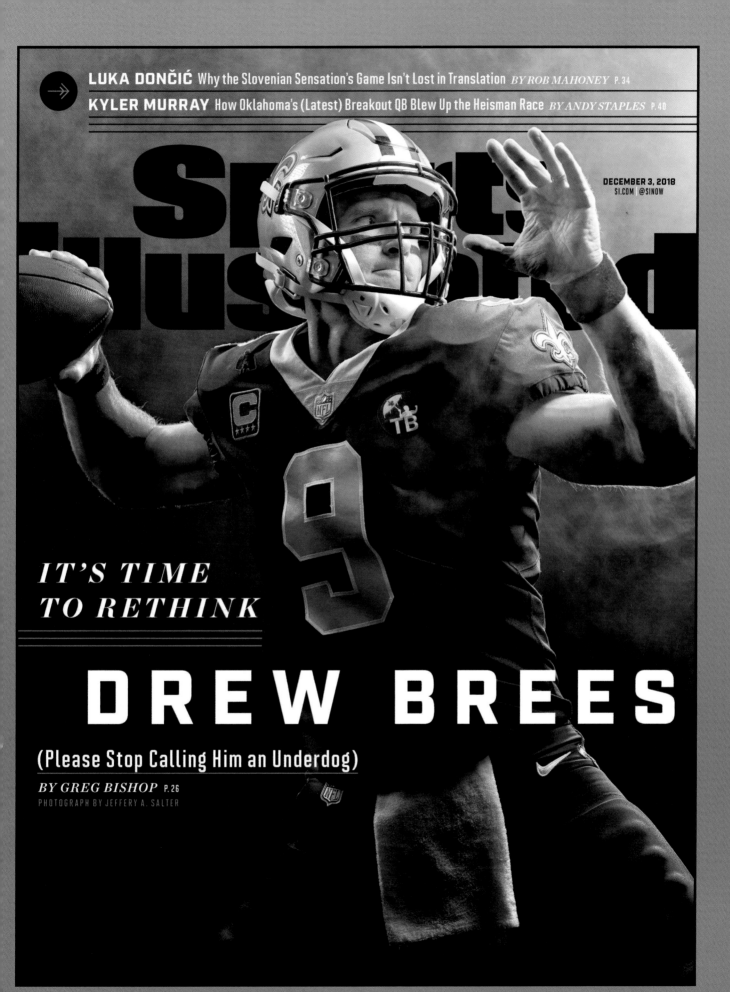

Sports Illustrated

DECEMBER 3, 2018
SI.COM | @SINOW

*IT'S TIME
TO RETHINK*

DREW BREES

(Please Stop Calling Him an Underdog)

BY GREG BISHOP P. 26

PHOTOGRAPH BY JEFFERY A. SALTER

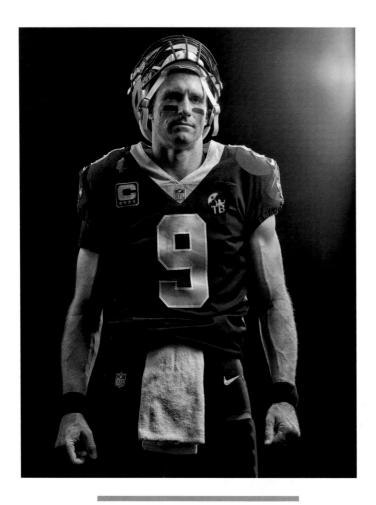

Brees is the NFL career leader in completions, completion percentage, and regular-season passing yards, and is second in touchdown passes.

Ravens, the only team Brees had never beaten. Not his 500th career TD pass. Not the fact that he bolstered his league-leading marks for efficiency (121.6) and completion percentage (77.3%) and had still yet to throw an interception. "Great game yesterday," one parent musters. That's it.

It can seem like Brees prefers life this way, content to let his contemporaries be described as nonhuman quarterback deities. Brady, with his supermodel wife and all those rings, the holistic health guru who just might play forever; Rodgers, the golden-armed God with the celebrity girlfriends, helming an iconic franchise; and Manning, the genius gridiron savant. Meanwhile, here's Brees, this middle-aged guy, just plugging along off to the side, *coaching flag football*. Because of that image, and because of a series of events from early in his career, he's portrayed as merely human—or rather, something less than superhuman like the others.

In other words, Brady and Rodgers and Manning are the bouncy house. We're the kids, mesmerized by these shiny distractions. Brees is just Brees, the dad toiling in the shadows. And that notion of Brees as the plucky everyman is not merely overly simplistic. It's wrong. In reality, he's just like them, a cyborg quarterback. One of the greatest players in NFL history.

"Everyone's going to catch a ball," Brees tells the kids in his well-worn dad voice. "*Then* we'll go over to the bouncy house."

"I'd rather go *therrre*," pleads Bowen, who was born eight months after his father won Super Bowl XLIV in 2010.

"I know you would," Brees says patiently. "But we have to do this first."

Later, after practice, as Bowen bounces and Brees cuts slices of *Fortnite*-themed cake and asks his daughter, Rylen, where her shoesies are, no one mentions the events of the previous day. Not the Saints' 24–23 victory over the

The proprietor of the Mother-in-Law Lounge in New Orleans knows his history. Kermit Ruffins—trumpeter/singer/composer/Saints fan—wore his black No. 9 Brees jersey for 15 straight days this fall, not wanting to mess with his quarterback's mojo. "Brees sets the tone for the city the same way musicians and chefs set the tone," says Ruffins. "Playing his ass off like that at almost 40 years old—that is freakin' gangster! Anything else you think gangster ain't gangster!"

Ruffins takes a long pull from a Bud Light. "History is funny, man. Sometimes it sneak up on you."

In fairness, this season of records broken crept up on Brees, too. Growing up in Austin, he played flag football until ninth grade, made forays into tennis and track and basketball and baseball, and almost quit the jayvee football team. The only history he cared about at that point was becoming the first athlete to play professionally in three sports.

Sure, as a Cowboys fan he loved Troy Aikman, and he emulated Joe Montana, John Elway, Dan Marino and Jim Kelly. But he only came to appreciate that last golden age of quarterbacks in hindsight. As for his current place among, if not *above*, them? "I don't think that was ever on my radar," he says. *Really?* "Honestly."

Brees still remembers his first preseason game, in Miami with the Chargers in 2001, and how he looked to the upper deck and saw Marino's name up there, next to all of the Dolphins legend's gaudy career accomplishments. But it wasn't as if Brees resolved at that moment to pass Marino in every statistical passing category known to man. Instead he thought, *Hey, don't screw this up; let's just try and complete some passes today.*

So that's what he did. He wanted to become a starter. Lead his team to the playoffs. Find a franchise that wanted him. Make the Pro Bowl. Win a Super Bowl. Then one day he woke up and he'd done all that, in 10 years. He decided he'd aim to play until he was 35, at least. When he did, he resolved to try for 40. And then, this summer, he looked at the Saints' 2018 schedule and noticed the Washington game in Week 5, in prime time. It was almost as if the NFL expected something—like, maybe he'd break Manning's all-time passing mark. (Coming into the season Brees sat at 70,445 yards; Manning retired in '15 with 71,940.) The league's decision struck Brees as a tad presumptuous. He'd have to average 300 yards a game to get there. "At that point," he jokes, "it's like: All right, no

pressure." Then he resolved to "play ball. Make them right."

As Oct. 8 approached, Brees worried most about the kinds of things only Brees would worry about. That he might break Manning's record late in the game, in the middle of a critical drive, halting his team's momentum. Instead, his family made its way onto the field late in the second quarter. Brees found wideout Tre'Quan Smith streaking up the right sideline lofted a perfect spiral and watched Smith carry him, 62 yards later, into history.

Brees remembers every detail about the aftermath. Hugging tackle Terron Armstead. Searching for his coach, Sean Payton. Embracing his wife, Brittany. Telling his four children they can accomplish anything they work for. Handing the ball over to Pro Football Hall of Fame president David Baker. "Perfect," Brees says. Baker wore white gloves for the occasion, ensuring that the last hands to touch the ball were those of the man who threw it.

Later that night he decamped to Rock-n-Sake Bar and Sushi. Over sashimi and wontons and pork-belly lettuce wraps, he told a small group of close friends and family what they meant to him. Former President Barack Obama would later call the QB "a class act." Manning would joke that all he had left in life, after his record fell, was "making dinner for my family." Brees's friend and former Saints teammate, Scott Fujita, would say, "I'd argue he's playing the best football of his career." His trainer, Todd Durkin, would say, "We're watching Picasso with his paintbrush." At dinner, though, the discussion never touched on Brees's place in history. And that was fine with the guest of honor, the record breaker who never bought into any narrative laid out for him.

"I don't get it," James Carville says over a glass of Woodford Reserve and a plate of pasta at an Italian restaurant in Baton Rouge. "It's like

living in New York in 1926, when Babe Ruth was there. Or Chicago in 1995, with Michael Jordan. To actually live in a city where Drew Brees is critical to our lives 16 days a year—it's stunning. He's become like the river. He's just a part of us." The Ragin' Cajun continues: *"People want to talk about how [Brees] never won MVP, [just] the one Super Bowl. . . . What difference does it make? Ted Williams never won a World Series. He's still Ted f------ Williams."*

The problem with Brees and his place in the pro football pantheon is that the story of his career, while fascinating, inevitably leads us to the absolute wrong conclusion. Consider the facts: Yes, Brees did tear his right ACL late in his junior year at Westlake High in Austin. No, he was not recruited by the local powers, the Longhorns or the Aggies. Yes, he did fall to the Chargers in the second round of the 2001 NFL draft, in part because of his height: an even 6 feet. He did struggle (by his eventual standards) in his first two seasons as a starter. San Diego did draft Philip Rivers in '04, and Brees did win the league's Comeback Player of the Year award that season, essentially for thriving in the face of doubt. He did dislocate his throwing shoulder in '05, undergo surgery, suffer through free agency, land in New Orleans and lead the city, still reeling from Katrina, to its first and only Super Bowl win in that magical '09 campaign.

So as the years passed, the story of the short signal-caller who conquered insurmountable odds—the kind of story sportswriters love to tell almost as much as fans love to ingest—morphed into folklore. Brees became the 6-foot, twice-injured savior who scrapped his way to football immortality. *The little quarterback who could.* But any narrative that centered on height and shoulder surgery went too far. It's like we're more *proud* of him for his greatness than we are *transfixed* by that greatness the way we are with, say, Brady and Rodgers and Manning. In other

words: Brees's path may have been unlikely. But the quarterback? Just great.

Come on. Brees threw for 90 touchdowns and almost 12,000 yards at Purdue. He won his seventh passing title in 2016, 11 years after he won his first. He owns five of the nine 5,000-yard-plus passing seasons in NFL history. *More than half!* Sure, Brady and Rodgers had their own origin struggles, but the focus of their stories evolved to center on their other-worldly gifts. Brees? Still the little guy with the big heart.

But consider the similarities. Like Rodgers, Brees is more athletic than he's given credit for; he beat fellow Austin native Andy Roddick in junior tennis and played AAU ball with NBA big man Chris Mihm. Brees, too, has a legendary memory, full of slights, and a long history of overcompetitiveness—broken Ping-Pong paddles, long silences after wayward golf drives—that borders on unhealthy. Like Manning, he's notorious for his preparation, whether spending an hour debating a single play in a game-plan meeting or overseeing every aspect of the itineraries of family vacations with the Fujitas. Like Brady, he's learned under a Canton-bound football genius, and he's dependent on a long-in-place team that cares for his body, obsessing over nutrition, stretching and muscle pliability.

And also like a certain quarterback, who told New England brass years ago that drafting him in the sixth round was the best decision the organization ever made, Brees stared offensive coordinator Brian Schottenheimer dead in the face in 2004, as San Diego weighed drafting Brees's replacement, and said, "That would be the worst f------ mistake this organization ever makes."

So what, exactly, makes Brees the under-dog? What makes him any more human than those others? Short answer: nothing, unless we cling to a few inches of height. And "we're talking frog hairs here," says Tom House, the

longtime throwing guru who has long worked closely with both Brees and Brady. "If [Brees] was doing this stuff by himself, it would just be absolutely amazing. [But] he's been hiding in a crowd."

Now, all these years and broken records later, Tomlinson posits a more accurate look back. Had Brees remained in San Diego for the 2006 season, when Tomlinson won league MVP and the Chargers went 14–2, he says they would have "probably gone undefeated" and won the Super Bowl. Not as plucky, lovable hustlers. But as an NFL powerhouse.

"He still hasn't gotten the due he deserves," says Tomlinson, now an analyst for the NFL Network. "We get enamored with size or appearance. Drew Brees is the most accurate quarterback in NFL history and he's six feet.

"What's the problem?"

Wendell Pierce was filming a TV show in Moscow when he made time to watch Brees break the all-time passing record. The quarterback means that much to the New Orleans–born actor. Pierce also remembers attending the NFC championship game in 2010 against the Vikings, and how an

Brees's 2005 injury marked a major low and ended his tenure in San Diego, but the highs since he became a Saint have been considerable.

older gentleman in front of him just couldn't bring himself to watch the overtime field goal attempt that might send the Saints to their first Super Bowl. Pierce grabbed the man's head and physically turned it toward the field. "Goddammit, we've been waiting all these years!" he shouted. "You're going to watch this!"

When Garrett Hartley's 40-yarder drifted through the uprights, the two men hugged and danced and cried like children. "I never got to see Jesse Owens run," says Pierce. "I never saw Joe Louis box. But, man, if it isn't special to be alive and watch Drew Brees every Sunday."

Cameron Jordan likes arguing with fans. "Just for fun," he clarifies. The topic: Drew Brees is the single best quarterback in the history of the NFL. The numbers make a compelling case: 73,580 passing yards on 6,494 completions, with a 67.3% connection rate, all records. Then there's his metronomic consistency: He last threw for fewer than 4,300 yards in 2005. (Let's preempt your freakout. No one is calling Brees the GOAT. Just: His case is stronger than you might think.)

Fans arguing with Jordan inevitably bring up Brady's rings or Rodgers's arm or Manning's brain or Montana's grace. Jordan will stick to the numbers. "Who's had more passing seasons like Drew Brees?" he'll ask. "I'll wait."

Jordan will reference an old *Sport Science* segment from 2009 that measured Brees's accuracy throwing balls at a target. The quarterback released each one at a launch angle of almost exactly 6 degrees, and his passes traveled an average of 52 miles per hour, with almost 600 revolutions per minute—not as hard as Patrick Mahomes, but sharp enough to hit open receivers all over the field. Brees threw 10 balls from 20 yards and hit 10 bull's-eyes—more accurate than most elite archers. "Who completes passes like Drew Brees?" Jordan asks. "I'll wait." Brees, he'll note, is flirting with an 80% completion rate this

season—that after setting an NFL record last year of 72%. He's made 320-yard passing games his norm, turned pedestrian wideouts into household names and transformed the Saints, again, into football's scariest offense—all of which makes that whole underdog thing such a ridiculous sell.

"Facts," says Jordan. "The only way that you underrate Drew is if you *don't count* completion percentage, total yardage and touchdowns."

Brees has won throwing deep and won throwing short. He's won with the league's 28th-best rushing attack, and he won 11 games last season with Alvin Kamara and Mark Ingram becoming the first running-back tandem in NFL history to each surpass 1,500 yards from scrimmage. What he *hasn't* won is what Jordan is so fired up about. Brees has never won the league MVP award, not even after he broke Marino's single-season passing mark in 2011, throwing for 5,476 yards. (The MVP that year, with 48 of 50 votes: Rodgers, who threw for 800 fewer yards but ended up winning one more regular-season game.)

House can explain as well as anyone why Brees deserves to be viewed in the same realm as his contemporaries. He believes Rodgers "is probably the most talented thrower in the history of the game," followed by Brady and then Brees. Brady, he says, is the savant with computerlike recall, followed by Brees and then Rodgers. And Brees, he says, is the best at controlling the game—processing information, making split-second decisions—ahead of Brady and then Rodgers.

"He orders chaos as well as anybody I've ever seen," says House. As part of Brees's training, House affixes the QB with a band that measures brain activity, and whether Brees is dripping sweat or taking a water break, his readings hardly change. That he doesn't look the part, like Brady, Manning or Rodgers, is beside the point. Ignore the dad camouflage. He throws and obsesses and prepares and cajoles

and competes just like those others. Again: *splitting frog hairs.*

Instead of debating the merits of each quarterback, House proposes, we should kick up our feet and crack open a beer. He compares it to modern-day men's tennis. It doesn't get any better, might never be this good again. Brady is Roger Federer, the regal king with the most titles. Rodgers is Rafael Nadal, the artist whose very artistry makes him more susceptible to injury. And Brees is Novak Djokovic, the technician, the one whose greatness isn't as readily apparent, who is sometimes overshadowed by shinier objects. Like the bouncy house.

"They all go about their brilliance in their own way," House says. "We should just enjoy that we get to watch it."

Last year someone sent Archie Manning a photo from an honors ceremony. Pictured: Marino, Brett Favre and Archie's son Peyton, along with a caption noting the 200,000-plus passing yards accounted for in that one snapshot. But now, Archie points out, you could swap in Brees for Marino and that number would go up, past 215,000. That's football today in a nutshell, he says: "If Patrick Mahomes plays into his 40s, he'll have 100,000 yards."

Records indeed fall. Peyton sent his father a text message recently. There's a kid at Peyton's old high school, Isidore Newman, who broke his single-season passing record. "All my records!" he wrote. "They're all gone!" In the NFL they fell to Brees, mostly. For now.

So it's the first weekend in November. On Sunday the Saints welcome the 8–0 Rams. But first: Brees, sliding comfortably into dad mode, is "super pumped" and "really, really excited" for a series of flag football playoff games on Friday night at City Park in New Orleans.

His first- and second-graders win two playoff games. Imagine what it must be like to stand on the opposite sideline, coaching your

kids, only to look across and see the NFL's chief record breaker holding that black binder.

Brees's older team, the third- and fourth-graders, take the field last. They fall behind, roar back to tie it up and *just* miss an extra point that would have settled the whole thing in regulation. For a second Brees flashes that thing that makes him Brees—arms splayed out, face twisted into a grimace. Then the Boilermakers lose in overtime and Brees gathers them in a huddle, telling them as they wipe tears from their eyes that they should be proud of their season.

Two days later Brees will throw four TDs, handing the Rams their first loss. He'll say that he has no imminent plan to retire, no long-term vision after football beyond expanding his flag league and coaching his own kids. In all this, he's not actively trying to change his story. But with the history he's making, the narrative surrounding Brees and his career is becoming more accurate.

Yes, the injury and the surgery and the recovery are still part of it. So is Katrina. But so are all the numbers, and the wins, and the performances that are, dare we say, superhuman. They're the reason Bobby Hebert, the Saints quarterback turned broadcaster, wonders in all seriousness whether local officials will replace the city's torn-down Robert E. Lee monument with a statue dedicated to the quarterback. Ruffins, Carville, Pierce—they're all right. It's time to see Brees the way they've long viewed him, regardless of height or appearance or false premises.

They know the real story, that of the genius-surgeon-robo-quarterback and the dad absorbed in flag football 48 hours before the season's biggest game. That Brees can be both of those things at once doesn't make him any less heroic than Brady, Manning or Rodgers. It just makes him Drew Brees, one of the greatest quarterbacks—if not *the* greatest quarterback—who ever lived. ●

Brees managed to be both a grounded flag football coach and the leader of one of the greatest air assaults in the history of the NFL.

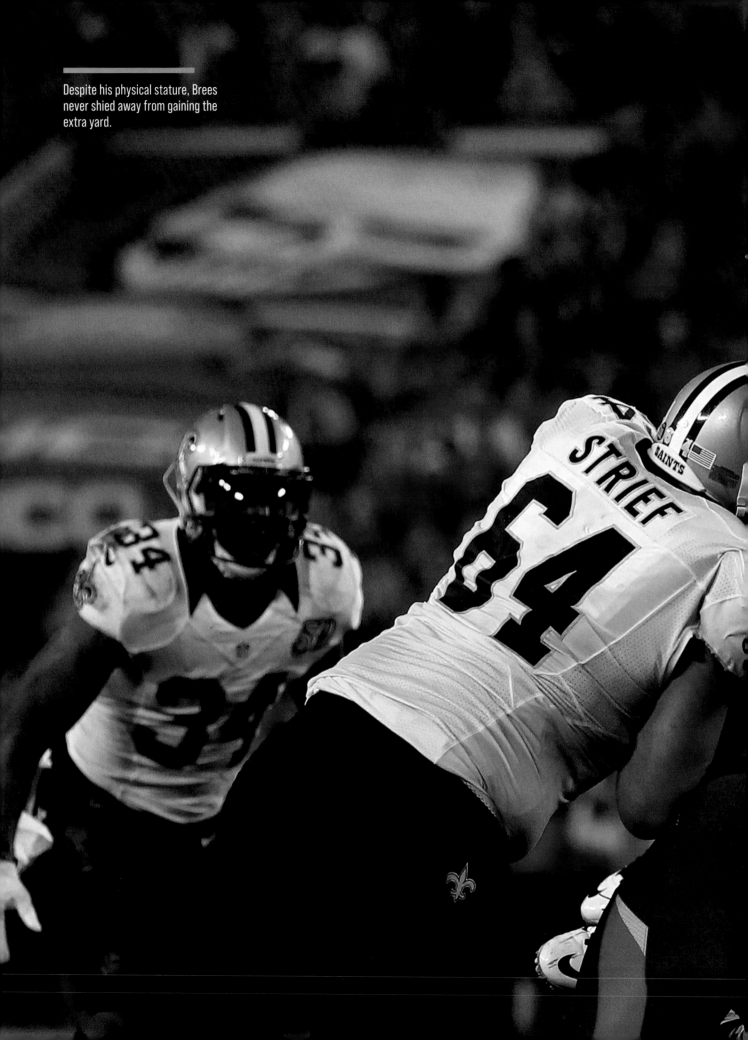

Despite his physical stature, Brees never shied away from gaining the extra yard.

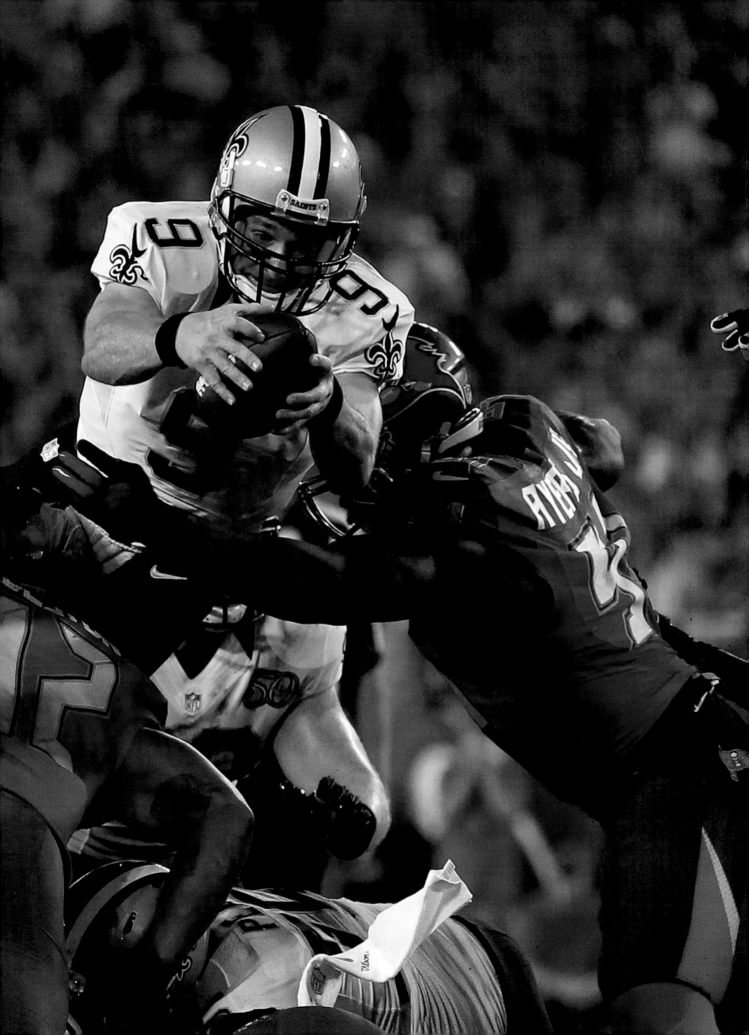

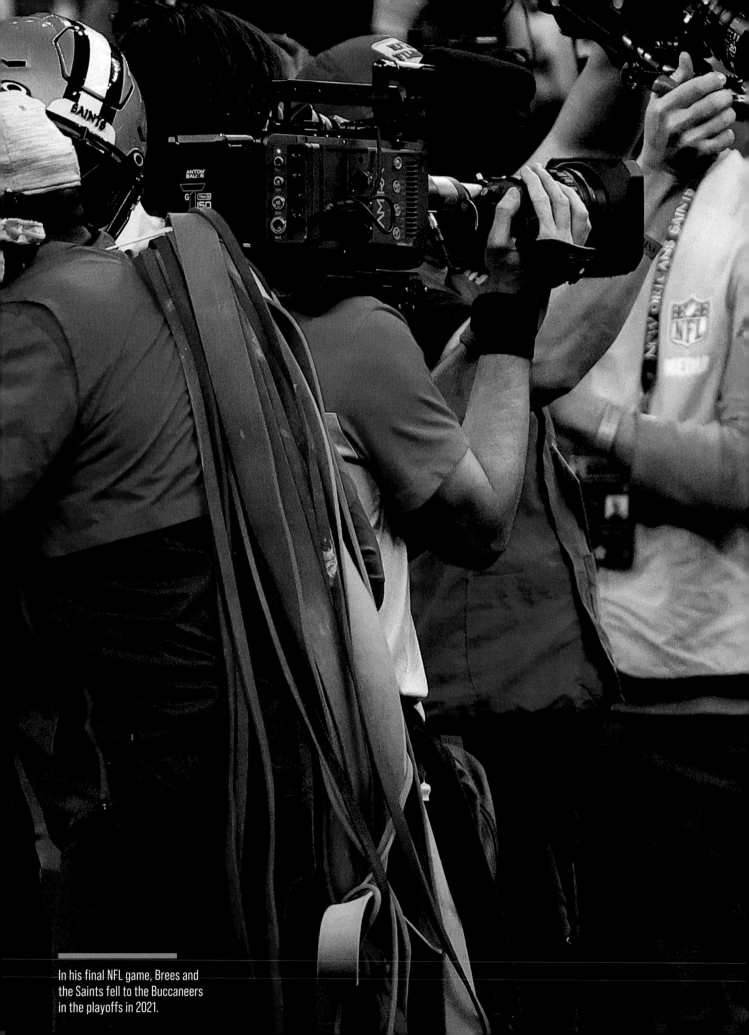

In his final NFL game, Brees and the Saints fell to the Buccaneers in the playoffs in 2021.

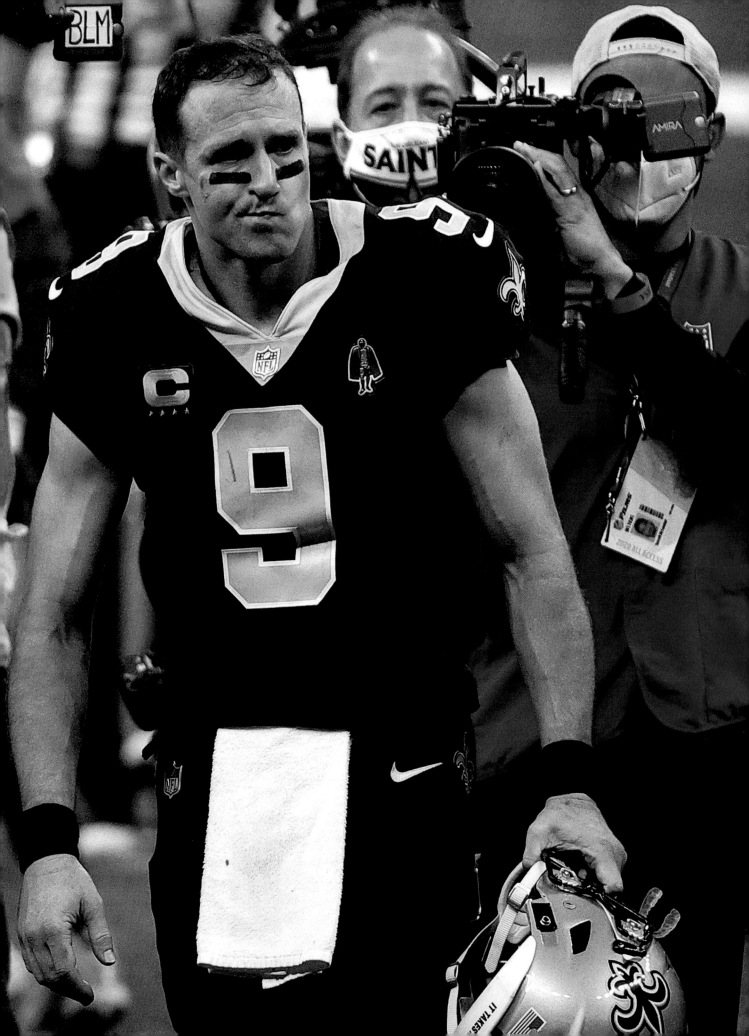

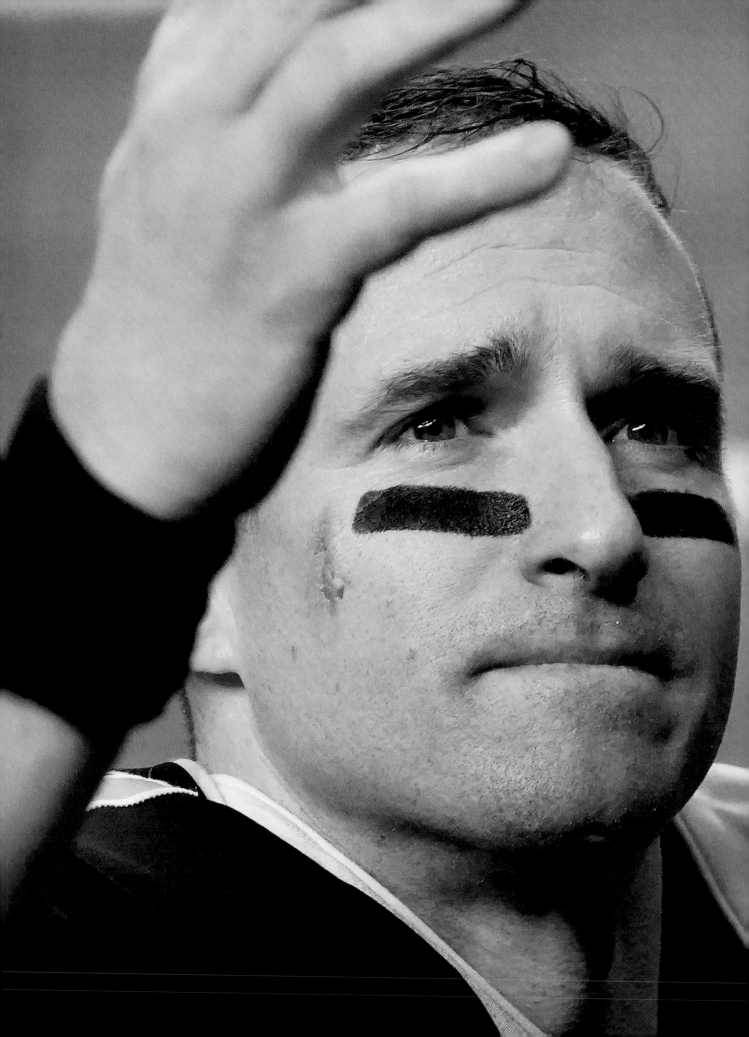

Brees waved to his family as his playing career came to a close.

Following his final game, two NFL legends, Brees and Bucs quarterback Tom Brady, spent time on the field with family.

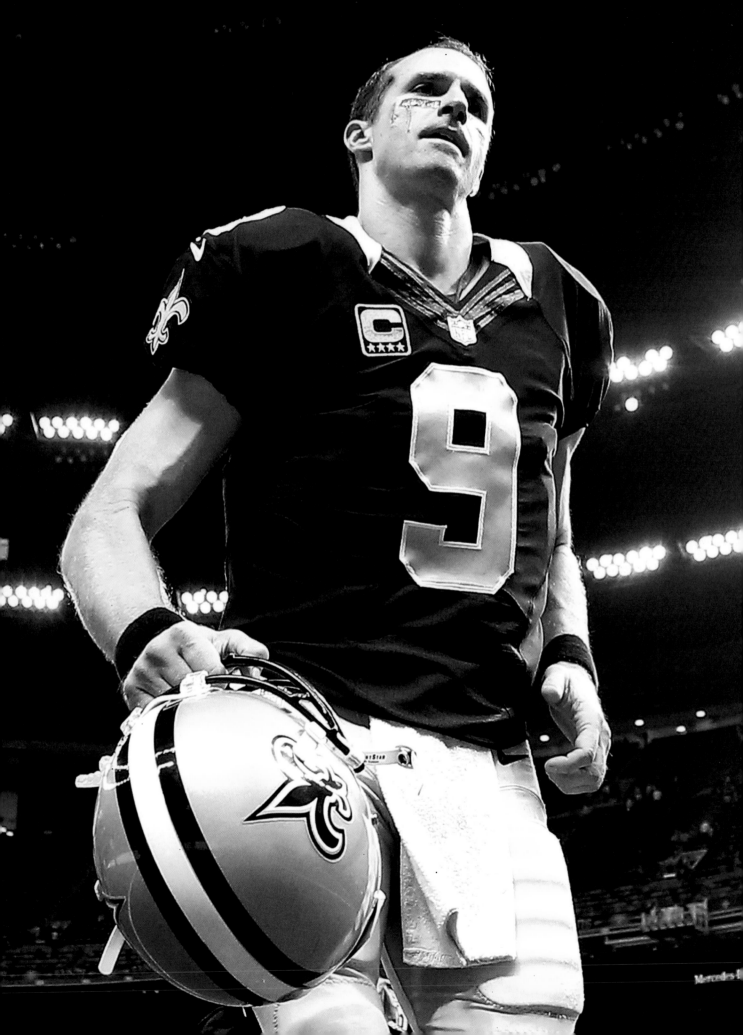

By the Numbers

While the story of what Drew Brees achieved in his 20 NFL seasons goes beyond statistics, the figures are pretty darn impressive

BY MARCUS KRUM

7 Seasons in which Brees led the NFL in passing yards, the most of any quarterback.

74.4 Brees's completion percentage in 2018, a single-season record. He holds the top three marks in this category and four of the top five (2018, '19, '17, and '11).

7 Playoff games in which Brees completed at least 70% of his throws, the most ever (minimum 20 attempts).

505 Yards by Brees in a 2015 win over the Giants. Y.A. Tittle and Ben Roethlisberger are the only other quarterbacks 36 or older to surpass 500 yards in a game.

96.7 Brees's completion percentage in a 2019 game against the Colts (on 29-of-30 passing, for 307 yards and four touchdowns), an NFL record.

16 Career 400-yard passing games by Brees, an NFL record.

73 Number of players who caught one of Brees's 571 touchdown throws.

0 Quarterbacks, besides Brees, listed at 6 feet or under to pass for at least 50,000 yards (Brees has 80,358).

13 Seasons in which Brees led the NFL in a major statistical passing category while with the Saints. He played 15 seasons in New Orleans.

5 5,000-yard seasons. No other quarterback has more than one.

6 Seasons in which Brees led the NFL in average yards per game, including a career-best 342.3 in 2011.

98 Length, in yards, of Brees's longest completion, to Brandin Cooks in 2016.

70.5 Completion percentage in Brees's valedictory campaign of 2020, the sixth-best in his 20 NFL seasons.

DREW BREES

FIRST SAINTS GAME

Sept. 10, 2006, Cleveland

Drew Brees opened up his New Orleans career with a 19-14 win over the Browns. His stats were modest— 170 yards on 16-of-30 passing—though he did lead five scoring drives.

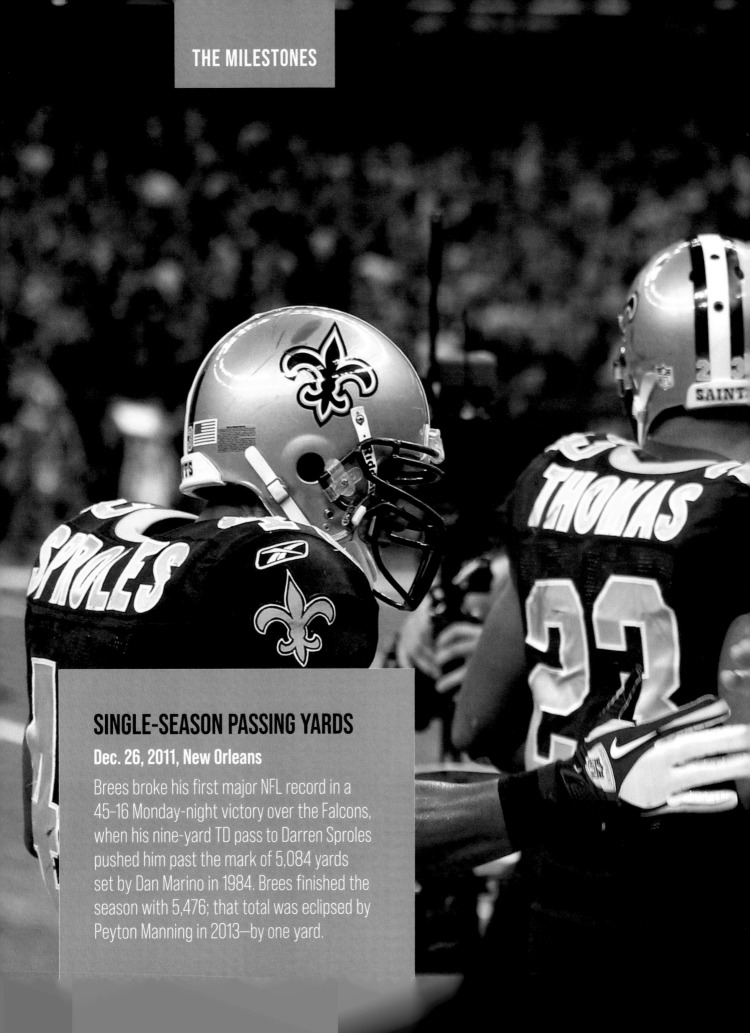

SINGLE-SEASON PASSING YARDS

Dec. 26, 2011, New Orleans

Brees broke his first major NFL record in a
45-16 Monday-night victory over the Falcons,
when his nine-yard TD pass to Darren Sproles
pushed him past the mark of 5,084 yards
set by Dan Marino in 1984. Brees finished the
season with 5,476; that total was eclipsed by
Peyton Manning in 2013—by one yard.

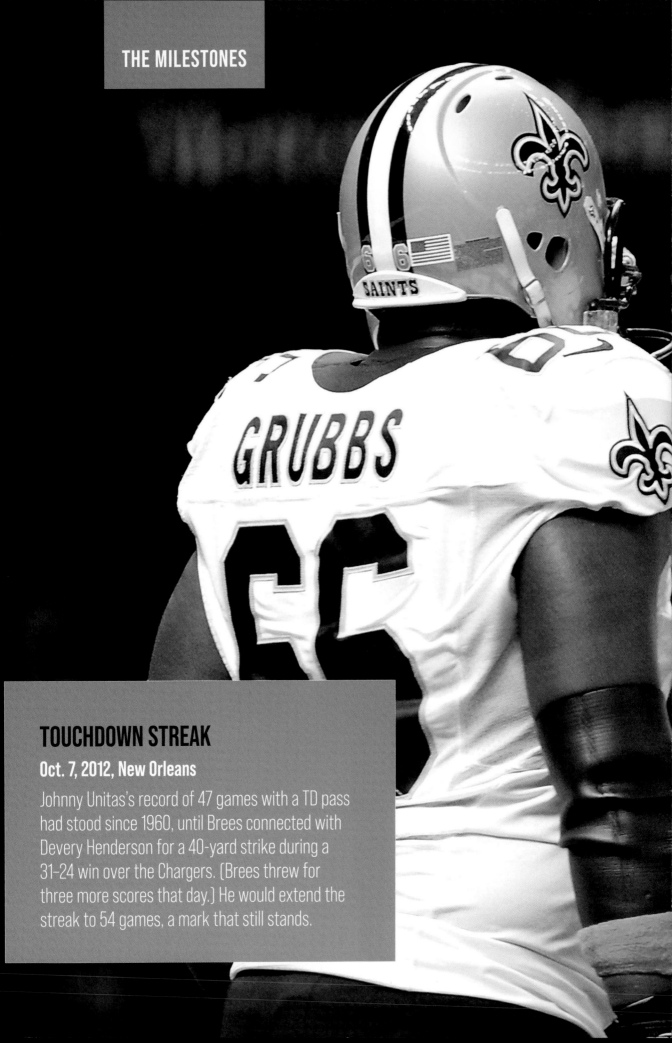

TOUCHDOWN STREAK

Oct. 7, 2012, New Orleans

Johnny Unitas's record of 47 games with a TD pass had stood since 1960, until Brees connected with Devery Henderson for a 40-yard strike during a 31–24 win over the Chargers. (Brees threw for three more scores that day.) He would extend the streak to 54 games, a mark that still stands.

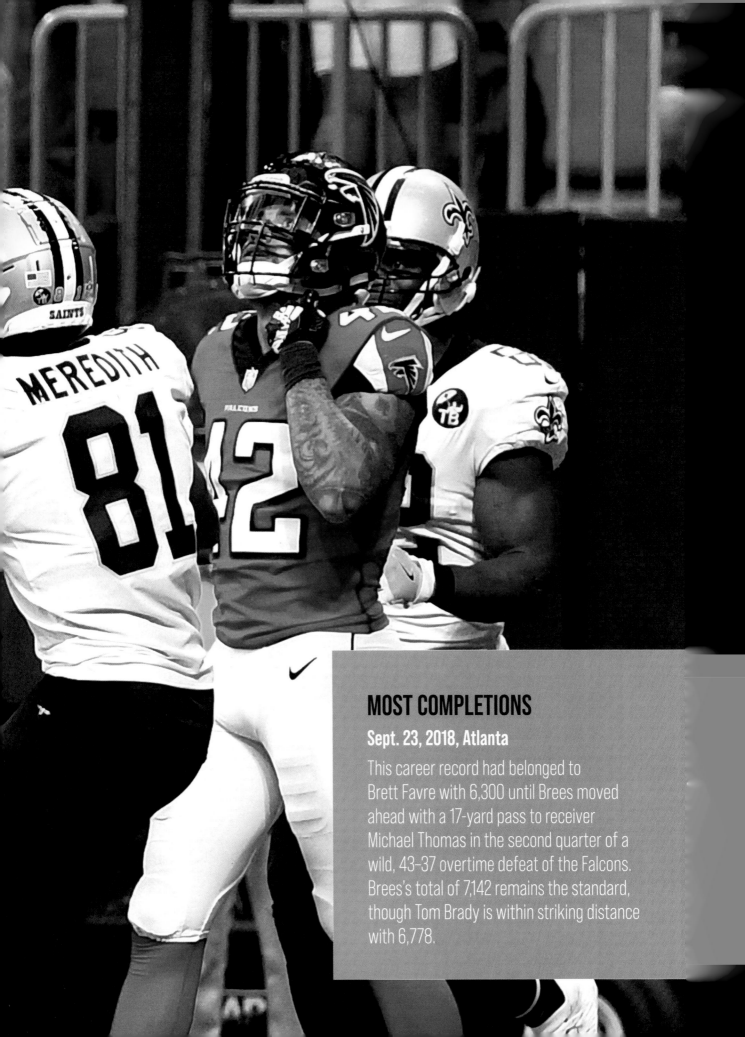

MOST COMPLETIONS

Sept. 23, 2018, Atlanta

This career record had belonged to
Brett Favre with 6,300 until Brees moved
ahead with a 17-yard pass to receiver
Michael Thomas in the second quarter of a
wild, 43–37 overtime defeat of the Falcons.
Brees's total of 7,142 remains the standard,
though Tom Brady is within striking distance
with 6,778.

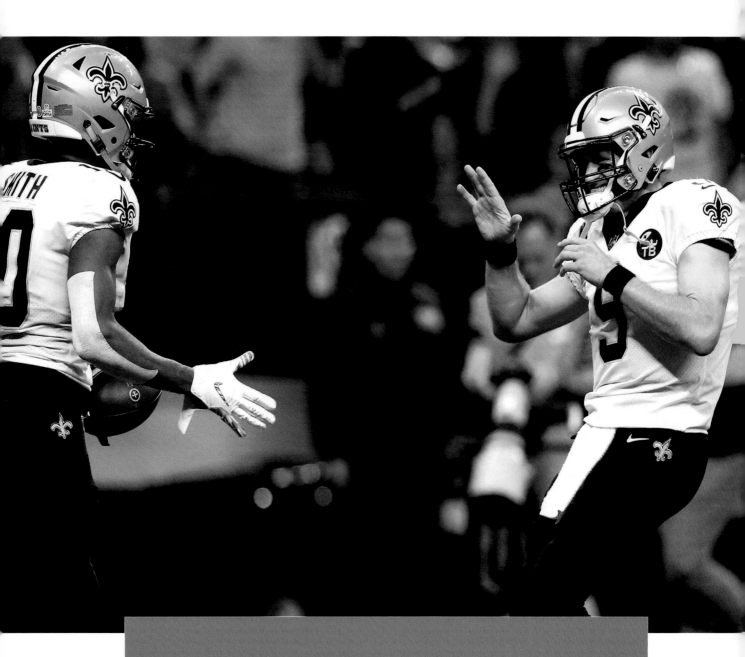

PASSING YARDS

Oct. 8, 2018, New Orleans

Brees broke Manning's career yardage record in style, hitting receiver Tre'Quan Smith for a 62-yard touchdown in a 43–19 win over Washington on *Monday Night Football*. Manning's mark was 71,940 yards; Brees retired with 80,358. Brady, in second place, will enter the 2021 season 1,154 yards behind.

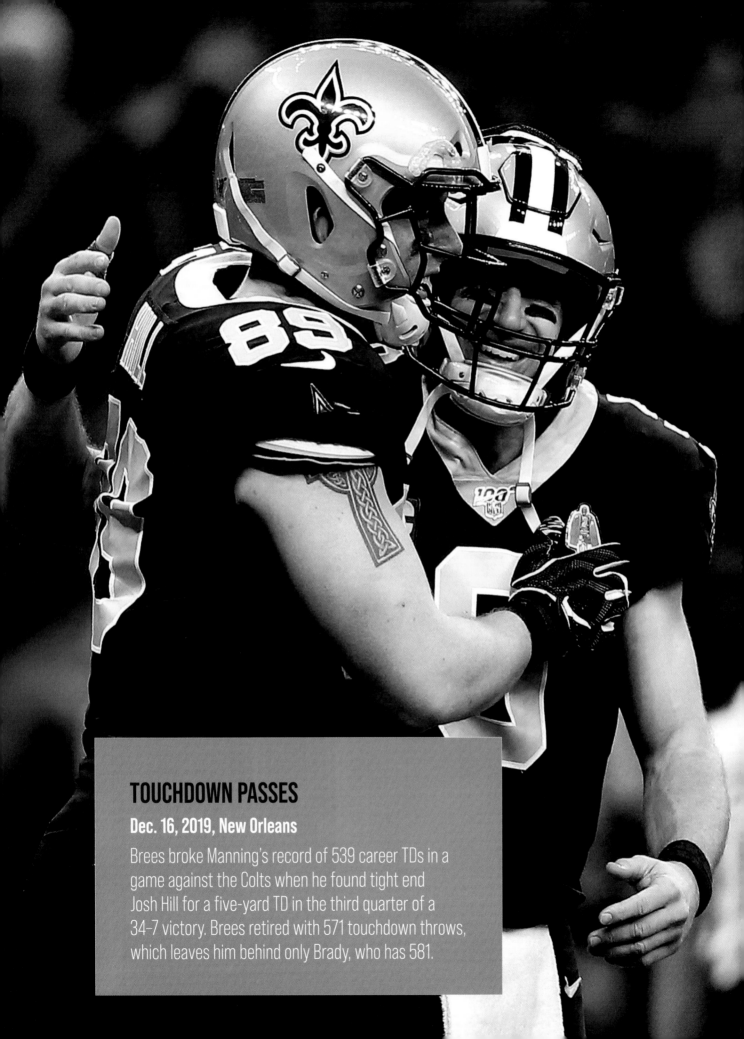

TOUCHDOWN PASSES

Dec. 16, 2019, New Orleans

Brees broke Manning's record of 539 career TDs in a
game against the Colts when he found tight end
Josh Hill for a five-yard TD in the third quarter of a
34–7 victory. Brees retired with 571 touchdown throws,
which leaves him behind only Brady, who has 581.

Jan. 22, 2007

Feb. 1, 2010

Sept. 6, 2010

Feb. 15, 2010

Dec. 6, 2010

Jan. 9, 2012

July 28, 2014

Sept. 1, 2014

Dec. 3, 2018

Feb. 2020

Photo Credits

Al Tielemans: Pages 4, 7, 96, 164, 182; Bill Frakes: Pages 38, 41, 46, 48, 100; Bob Rosato: Pages 78, 82, 90, 110, 113, 120, 142, 162; Damian Strohmeyer: Pages 2, 26, 34; David E. Klutho: Page 208; Jeffery A. Salter: Pages 1, 202; John Biever: Pages 24, 36, 94, 134; John W. McDonough: Pages 55, 60, 62, 64, 67, 70, 71, 106, 184; Peter Read Miller: Pages 14, 50, 74, 76; Rob Tringali: Page 146; Robert Beck: Pages 10, 21, 32, 45, 56, 58, 188, 191; Simon Bruty: Page 138; Walter Iooss Jr.: Page 160.

Additional photography: Ali Nasser/Disney: Page 172; Andy Lyons/Getty Images: Page 220; Anthony Causi/Icon SMI: Page 104; Ben Liebenberg/AP Images: Pages 125, 140; Bill Haber/AP Images: Page 169; Brynn Anderson/AP Images: Page 214; Butch Dill/AP Images: Pages 205, 216; Charlie Riedel/AP Images: Page 124; Chip Somodevilla/Getty Images: Page 131; Chris Graythen: Pages 80, 86, 116, 122, 136, 212, 222, 232; Christian Petersen/Getty Images: Page 108; Denis Poroy/AP Images: Page 205; Diana Zalucky/Disney: Page 166; Don Juan Moore/Getty Images: Page 196; Donald Miralle/Getty Images: Page 98; Ezra Shaw/Getty Images: Page 170; Harry How/Getty Images: Pages 194, 224; Icon Sportswire: Page 30; Jamie Squire/Getty Images: Page 102; Jeff Gross/Getty Images: Page 72; Jeff Zelevansky/Getty Images: Page 150; Jemal Countess/Getty Images: Page 152; Jonathan Bachman/Getty Images: Page 229; Josh Brasted/Getty Images: Page 180; Kathy Willens/AP Images: Page 169; Kevin Winter/Getty Images: Page 198; Larry French/Getty Images: Page 8; Larry W. Smith/Getty Images: Page 75; Lee Celano/Getty Images: Page 84; Lynne Dobson/Austin American-Statesman: Page 16; Mark Cunningham/Getty Images: Page 176; Mark LoMoglio/Getty Images: Page 210; Matt A. Brown/Icon Sportswire: Page 52; Paul Sancya/AP Images: Page 28; Ralph Barrera/Austin American-Statesman: Page 18; Rob Carr/AP Images: Page 132; Scott Cunningham/Getty Images: Page 226; Sean Gardner/Getty Images: Pages 218, 228; Simon Russell/Getty Images: Page 174; Skip Bolen/Getty Images: Page 144; Skip Bolen/WireImage: Page 168; Stan Liu/Icon SMI: Page 69; Streeter Lecka/Getty Images: Page 148; Taylor Johnson/Austin American-Statesman: Page 17; Timothy A. Clary/Getty Images: Page 12; Tom Dahlin/Getty Images: Page 118; Tyler Kaufman/Getty Images: Page 178; Wesley Hitt/Getty Images: Page 192.

Library of Congress Cataloging-in-Publication Data available upon request.

This book is available in quantity at special discounts for your group or organization.
For further information, contact:

Triumph Books LLC
814 North Franklin Street, Chicago, Illinois 60610
(312) 337-0747
www.triumphbooks.com

Printed in U.S.A.
ISBN: 978-1-62937-989-0

Drew Brees:
quarterback, leader, champion.